Good Daughter, Good Mother

a memoir

Pamela York Klainer

To Alice, Bern, Minga,
and all those who bring
mothering presence

What
Makes a
Mother?

<div style="text-align:center">I</div>

My mother, Margaret, was expecting us for a weekend visit. Jerry and I called from the road, updating our arrival time, and I said that we planned to take her out for pancakes and bacon, her favorite evening meal. As we climbed the front steps, Jerry heard me sigh. He reached for my hand. I was surprised to hear Margaret vacuuming; the loud whine of an old machine being dragged across the carpet grated on my ears. Once we were inside, Margaret motioned to Jerry to take the bags upstairs and then turned to me, primed for an argument. He'd barely disappeared around the corner of the staircase when she began a shrill screed, berating me for a transgression known only to her. Halfway back down Jerry stopped, his eyes wide and wary. Suddenly Margaret shoved the vacuum aside and fled up the stairs. We heard her bedroom door slam, then drawers opening and closing, and hangers falling from the bar in her closet. She reappeared, bag in hand, and stormed out the front door. We watched her get in her car and drive away. She didn't come back or call to tell us where she'd gone.

We spent the weekend in her empty house. A few days after returning home I received a handwritten note from my cousin Jan in Pennsylvania.

"Well, Aunt Marge is surely full of surprises. Dick and I were watching football, and we heard someone banging on the front door. Good thing we didn't have any plans to go out for supper Saturday night, because Aunt Marge said she'd come to stay until you and that husband of yours were long gone. She fussed and sputtered so bad we even stayed home from church on Sunday. Dick thinks Aunt Marge is plumb out of her mind, but you know I wouldn't turn her away, and I hope you didn't worry."

II

Minga was not expecting me. We hadn't written or spoken since my Peace Corps service in the late 1960s, and after such a long gap she surely never thought I'd return to Panama. Occasionally I thought of making the trip, but something always intervened: a political coup, rioting in Panama City, an outbreak of malaria or dengue fever. Then, in 2008, I was in Panama City for a consulting engagement, only ninety minutes by car from the village. My daughter Sara was with me, wanting a few days of vacation. She was silent for the first part of our drive into the interior and then asked with clear concern in her voice, "Mom, do you have a plan to find Minga? It's been forty years. What if she's moved away or dead, or we just can't find her?"

I did have a plan, and it started at the mayor's office. I greeted the two women behind the desk. We exchanged a few words in Spanish about the heat, about the dust of dry season. Then I said, "I'm looking for Señora Minga, who lived here a long time ago. Do you know her?"

The women looked at each other, considering. Then one said to the other, "Could she be looking for Rufina's mother?"

My heart began to pound. "Yes. Minga has a daughter named Rufina."

An old man came in, leaving his bicycle resting against the building. "She's looking for Minga," the women told him. "Can you take her?"

Now my heart was racing. "Is she really here? Do you know her?"

"Oh yes," he said. "She lives just over there. I'll go with you."

He climbed into the car, and we drove a few hundred yards down a bumpy dirt road, stopping in front of a pastel cinder block house. He walked up to the open door.

"Minga," he called, "Come out. There's a surprise for you."

She stepped out onto her sheltered concrete patio and looked at me, puzzled just for a moment. Then she raised her arms and gathered me in.

"Pamela. Pamela, Pamela, Pamela."

III

Minga is not my mother. She tells and retells the story of my return to the village to anyone who will listen: how she didn't expect me, and suddenly there I was, on an ordinary day when nothing special was supposed to happen. I promised her long ago I'd come back. A lot of time went by with no sign of me, and then a car pulled up and I was there, right at her front door. She moves from that story to the older ones: how little Spanish I knew when I first arrived as a young Peace Corps volunteer and how she cooked for me because I didn't know how to make a wood fire or hull rice or kill a chicken. She speaks lovingly of caring for me; her brown eyes glow, and if I'm seated near enough she reaches over and touches my hand, strokes my forearm, murmurs my name over and over. Pamela. Pamela.

Margaret is my mother. She often told me the story of my early May birth. Spring flowers were in bloom, and my father brought her a bouquet in the hospital to celebrate the arrival of their second daughter. When we left the hospital to go home two weeks later, Margaret wore a gorgeous flowered hat. She remembered every detail of that hat until the day she died. She could describe the fullness of the fake roses and how the curved brim framed her face and how the pink blooms exactly matched the shade of her favorite dress and shoes. With such a stylish outfit, topped by that remarkable hat, her homecoming could have been a feature on new mothers in a ladies magazine.

No flowers greeted Minga when she gave birth. Her first child, Ana, arrived when Minga was fourteen. Minga's babies were all born in her tiny, mud and thatch-roofed house, on a lumpy mattress raised merely inches from the dirt floor. Some births were attended by a midwife, others not. There were stillborn infants and early miscarriages; Minga doesn't remember how many. With each new baby she was up again as soon as her legs would hold her. There was firewood to gather, water to carry from the pump hundreds of yards away from the mud and thatch house, rice to hull and cook, and probably another little one not yet weaned begging to nurse.

Margaret was not the first person to hold me; she was anesthetized against the strains of delivery and didn't wake up for hours. My father wasn't allowed in the delivery room; men weren't in those days. I was handed by an obstetrician to a nurse and not brought to my mother until she felt strong enough to receive me.

When our daughter, Sara, was born in 1976 her father was the first to hold her, right in the delivery room and moments after she emerged and took her first breaths. Jerry nuzzled and kissed her tiny pink forehead, then laid her gently on my chest to root and to nurse.

Minga nursed all of her children. With no store carrying formula in the village and no refrigeration, breast milk was the only safe nourishment for a newborn.

Margaret didn't nurse us. She said her breasts were too small, her nipples too tiny for an infant mouth to grasp. And breast feeding wasn't encouraged. Margaret said she was told that bottle feeding was better. With a bottle, she'd know exactly how many ounces her baby consumed.

I connect mothering with that primal act of feeding, but not with my mother's breast milk, and not with Margaret. Mothering came to me in a simple tin bowl of soup, from Minga, and long after I was born. But first there was Margaret.

The
Early
Years

They say children don't develop tangible memories until they are nearly four. I was just about that age when Margaret's triplet pregnancy took its bad turn. One baby survived: my sister Barbara.

I don't remember sunlight in the apartment for the months leading up to Barbara's birth. I remember darkness and being alone with Margaret and her lying flat on the couch. Hours went by, then she'd leap suddenly to her feet, voice shrill, upset by something, although not always me. That must have been early in the pregnancy, before her swollen belly and puffy limbs made a quick rise to her feet too hard. One fetus died, as her body filled with fluid. Then she needed a hospital bed in the living room. She could no longer startle me by jumping off the couch. Instead, she rose painstakingly from the bed, slid her feet over the side, and often fainted.

I remember the heavy black rotary phone and the circle that said O. I knew to poke my finger in that hole, slide the heavy dial all the way around, and then let go. A voice came on, saying, "Number please."

"Mommy fell," I said.

I waited. Soon the police came and a stretcher, and everyone left. I don't remember where I went when they took her away. Years later, when I asked, Margaret couldn't remember either. She thought perhaps I went to the lady upstairs.

I remember my father coming home from his shift at the chemical plant, bringing my older sister Linda from school. My father had big hands, Iowa farm boy hands, strong and secure. They were the hands of someone who had things under control. He turned on the lights, cooked supper for us and for our mother who ate little. He gave us a bath and got us to bed. We didn't have a television yet, where he could set us down to be entertained. Linda's first grade classroom sent no work to occupy the hours after school. The dark of winter made an early bedtime seem right.

I don't remember toys scattered on the floor; Margaret might have tripped on one during her slow walk to the bathroom. I don't remember being held on my father's lap for stories before bed; he had too much to do. The laundry. The grocery shopping. Laying out Linda's and my clothes for the next day. Paying the bills, parsing his weekly paycheck among too many empty envelopes. I felt safe when he was there. He left a small light on in the bedroom Linda and I shared, so we could always see each other. He smiled encouragingly at me when he left for work in the morning, Linda holding his hand. Perhaps he cast a last, worried look at Margaret before he and Linda went out the door.

I remember knowing the end would come, and I would have two new baby sisters. The end came but there was only one baby, my sister Barbara. She and my mother didn't return home right away. My mother was too weak, and Barbara was too sick.

When they did come home, I liked having a baby sister, and my mother wasn't swollen anymore or in a hospital bed. But the sun didn't come back. The winter was gloomy, and it was still only March, too early for bright yellow daffodils on the side of our house to bloom. My mother needed to regain her strength, and my father said Linda and I had to be good and not trouble her.

I remember playing with Barbara on the floor and hearing her chuckle and trying to hand her a toy. But her fists stayed clenched and she couldn't even hold a light rattle. I remember her in a stroller and hitting her on the forehead with a soft Kewpie doll and hearing her laugh. That was the day she went to our small community hospital for tests. I didn't want her to go. My mother told me not to be silly, that Barbara would

come home in a few days. They had to find out why she cried all the time and how to stop it. The crying was driving my mother crazy, and she and my father couldn't sleep.

But the very next day they returned from a visit to the hospital without Barbara, and my father sat on the bed and cried when he called his family in Iowa to say that Barbara died. My mother said it meant Barbara went to heaven and God had her and we wouldn't see her anymore. My mother didn't cry, but packed up Barbara's toys and clothes and bottles and put them all in boxes for my father to carry up to the attic.

They took us to the funeral parlor and lifted me up to kiss Barbara on the cheek, which was cold and waxy and didn't feel like Barbara at all.

Barbara was gone but not the medical bills that kept coming. Linda and I played underfoot, able to hear our father's worried tone when he talked to Margaret about his fear of losing our home. One day he put on a suit and went to the bank. His step was heavy when he went out the door. When he came back his spirits were lighter. The man at the bank said my father could pay only the interest for a whole year, and then they'd add an extra year at the end for him to catch up on the principal. He was relieved, and Linda and I were too because he was. Margaret started getting dressed again in the morning.

I became quietly independent, playing by the hour with my fistfuls of red and blue plastic cowboys and Indians. As summer came I was outside playing with the boys, kickball and cops and robbers. I ran around without a shirt or shoes, dirty and tanned like my friends. That lasted until the summer I was six, after we started kindergarten and had to line up as boys and girls and I had to wear a dress every day to school. Then the boys knew I wasn't like them and couldn't play, and I was back to cowboys and Indians on my own.

My self-reliance grew. I was allowed to walk by myself a few doors down from our second floor flat to a playground, where I spent hours on the swings and slide and merry-go-round propelled by flying feet. Once, not paying close attention, I walked behind someone swinging a baseball bat and was grazed in the head. The gash bled profusely. I remember

looking down at my white Keds spotted red with blood and wondering all the way home how I was going to tell Margaret without upsetting her. I trudged up the backstairs to our apartment and stayed at the screened door, calling in for her to hand me out a Band-Aid. She came out instead and screamed at the blood streaking my face. At the doctor's office I got painful stitches while she drew everyone's attention with her high-pitched wails. I think eventually the doctor had to give her something to calm her down.

We always went to Iowa for the last two weeks of August to visit my father's family. We skipped the summer after Barbara died but did go the next year. Going back to Iowa meant finally resuming normal life. I loved those trips. We were the little cousins, and our older, boy cousins sat us on the horses and took us with them to run mazes in the cornfields and showed us how to climb up onto the hayrack in the barn and then swing down with ropes. The aunts taught us to feed the baby lambs from a bottle with a big rubber nipple, and they baked pies with berries that we picked from wild blackberry bushes. The uncles, out in the fields all day because it was late August and time to bring in the hay, didn't talk much. They wore peaked caps with the name of the feedlot on the front and long sleeved shirts and overalls against the sun, but their faces were tanned and leathery as were the backs of their hands.

My father didn't put on a cap like that when he went back home, and his skin remained fair. He always wore slacks and a short sleeved button shirt and leather tie shoes, not work boots. We have a black and white photo of him with his father, Newton Elbert York, and his brothers Alvin, Owen, and Harold. The Iowans are all dressed alike. Our father is the odd man out. His clothing says he wanted it that way, to make it clear that he was the one just visiting.

Linda and I wore shorts and cotton shirts and white socks and Keds. Margaret stuck miraculous medals on silver chains around our necks and made us wear them for the two week vacation. The Iowa Yorks were Protestant, members of the Christian Church. My father remained Protestant too, although he agreed to be married by a priest and to have my mother raise us Catholic. We were never, as my east coast cousin

Adrienne used to say, "rosary clutching Catholic." But for the time we were in Iowa, Margaret clearly needed to mark us as daughters of the Virgin Mary. Margaret also insisted that we drive an hour or more on Sundays to find the rare Catholic church and attend Mass — no skipping the obligation just because we were on vacation, which would show a bad example to our relatives.

Our Aunt Pauline, my father's only sister, had a small foot-pedal organ in her living room, and when we went to her house, she and my father sat at the organ and played and sang hymns. They were Protestant songs, and Linda and I didn't know the words, but we liked to hear our father sing. He and Pauline sang in harmony and smiled a lot, and I wanted to sit by them the whole time and listen and hum along instead of going outside to play.

Margaret, like her sisters-in-law, wore a flowered sundress with little cap sleeves, trying to stay cool in the August heat. But she didn't join the aunts in the kitchen, talking and laughing while they baked pies, or help can the huge crops of vegetables coming in fresh from the garden, or take a turn preparing the massive lunches trucked out to the fields for the uncles and the extra hired hands that were brought on to help bale the hay. She drank sweet tea as it was offered. She packed and repacked the car, finding places to stuff the growing mound of dirty clothes that could only be washed in Iowa with cold water pumped from a well with great physical effort. She liked going to the town square at night, where people greeted my father as a college man, one of the few who left home and made good.

As the months passed after Barbara's death, life got better with Margaret in other ways and not just because of the trip to Iowa. She joined the PTA and volunteered at the hospital. She acted in local plays. She took elderly neighbors who didn't drive to get their groceries. One, Mrs. Mullen, was quite rich, and Margaret had expectations. When Mrs. Mullen died and left her nothing more than a sterling silver comb and brush set, Margaret felt used. "After all I did for her ...," she said to my father over and over. She took the blue velvet-bagged, carefully polished

brush and comb and threw it in a bottom drawer where the pieces slowly tarnished.

I was shy and quiet in school, perhaps even withdrawn, which drew the attention of my third grade teacher. Most of my elementary school teachers have faded from memory, but not Miss Goodman. She had bushy dark eyebrows and big feet and wore soft pastel sweater sets. I knew she liked me, because at the end of the day she always picked me to take the erasers out to the playground and clap them free of chalk dust. One day Miss Goodman asked Margaret to come after school to meet with her. I didn't think Miss Goodman was angry with me, although no one else's mother had to come. I waited in the Principal's office with a book, and Margaret was brusque with me on the way home. Later that night she and my father argued, and I heard her shrill voice and his deeper one as he tried to calm her down. They were fighting over why I didn't talk in school. My father said to leave it alone, and my mother said she didn't like being called in by the teacher and what was the matter with me anyway.

I didn't know why talking more was important but decided to do it so Miss Goodman wouldn't think something was wrong and call my mother again.

We didn't talk at home about Barbara; she was just gone. I missed having my baby sister with us. If we couldn't have her, I didn't want any more babies in our family, but Margaret did. She even cut out a picture of a Korean orphan that we might adopt, but my father said, "Jesus Christ, Marge," with an extra edge. Finally Margaret got pregnant again, and when I was seven my sister Wendy was born.

Babies didn't really make our mother happy, just the thought of them. With a crying newborn in the house and up once more for night feedings, Margaret grew nervous and edgy just like before. This time she turned for help to our neighborhood church.

Taking us to Mass wasn't new, but looking for help from the parish priest was. Priests were distant figures, sequestered in the rectory and only visible on the altar on Sundays. Nuns were more accessible, although not necessarily warmer. Margaret was, as a child, frightened by the nuns in Catholic school and sometimes humiliated. A nun pinned long white

men's handkerchiefs to her short sleeved dress on a day her class went to Mass and what my mother wore was deemed immodest. The nun forced her to keep the handkerchiefs pinned on all day, as a reminder. Every time Margaret told the story, her face burned anew with shame and her eyes filled with tears. "I was only a little girl," she said brokenly, "and my mother set out the clothes for us to wear, and all the kids laughed at me, and I was so ashamed."

Even with those bad memories, in her distress after Wendy's birth, she took Linda and me to a priest. She told us, her voice abrupt and nervous, that the priest wanted to talk to us one day after school. She said he was nice and wouldn't yell at us. There were three priests in our parish, and none of them had ever spoken to me, not even to say hello. Margaret walked with us to the rectory, but once inside she remained in a formal, cheerless parlor while Linda and I were led into a priest's office. He sat behind a desk; in front were two massive ornately carved wood chairs where we were directed to sit. I slid into the red velvet seat, having no idea what was to come. Indeed the priest didn't yell but went on a long convoluted ramble about our behaving better and not upsetting our mother. I don't remember speaking. I don't think he asked us to. He seemed not to know that Linda and I walked on eggshells all the time, just so Margaret wouldn't be upset. Eventually he got up and opened the door of his office and took us back to our mother. She and I and Linda walked home silently, and I suspect she never told my father about the visit.

I was angry at having to go talk to the priest. Miss Goodman talked to my mother, but I knew Miss Goodman liked me and meant me no harm. I didn't know that about the priest. He didn't seem to like us. He looked annoyed, and bored, and never smiled the whole time we were sitting in his big chairs. When he was done talking, he seemed happy to return us to Margaret and see us go out the door.

My older sister Linda liked church, and I don't think she minded seeing the priest. She liked the incense and the bells and the feeling that God was watching. I thought the incense smelled bad and made it hard to breathe. I thought the ashes we got on our foreheads on Ash Wednesday

were from dead people, not palm fronds burned from the year before, and that the crossed candles applied to my throat for the feast of St. Blaise would, although unlit, somehow set my hair on fire. I found the big stone church cold and forbidding. And I never thought God was watching or that God welcomed my sister Barbara with open arms and had her in heaven. I thought Barbara was in the cemetery, buried in the mud beneath tiny crosses and faded toys and forlorn, rain-soaked teddy bears.

Margaret looked to church for help and stability, and she also had Miltown, a bottle of pills that she opened when she felt nervous.

Linda and Wendy and I had my father.

Decades later, in sorting through our mother's things, we found a letter to my father from his mentor and coach, Mr. Sands. My father had obviously written, asking for advice. In response, Mr. Sands wrote that he had no idea what might be the matter with Marge, but that my father should stick it out for the sake of the girls.

"Stick it out" sounds like something you make yourself do. But my father liked being with us. He took all three of us for outings on the weekends, Linda and I walking and Wendy in the stroller. At the town park we invented expeditions that lasted for hours. As an alternative we got on the bus and rode to Penn Station in Newark, where we ran to the escalators leading from one platform to another, wanting to greet every arriving train. We were faster than my father, who had to navigate the stroller, and when he got to the platform, he always shouted for me to move farther back from the yellow line that kept departing passengers from getting too close to the sunken rails. I wanted to be as close as I could, facing down the big black locomotive, steam belching and brakes on the iron wheels screeching as the train pulled into the station.

During the week, I played with Wendy as soon as I came home from school. We created tent cities with blankets thrown over the dining room chairs, and our parents' double bed became a cruise ship with pillows serving as deck chairs.

But Margaret had Wendy all day long while I was at school. A friend of Margaret's ran a nursery school in her home for three- and four-year olds, and the friend agreed to take Wendy at two and a half. That meant

Wendy was gone five mornings a week, napped in the afternoon, and then I came home. Shortly after five, my father returned from work, and our family sat down for dinner.

Years later, when my mother was able to talk about that time, she recalled her nerves being constantly on edge and feeling that she had no help. She said that sometimes she'd stand at the top of the stairs holding Wendy and be afraid she was going to lose control and throw her down. She'd also thought of killing Barbara, when the constant crying became insufferable, and then killing herself, because killing was a mortal sin. But then she made a Novena to the Virgin Mary to take Barbara, and Barbara died.

When we dressed up to go to church or when my father took us out, I thought we looked like a normal family. But Wendy was too little to be in nursery school. And I didn't think other mothers took so many pills. Our father said, "Jesus Christ, Marge," far too often. And I, almost ready for fourth grade, still went to bed at night and sucked my thumb.

As Wendy began to get older, our family life settled into a routine. We three girls went to school. Our father went to work. Margaret, to assuage her restlessness, began to look at real estate. She'd find a new house on a slightly better street that only cost a little more than the one we had. My father could do cosmetic fix-up work, like painting and wallpapering. We'd sell the house we were in and move to the new one, sometimes we girls having to change schools. We always stayed in Kearny, the town where my mother grew up, except for one time when she persuaded my father to move to the country. That house had an empty chicken coop in the yard that we could make into a fort and a long country road with little traffic where Linda and I could ride our bikes. But my father came from work on the train and didn't get home until nearly seven at night. Margaret didn't like that, so back to Kearny we went. We moved into a brown wooden house on Magnolia Avenue next to Wilbur the hunchbacked tailor.

I don't remember most of the houses or the streets or the neighbors, because there were too many different ones. But I liked Wilbur, and

13

I wasn't afraid of his badly curved back like some of the kids, and he seemed to like having us playing in the yard next door.

We were getting ahead financially, making a little money with each move. But then DuPont, where my father and many other town fathers worked, announced that the plant was leaving New Jersey and moving all production facilities to the South. My father had notice of the move and was told to look for a new job.

In those days there was no support for men who were being let go, no outplacement firms or separation packages. The men were paid through their last day of work. They were on their own to find other jobs, which they had to search for on the weekends. My father looked worried all the time as we trekked around New Jersey looking at the possibility of dairy farming, which he left as a boy because he hated cows, or opening a restaurant. He worked his way through high school in Bloomfield, Iowa, as a short order cook at the Royal Cafe on the town square and knew his way around a kitchen. Finally, just when the plant was about to close for good and his getting a new job seemed less and less likely, he was hired as personnel manager of a small, family-owned tool and die company right in town. We were all losing hope, and his getting hired seemed like a lifesaving turn in our family fortunes.

He started the new job in September, and I started high school with a full load of honors courses including Russian.

In mid-October he told my mother he'd be late home from work one night that week. The company owner asked my father to serve as master of ceremonies for an employee dinner at the Robert Treat Hotel in Newark. We girls were proud of him; master of ceremonies sounded important. When that night came, Linda was gone, having just started college. Seven-year old Wendy went to bed. I stayed up until about ten; he was due home around nine-thirty. My mother made a pot of coffee and said she'd wait up.

Strange, rumbling voices, broke through my sleep. I crept downstairs in my bare feet, startled fully awake by the cold linoleum on the kitchen floor. Three men stood in the kitchen, one wearing a suit with a badge on

his lapel, the other two in blue uniforms with hats held in the crook of their arms.

My father's worn leather wallet lay on the kitchen table. I knew he'd never give his wallet to strange men even if they were the police. My father must be dead.

Margaret shrieked. "NO, NO, NO, NO." In low, firm voices the police kept asking for the name of someone they could call. No one saw me in the doorway. I was a ghost, invisible, washed out of the picture by the volume of Margaret's wailing. I went to the stove, poured a cup of my father's strong black coffee, and drank it down, then emptied the rest of the pot into the sink. I went back upstairs, still unnoticed, not wanting to be there when my aunt and uncle eventually arrived.

For a moment, waking up early the next morning, I allowed myself to think it was a terrible nightmare. But the house felt unnaturally silent, and there was no smell of coffee or sound of my father opening the silverware drawer or letting the dog out or crinkling the bread wrapper while taking out slices for toast. I was sure Wendy was awake. But there was no sound, not even of someone breathing. My mother and Wendy and I stayed in our separate bedrooms, not knowing how to get up and start a day when my father would not come home after work and turn on the lights.

Margaret and I had one violent and uncharacteristic argument as she planned the funeral. My father never converted. She wanted to bury him in her family's plot in a Catholic cemetery in a nearby town, and for the casket of a non-Catholic to be accepted it would have to be surrounded by a concrete vault so his body wouldn't touch the consecrated ground. I hated the thought and begged her to bury him anywhere else. She shouted that it was her husband and she would bury him where she wanted, and I eventually fell silent.

I remember finding a moment at the funeral parlor in front of the casket when it seemed as if no one was looking. I tried to lift his big, reassuring hand one more time. The hand was heavy, cold and waxy just like Barbara's had been, no longer comforting and warm. The sensation

shocked and repelled me. I dropped the hand. I felt startlingly alone, clinging to a mother whose story of my birth was about her big flowered hat and who hadn't seen me in the kitchen the night my father died, not at all.

"So God Damned Independent"

I wanted my father's wallet as a remembrance or the fedora he always wore when going to work or his baseball glove from the time before he met my mother when he was a lefty pitcher for the Wisconsin Blues. But that wasn't Margaret's style. Within days of the funeral everything that reminded me of him was gone. She sold the car because he died in it, slumped over the seat with a massive heart attack after leaving the dinner. She sold the new house my father and a friend spent weeks painting and remodeling before we moved in. She bought a two-family in a more commercial neighborhood, one that offered rental income. She bought a different car, a white Chevrolet Impala with red trim, and people began calling her The Merry Widow. The car smelled new, not like our father's Camel cigarettes and not like Betsy the dog who used to come with us when we took Sunday drives.

I took a city bus to school but on a different route, so I could no longer meet up with my friends who lived near the old house. Margaret, Wendy and I had new neighbors again, and the ones next door weren't friendly like Wilbur and didn't like noise in the yard. Margaret stopped cooking dinner, and we stopped eating together as a family because we weren't one anymore, without my father coming home after work. There

was a small market around the corner that delivered, and Margaret ordered tinfoil wrapped frozen TV dinners, enough to cover every night of the week.

I missed several days of school right after my father died, and it seemed as if I never caught up. When I returned to classes everything sounded as if it was happening in a foreign tongue, or even like random gibberish. My honors algebra teacher, Miss Micchelli, expected bright students who learned quickly and moved ahead fast. That was the point of being in an accelerated group. After my father died I didn't understand anything she said from the beginning of class until the end. She may have wondered why I went from catching on to sitting blank and silent when she called on me with a question, but she didn't ask. I didn't go and see her after school. I hoped I could remain invisible, and that no one would know how lost I was. That worked until I failed the final exam. Miss Micchelli said quietly as she handed me back the dismally red marked paper with the huge underscored F visible to those around me that she thought I would manage better with a slower moving group.

I also felt some very subtle shifts with my closest friends in the way that a fourteen-year old wanting desperately to fit in knows when something has changed. We didn't talk about what I felt. We kept working on the school newspaper in our free periods and complaining about the food at lunch and going to Saturday football games in the stadium behind the high school and to dances in the gym on Saturday night. But I sensed that they didn't really want me around, as if I might somehow be tainted by a bad turn in life.

Decades later I visited my friend Rita in Florida, and we spoke with the raw honesty of older women. I was the first to lose a parent, she explained, and the implications terrified her and probably the others too. If my father could could die with no warning so could hers. Pulling back emotionally wasn't about me but about what my sudden, shocking loss might portend.

In the months after my father died I felt vulnerable everywhere: in school, with friends, and, most profoundly, at home. Margaret's rage at being left a widow spilled unchecked into spaces where my father once

stood ready to absorb or deflect her volatility. For months, unable to remain asleep even with medication, Margaret woke screaming into the darkness that he was a bastard for leaving her with three children to raise. Her cries always woke me. I went in to comfort her. She pushed me away, but I sensed she wanted someone there, so I stayed. Wendy never came in, and she and I never talked about hearing our mother in the night. Margaret stayed in her nightgown and in bed most of the day during those early months. Wendy and I went to school.

Margaret resumed taking heavy tranquilizers. She finished one prescription, went through the refills, and then returned to the prescribing internist whom she seemed to like and trust. She came home from her appointment angry and empty-handed. The doctor was concerned about the amount of time she'd been on medication and the volume of pills she was taking and said he wouldn't write a new prescription without an evaluation by a psychiatrist. Spitting with rage, she demanded I get on the phone with the doctor and tell him she most certainly wasn't crazy. She insisted I do it right then, with her secretly listening from the extension in her bedroom. The doctor listened politely, and then repeated his diagnostic judgment and said she would be getting no more prescriptions from him until she saw a psychiatrist. I felt used and longed for the doctor to ask if Margaret put me up to the call and if she might be listening on the other line. I would have said yes. But he took the call at face value and didn't ask.

Margaret waited until he hung up, then slammed down the phone. Never, never, never would she see him again. There were a lot of doctors, and she'd find a good one, someone who understood her condition. Who did this bastard think he was?

I knew, although it was never said explicitly, that I wasn't supposed to talk with outsiders about my mother. My father did only once, with that secret letter to Mr. Sands. I knew she would be coldly unforgiving if her Women's Club friends heard the slightest suggestion that she was less than a good mother. But I was desperate, whipsawed between her bleak depression and the sudden, frightening rages. Our aunts and uncles returned to their own lives right after my father's funeral. The doctor

made his observation and then moved on. My teachers shifted me out of their view. My older sister rarely came home from college, and when she did Margaret became even more volatile.

I did reach out once, on a Sunday afternoon when Margaret had a violent argument with Linda, who left in the midst of the fight to return to campus. Margaret paced and cried and railed against her and against my dead father for hours. I finally called our family doctor, who wasn't home. His wife, a friend of Margaret's from Women's Club, heard the panic in my voice and asked what was the matter. I said my mother was out of control and I needed help, because Wendy and I were alone and I didn't know what to do. The woman asked me to put my mother on the phone, and the two talked. When they hung up Margaret stormed into her bedroom and slammed the door, refusing to speak to me for days. I never heard from the doctor or his wife again.

I was like my father in many ways, having inherited his typically calm Midwestern temperament. Margaret, in the moments free of her rage, groomed me to be her new confidant, her listening ear for the things she would have talked over with him. When Linda or Wendy had a question, instead of responding with her own thoughts, Margaret told my sisters, "Ask Pam and see what she thinks." Linda, rightfully resentful of my new role, didn't ask. Wendy did and turned to me with her deepest fears. She asked me in anxious whispers what would happen to us if something happened to our mother. I assured her in the most confident tone I could muster that I'd take care of us, which I knew to be a lie. Not long after my father's death, with Margaret spiraling downward and Wendy adrift, I went to the library to find books on becoming a legal guardian. I knew you had to be eighteen to be considered sufficiently mature and responsible. I was far short of that.

I suppose on some level I liked being so important in our family. But I was badly over my head. Not only had I lost a father, I felt like I was without a mother as well. Before his death I called her "Mom" or sometimes "Mother." After, I began to think of her as Margaret.

In the most bizarre turn, because I'd just started dating boys my own age, I became Margaret's sounding board for the affair she started with a

married man. The relationship began about three months after my father's death and lasted for twenty years. I was filled with rage at the intrusion of a strange man into our lives. I never met him directly, and I've forgotten his name although I knew it at the time. I often saw them depart together on a date after Wendy went to bed. I stood by the window of our second floor apartment, sneaking a glance as they walked, laughing, to his car, his buzz cut clearly visible under the streetlamp. I frequently wished him dead and out of our lives.

He gave her gifts, including a dressy watch. She liked the watch, and wore it all the time even with her everyday pink and blue belted shirtwaist dresses. She flaunted the gift, seemingly unaware that a watch would evoke all the pain of our last Christmas with my father.

That last December my father had bought her a Bulova watch, and he took Linda and me aside with great excitement to show us the surprise. On Christmas morning she opened the package and all but threw the watch back in his face. They had too many bills, he'd spent too much money, and anyway it wasn't the watch she wanted or would have picked. My father was crushed, but all he said, as he did so often, was, "Jesus Christ, Marge." We never saw the watch again, and I think he took it back to the store.

I hated the new watch, the one she actually wore. I hated her lover. And at times I hated her.

Despite the affair, Margaret constantly portrayed herself as a woman alone. Wendy and I couldn't possibly make any demands on her because she was a woman alone. She couldn't be expected to pay the bills on time because she was a woman alone. She had to be excused for rude behavior toward the mechanic at the car repair shop because she was a woman alone, and the man knew it and tried to take advantage.

I really was alone, and felt more so as the months wore on. And I was dealing with a new, unfamiliar and very difficult emotion: betrayal by the person I cared about the most.

The summer before my father died our family was at the Jersey shore, staying in a cottage we rented for thirty-five dollars a week. The cottage was actually a converted garage with a partition down the middle of the

main area, creating two small bedrooms. The day was rainy, which meant all five of us were crowded inside with no TV or play space or other diversion. My parents began an argument, which quickly escalated. At some point I grew panicky, sensing that my father was going to walk out. I threw myself on the bed sobbing, and he broke off the fight with my mother and came in to sit on the bed beside me. He told me everything would be all right, they'd work it out, and that he wasn't going to leave. I took him at his word. The night he died, when I went up to my room alone and lay in the dark unable to sleep, I kept saying out loud, as if he'd again come to sit by the bed, "It's not what you said. It's not what you said."

I know, surely knew then, that he didn't choose to have a fatal heart attack and go away forever. But what I knew in my head didn't seem to lessen the acute grief over being abandoned.

Not long after, that sense of betrayal took an even darker turn. My mother's younger brother and his wife and their two children came to stay with us, as they'd often done before. In the middle of the night I woke up to find my uncle sitting on the side of my bed, rolling up my pajama top to fondle my breasts and murmuring to me to keep quiet. He thrust his tongue into my mouth, and I could hear him grunting as he masturbated.

I could have screamed—his wife was asleep in a bedroom across from mine, and my mother was down the hall—but I didn't, and finally he went away. I lay there stunned, thinking this was what it meant not to have a father to protect me. I did tell my mother the next day, and to her credit she made them leave. My uncle protested that I misunderstood; he heard me crying and went in to comfort me. No one ever spoke of the incident again, and much later, when my uncle was dying of cancer, my mother asked in an oddly perky tone if I was going to send him a card. I said no and asked if she'd forgotten that moment in my bedroom so many years before. She mumbled something about it being family and that you couldn't hold a grudge.

The winter months that first year seemed unusually cold and dark, with weekends looming especially long. There were no more Saturday

outings or Sunday afternoon excursions to get ice cream. On Sunday mornings we went to church, and then Wendy and I watched TV.

One Sunday a month was bill-paying day, a task my father used to do. Margaret sat at the dining room table all afternoon with piles of invoices that were separated from their return envelopes. Scattered about the house, the envelopes were used as coasters for spilled coffee or to blot her lipstick and were often stained and wet. She had a pen, the checkbook, terrible math skills and too little money; nothing ever added up. She wailed that we'd be out on the street, that our father was a lousy fucker for having left her with this mess, and that life was full of rotten breaks and she couldn't bear it. Finally, after hours of fruitless lament, she'd get the bills, the return envelopes, and the stamps all in one place, decide how much to send each creditor, write the checks, and leave everything in a pile to be mailed. She ended the day exhausted, too tired to cook or even stay up. She heated frozen TV dinners for the three of us and then went into her bedroom alone to eat and watch the news. Throughout it all, unable to help or comfort, Wendy and I remained studiously glued to the TV.

Margaret made me promise over and over that I would never leave, even after I went to college. Her lover made it clear that he had a wife and children. Margaret could be the Other Woman, but he wasn't leaving his family to marry her. There was no promise of a new family on the horizon, a new life for all of us with this man. Margaret seemed terrified at the thought of being alone.

I said I wouldn't leave, knowing the words to be a lie.

Eventually Margaret found being at home all day unbearable, and she grew tired of trying to pay bills with the dwindling insurance money. She made the decision to go back to work, starting as a clerk and working her way up to executive secretary. She changed jobs often. Sometimes her bosses hit on her; she was beautiful in those days and had grown slender and alluring in the wake of my father's death. Sometimes she got into arguments with other employees and quit because she felt insulted and no one stuck up for her. Sometimes she just got bored.

She changed jobs as often as we changed addresses. Before my father died there was some sense of purpose to our moves: each time they were getting a slightly nicer house and fixing it up and making a little money. After he died, we simply moved. At one point we dragged our stuff to the second floor of a two family house. Trying to find the sheets and get our beds set up, Margaret paced back and forth among the boxes, her heels pounding on the bare hardwood floors. Our doorbell rang, and it was our young landlord from downstairs. He said his wife was trying to get their baby to sleep, and if my mother could stop pacing for a half hour or so they would be successful and the sleeping infant would no longer respond to the noise. He was polite, and his request was limited. He simply asked for half an hour. But when he left, Margaret fell into a familiar sputtering rage.

"That's it. We're moving. No one talks to me that way." And we stopped unpacking right then and there. We were out of that place and into a new one before the month was out.

After what seemed like a long, gray passage of time I entered senior year of high school and began looking at colleges. I had no interest in the kind of college you went to during the day while you lived at home. I wanted to go away.

Some of my friends had parents with college degrees and some degree of savvy about higher education, and those kids wound up at places like Cornell and the University of Wisconsin. Margaret knew about the College of St. Elizabeth, run by the Sisters of Charity, because she had two aunts who were nuns and lived there at the Motherhouse. The College was only an hour from Kearny and didn't seem to her too far or too different from the life we already knew.

Margaret was determined that all three of her daughters go to college, understanding that education was the ticket to a life beyond a secretary's desk. Linda was already at St. Elizabeth's, first as a student and then as an aspiring nun. She'd entered the convent the year after our father died. Margaret took me up to campus to see Sister Lucille, the Admissions Director, who was from Kearny. They had a friend in common, a rich lady from church who was a graduate of the College and a donor. Somehow,

by the end of that appointment, I was accepted without even a formal application.

Once at college I felt less and less like coming home for weekends. I said I had to study. Margaret said Wendy missed me. Then she said, with increasing ire and bitterness, "I wanted you to be independent, but not so God-damned independent."

Ideal
Elizabethan

College was a relief, and I loved being there. Nobody at the College of St. Elizabeth yelled in anger. There weren't ostentatious displays of emotion of any kind, and after the constant tumult at home I found the narrow emotional range soothing. Serenity, seen as a virtue and highly prized, was a new experience for me.

Daily life on campus was quiet, orderly, and predictable. The world around us in the mid-1960s was exploding into rebellion on all fronts, pushing back against the complacent, 1950s' ideal of American culture. But I hadn't lived that ideal, or anything remotely like it. I needed a place where my constant vigilance could soften. St. Elizabeth's offered a kind of tranquil flatness, a blank and therefore inviting canvas. I didn't have much ability to push back against my environment at home. Margaret sucked up all the oxygen in any room she entered; around her I simply endured. This muted new environment gave me room to experiment, to create a small amount of space that was truly my own.

Pushing back, at least for the young person I was then, meant openly challenging my theology professor Sister Winifred, who gave me a B instead of the A I earned because she couldn't "credit me as an equal to girls who went through Catholic schools all their lives and knew much more than I did about the faith." I think Sister Winifred was surprised

by my polite objections, my drawing her attention to a record of stellar papers and test scores. The grade for that semester stood, but in the next grading period, she gave me an A. I sensed that in class she began to treat me with respect. I didn't know in those days that you could go to the Academic Dean and protest an unfair grade. I was deeply schooled in taking care of things as best I could on my own.

Margaret sensed all too quickly that in the shelter of a new setting I was withdrawing from the family drama. She created a new one, focusing on her health, finding ways to be checked into the hospital for tests that might reveal some physical cause for her unhappiness. She got really good at convincing doctors she suffered from an obscure medical mystery, and one after another took her case. Her tests never resulted in any treatable findings, but the attention seemed to make her feel temporarily better. During each hospitalization she sent Wendy to be cared for by friends or neighbors, all the while assuring us each time that she finally found a doctor who was going to help her "get to the bottom of this thing." She kept a hospital bag at the ready with a pink satin bed jacket and always made sure to have her hair done. Sometimes she had small bottles of champagne, the kind you'd get on airplanes, tucked into the bag to sneak as an accompaniment to her hospital dinner.

Margaret loved everything about being in the hospital and did until the day she died. Even in later years, when health insurance got more stringent and hospital admission was harder to procure, she knew just what to say. A female who presents in the emergency department with jaw pain radiating down her left arm is very likely to be admitted for a cardiac workup. And she usually was admitted, snagging a coveted bed for at least a couple of days. Then she got to rest all day and watch TV, while someone prepared and served her meals and took away the dirty dishes. Any discomfort associated with tests seemed a small price to pay. Sometimes she repeated at the same hospital, and she was always thrilled when the nurses and aides remembered her. They became sort of a faux family, happy to welcome her home.

We weren't allowed to have cars on campus, but I got special permission to have Margaret's car for very limited periods when she

was hospitalized. I drove to our home town in the late afternoon to see Wendy, stopped to visit Margaret, and then went back to the dorm to study and write papers.

Wendy got quieter and quieter during my visits although I think the different people she stayed with tried to be kind. Some of the families who took her I barely knew; they were Margaret's friends from Women's Club. Most of our Halpin aunts and uncles lived in Kearny or in nearby towns but all kept a careful distance.

I tried hard to get back to campus for dinner; in those days there were no snack bars or alternative venues selling meals. Students ate in the dining hall. I came to college hating the TV dinners we had at home. Meal service with my college friends was like rediscovering family dinner, where you eat at a table, have food that isn't mass-produced and flash frozen, and people talk to each other. The college dining hall was huge, and our main meal was served at noon. We ate together at tables set with immaculate white linen table cloths and napkins, white china and sterling silver. Facing the huge crucifix on the wall, we stood to say grace in unison before sitting down to eat, prompted by a bell rung by one of the nuns. The two Sisters-in-residence in charge of the dorms sat at their own table, there to guard against anything unruly. The second year nuns-in-training, called novices, served us, marching out of the kitchen carrying huge platters of roast beef and mashed potatoes and gravy, followed by homemade pie. We couldn't talk to them, other than to ask for more food. Most of them were our age. Some of them had friends at the college, having gone through Catholic high school together. But there was no exchange of laughter, no teasing about their somber black habits and old lady black tie shoes, no lighthearted inquiry about plans for the weekend. We called them Sister, as in, "Sister, may we please have more gravy?" and they nodded in silence and brought the gravy without calling us anything.

I had one big hurdle to overcome before I could begin to shape the college experience into something completely my own, and that was learning to navigate the world of nuns. Most of my classmates came through the Catholic school system and were more overtly devout than I,

more accustomed to the expectations of religiously vowed women. Sister Jane Marie, a humorless figure with paper-thin skin, bony fingers and sunken eyes, served as director of the freshman dorm. She was an ex-missionary who'd been thrown out of China when the communists took over. On our very first night in residence she had us into the main parlor to recite the rules of dorm living and to tell us that we were certainly privileged young ladies compared to the starving people dying for the faith in China. She also told us not to use too much hot water.

Right outside my dorm room was a seven-foot tall plaster statue of the Virgin Mary, and after Sister Jane's long and dreary meeting I wanted a shower. Stepping out into the hall in my bathrobe and carrying a bottle of shampoo, I stumbled right into a cluster of girls on their knees along with Sister Jane, all clutching rosaries and praying out loud and in unison to the statue. I couldn't see how to make my way through them. Sister Jane's glaring eyes froze me in place and made it impossible to turn around and go back into my room. Lacking another option, I knelt too, shampoo bottle in hand instead of a rosary, mumbling along. Sister Jane, her back ramrod straight and her black-clad body rigid with disapproval, seemed not to see my kneeling as a gesture of respect. As we all regained our feet after the endless prayers, she pointedly turned away from me as she urged the other girls to join her again the next night for the rosary.

Sister Jane and I never got back on the right foot. Some weeks later, she and I met at the door to the campus library at exactly the same moment. She taught Chinese to a few students and carried a single book. I had an armload of fifteen books, the sources for my first lengthy college paper. In early November the weather was chilly, and my bare hands were freezing. My arms felt ready to break from the load. I waited for Sister Jane, with her lone book in hand, to open the door. She stood motionless, her glare growing more malevolent by the moment. I had no idea why we were at a standstill, why she didn't simply open the door. Just then someone came out of the library, and I slipped in, going to the library counter to lay down my books. Sister Jane followed, excoriating me for rudeness. Any girl properly admitted to the College, she hissed, would put her books down on the ground and open the door for Sister.

I think I refrained from saying I thought such an expectation was both crazy and rude, but my expression must have been clear. For the rest of the year, Sister Jane hounded me with minor infractions of dorm rules, demonstrating her conviction that I was not and would never be an ideal Elizabethan.

If college had been all about Sister Jane and Sister Winifred and the other rigid, rule-abiding nuns I might have left with a degree but little else. Instead I met Sister Alice, who taught the only English elective I could fit into my schedule: Victorian literature. Sister Alice was tall and angular, wore wire rimmed glasses, and had a penetrating stare. The Sisters were still in black habits then, and the older students all referred to Sister Alice by the nickname Crow. Draped in black and with her forward lean and piercing stare she quite looked like a crow. I found out years later that even with thick lenses she had trouble seeing, but in the beginning that stare conveyed intensity, curiosity, and passionate interest. She quickly decided I was one of the brighter students in her class. Early in the semester she asked if I'd like to do some independent study on an author she thought I'd enjoy but whose work couldn't be crammed into the very full syllabus. If I accepted, she said I could have a full fifty minute period to present the author to my classmates. I went that very day to gather a new armload of books from the library and began to read. Sister Alice didn't tell me what I was supposed to learn from the author; she left that up to me. She never asked for updates on my progress or if I needed help or if I was in fact getting anywhere. She simply asked me to let her know when I was ready to speak to the class.

We agreed on a date, and I began to pull my thoughts into an organized presentation. A few days before our class, when I had yet to write anything down, Sister Alice caught me in the hall. Something else came up for our Friday class, and she wondered if I could give my talk later that day instead. She said if necessary I could have a few minutes at the beginning to run back to the dorm for my notes.

I replied that I didn't yet have any notes but would be glad to give the presentation. I had about a half hour before class started, and I sat quietly and polished the talk in my mind.

I don't think I could have done better even with more time or with a written outline, and I could see Sister Alice beaming. Her offer of independent work wasn't about a grade, or extra credit, but about the chance to put on the mantle of scholar. I felt smart to figure out the author on my own, and I remember his name all these decades later: Alain Robbe-Grillet. I felt happy to live up to Sister Alice's unquestionably high expectations. There were a lot of smart girls in the honors English section, and if Sister Alice saw something of promise in me, I felt the stirring of a belief that promise might exist.

Sister Alice wasn't the only one with whom I formed a quick bond. Sister Bernadette Therese was executive assistant to the president of the College and also the president's driver. I don't really remember how we became friends, but she began giving me books by Teilhard de Chardin, and soon enough we were sneaking away from campus in the late afternoon to take the president's car to get ice cream. I smile now at the innocence of it; 1963 was at the heart of a drug-soaked decade. But we weren't sneaking away to smoke pot or to drink cheap wine out of a jug. We really were going to a nearby town for double scoop cones. Bern was ten years older than I. Despite the age difference, we formed a real friendship. She showed me the black and white photo of the young man she left behind when she became a nun. I shared my exhaustion at the nightly calls from Margaret, the lingering entanglement I seemed unable to break. Bern asked what I wanted in the relationship with my mother, which was a question entirely new to me.

Bern suggested setting modest limits, such as not staying on the phone with Margaret every night for an hour or more. "I have to study," Bern assured me, was a legitimate reason to get off the phone. The simple change created a dramatic shift in our family structure. I felt, for perhaps the first time in my life, that I had a small amount of control in the mother-daughter relationship. Margaret felt pushed aside and responded by making her own efforts to become friendly with Bern. Margaret urged me to invite Bern to accompany us for supper on the nights Margaret and Wendy drove me back to campus. Margaret asked me for the date of Bern's birthday and sent a card. Bern was cautious about Margaret's

approach, deciding on a limited response. During one of Margaret's hospitalizations, when a class ended late and I couldn't go back to Kearny to get our car, Bern said she would drive me but that she would wait downstairs in the lobby.

I didn't think Bern remained on the first floor to give me privacy with my mother. I thought Bern was pulling back, as if Margaret were someone whose needs my friend didn't want to manage. The suspicion shocked me. I thought everyone loved Margaret, the center of all attention and the life of every party. I thought I was the one who was too quiet, too much on the periphery, the one easily overlooked. Margaret said that often about my father and about me.

The consequences of my pulling back fell most significantly on my sister Wendy. With the triplets coming between me and Wendy in the birth order, she was a full seven years younger. When I started college at eighteen, she was only eleven. She had the fewest years with my father, the most limited experience of a family of five who did things together, and the most time alone at home with our mother. In addition to not calling every night, I went home less and less often for the weekend. I did live at home during the summer while I worked, but Margaret was also working by then and sent Wendy to residential camp for eight weeks. Whatever role I played as a stabilizing figure for my younger sister was sharply curtailed, and the impact, while unintended, was large.

Many years later, when Wendy and I were both grown women, she and I went out to lunch. We were talking frivolously, about what to order and about Saturday afternoon shopping and about the latest movies. With no preamble she grew serious and asked if I realized what my going away to college and leaving her alone meant. I took a deep breath and said that I did. I didn't want to walk away. I just couldn't figure out how to leave home and take my little sister with me.

Sister Alice shaped the intellectual part of my college life. Bern brought in emotion. Later in her life as a Sister of Charity she became a therapist. But even when I first knew her, she was unusual among the Sisters, most of whom lived in a world of thoughts and ideas, by placing significant value on how people felt.

Trumping both the life of the mind and emotional well-being was the Sisters' zeal for our spiritual growth. The college employed a full time chaplain-priest who taught theology and said daily Mass. A cluster of pious students from each class went to the early morning Mass, mingled with the nuns, and every year some of those girls decided to become nuns themselves. On holy days of obligation all students were required to attend Mass in academic gowns.

We had to take twelve credits in theology, almost enough for a minor, and the philosophy department in which I declared a major was heavily tilted toward the scholastic philosophers and Catholic church fathers. Sister Frances Augustine, the department chair and my major professor, was a regal, brilliant woman who hoped I would learn to love the traditional Catholic philosophers and theologians as she did. Perhaps she hoped I'd follow her path and become a nun. She was aghast when I gravitated toward the existentialists, Camus and Sartre and Kafka. To her credit, as long as I would read her favorite St. Thomas Aquinas, she agreed to read and grapple with me over the meaning of Camus' iconic work, *The Stranger*, and Sartre's epic *Being and Nothingness*. She always looked worried when I came into her office, especially when I brought her the latest book I wanted us to read, like Kafka's *Metamorphosis*. She wanted us to pursue the path of greater holiness, tackling Aquinas' massive work the *Summa Theologica*. I wanted us to read Kafka's novella about a man turned into a giant bug and the futility of his attempts to communicate. I think she hated every page of every book I wanted to read. I think she prayed every day that I'd have a conversion of heart and set existentialism aside. But I never did. The Catholic philosophers and theologians she assigned talked about rising from the dead as the central mystery of the faith. My father's death, and Barbara's, still weighed heavily on my heart, and I never thought they had risen anywhere. I thought they were simply gone.

No one thinks of a relatively unformed student going to a Catholic college in order to discover existentialism, and I imagine to this day that Sister Frances Augustine is turning over in her grave.

I'm not sure why I didn't absorb more of the authentic faith experience shared by Bern and Alice and Sister Francis Augustine. I never

doubted they felt, or saw, something I didn't. I thought about the picture of her young man that Bern once showed me, and it suggested how much she gave up to stay a nun. By the time I met them the world was opening up for women. Women could choose a life of ministry without entering a convent, without pledging to be poor and obedient and chaste for life. In the late 1960s and early 1970s many women left religious communities, but the ones I cared about dearly did not. They stayed for something, and it wasn't seven foot tall plaster statues or the chance to recite the rosary in unison while kneeling on a hard, unforgiving wood floor. Their great gift to me was that my skepticism, set against their faith, didn't matter. We were friends, not only in college but to the day each of them died.

The next step for an undergraduate philosophy major was typically a doctoral program and then an academic career as a philosopher. I thought the life of a college professor could be exciting. One of our professors, Sister Blanche Marie, taught for a year at the University of Baghdad, and the idea of working in a foreign country like she did seemed bold and adventuresome. In senior year, with Sister Francis Augustine's support, I applied to and was accepted at Georgetown for a doctoral program in philosophy.

Quite a different opportunity jumped out at me from a bulletin board around the College's career center: the newly formed Peace Corps. The first volunteers went overseas in 1961, which meant the Peace Corps was, like me, still relatively young and unstructured. Most volunteers were recruited for something called community development. I didn't really know what that was, but the vague mandate to improve communities sounded a little like Sister Alice throwing a new author my way and seeing what I could make of his writing. Liberal arts majors were welcome to apply; you didn't need any special skill set, only the desire to learn and to serve. I picked up the print brochures and liked everything: the chance to go to a faraway country where nobody knew anything about me, the opportunity to learn a language, and the opening to do some good in the world. If I never embraced the religiosity of the College of Saint Elizabeth, I did accept the belief that life is about more than selfish

gratification. And I desperately wanted to be on my own, even farther away from Margaret and her needs and her demands. Peace Corps had programs all over the world. I picked up one brochure for Micronesia, which was exactly on the opposite side of the world from New Jersey. That's where I decided I wanted to go. Very secretly, without telling Sister Frances Augustine or Margaret, I filled out the application and sent it in.

Before I saw the brochure about the Peace Corps, being a college professor seemed a settled, well-defined career. People would respect you as erudite, learned, someone who walked around carrying a book and engaging others in talk about important ideas. You'd earn respectable money, and have a lot of time to pursue your own scholarly interests. You'd write books. I wasn't aware of the relatively few tenured positions open to female scholars in the secular academic world, especially in philosophy; almost all of our professors were female and it looked like an open career path to me.

After I started the Peace Corps application process, I was off on an entirely new bent.

I didn't tell Margaret because I was sure she'd manufacture a health crisis to keep me from going, and I didn't tell Sister Francis because I didn't want her to mount arguments about wasting my academic potential.

The Peace Corps accepted me. They didn't have a Micronesia program opening any time soon, but they had one for rural Panama.

A few days before my late May graduation I finally went to tell Sister Frances Augustine. She said that she already knew; in March the FBI came to campus to do a background check and talked with her. She made a gracious and generous gesture, more than I realized then, in giving me the time to come to her. When I did come with news of my acceptance she spared me the reservations she probably felt, although not her perennially worried look.

I told Margaret around the same time, about three weeks before I planned to leave for training in Puerto Rico. She was furious and asked how I could possibly abandon my sister Wendy. I refused to be dissuaded

and left on schedule to meet my group of one hundred Panama trainees, first at our staging in Philadelphia and then for our flight from Newark airport to San Juan.

Peace Corps Training

Those of us accepted for training, mostly young and recent liberal arts college graduates from all over the country, followed the instructions mailed in the thick Peace Corps packet directing us to assemble in Philadelphia at what turned out to be an older hotel in a run down part of the city. I took the bus from New Jersey; the terminal was within walking distance of the hotel. We new volunteers got checked in, were assigned a room and a roommate, given a meal voucher for the hotel coffee shop, and had our photo taken for the official Peace Corps ID. We were then left to muddle around on our own. Some of us went to the bar. Some went out to explore the city. Some climbed out on their fire escapes and lit up joints. I didn't drink, not even beer, or smoke pot. I didn't want to know more about Philadelphia; I wanted to know about the Peace Corps and what I had just committed to. My roommate came with a friend from her Midwestern university, both accepted to the Peace Corps out of the same academic program. They went off together. I took my modest meal voucher and got a sandwich and cold drink at the coffee shop counter, then with nothing official planned for the evening, went to the room.

Our first gathering as official trainees gave Peace Corps the chance to send an important message: we'll establish the basic structure, but don't

look to us to take care of you or fill your time. Find something to do. Above all don't stand around looking lost.

Barely twenty-four hours later, before I knew any one's name other than my roommate and her friend, we were on a commercial flight to San Juan. Once there, we boarded four ancient yellow school buses for the ninety minute ride down the highway to Arecibo. The caravan turned off the main road onto a narrow, winding climb into the mountains. Our arrival came in the pitch dark.

Stumbling out of the bus, we were handed a set of sheets and towels, then given our cabin assignments in Spanish. The moment we landed in San Juan, all the staff switched exclusively to Spanish. I studied Russian in high school and college and had no idea what anyone was saying. Clearly the staff knew most of us weren't fluent, but from the no-nonsense looks on their faces I knew "what?" couldn't be the right response. I took the linens and stumbled along an unlit dirt path after everyone else. We reached the sleeping cabins, and I tried to match what I thought I heard getting off the bus to the names posted over the screen door of each cabin. Twelve of us wound up in a cabin with twelve beds; we fell asleep with little chatter, exhausted.

We were all up early in the morning, out of nervousness as much as anything else. Cooking smells came from a larger wooden structure in the middle of camp. My bunk-mates and I, after washing up in the cold water sinks of the nearby latrine and shower room, made our way toward breakfast. The cooks were speaking in rapid fire Spanish, and all the table conversation was in Spanish too. The second message was clear: no English. We have to get you bi-lingual in three months. Figure it out. You're in a Spanish-speaking culture now.

The cooks, all local people from the villages around the camp, let us point to eggs or bacon or toast or oatmeal when the Peace Corps staff weren't looking.

Our daily schedule was posted on a big bulletin board just outside the dining hall. Physical training, eight a.m. sharp in the grassy area north of the building. North? We arrived in camp in the dark. The camp itself was in a low area surrounded by hills and trees, like being in the bottom of a

round green bowl with very high sides and no distinguishing geographical markers. I'd never been a camper or a Girl Scout or a hiker. To navigate my life in Kearny or Convent Station I used street signs, postal addresses, bus routes, train schedules. I had no idea, standing in the middle of camp, what might be "north." Fortunately, the camp was small enough that I could simply see where people were gathering. No one dared oversleep and miss PT.

Peace Corps up until now seemed more of an impulse, a statement about a new way of sending mostly young Americans abroad, than it was an organized program. When I applied they didn't ask what I knew how to do, or what experience I had that was relevant to the lives of poor people in a developing country. They asked me to write an essay about why I was the right person to take up President Kennedy's call to help change the world.

But training camp, from that first morning on, was tightly controlled. The two hour fitness block started with a run down the mountain and back up again. This was no gradual entry into being physically fit. Not a runner? Too bad. Bloody raw blisters? Get ointment and band-aids in the medical tent. Out of breath and puking at the end of the run? You'll do better tomorrow and it's a good thing you didn't fall too far behind and please puke over in the weeds, not where everyone is standing. Thank God we were all young and healthy and passed physicals before coming. No one dropped dead on the way back up the mountain, or during the brisk calisthenics that followed.

The first people to quit the training program did so that very day. The Peace Corps literature never said that changing the world meant you also had to run up and down a mountain.

Fitness was followed by five hours of formal language instruction, then classes on cultural immersion and on project opportunities that might arise in Panama: tropical agriculture, ESOL teaching, nutrition and basic health, mosquito control.

In addition to not being a camper I'd never been a gardener, or taught so much as a swimming class, and I relied on good genes and luck to steer

clear of disease. I pored over the thick binders, trying to cram as much as possible into my head.

The classes on cultural immersion influenced me less than my small group's relationship with our Spanish instructor, Héctor Aguilar, a handsome Ecuadorian with whom I promptly fell in unrequited love.

All trainees had Sundays off. Most of us collapsed in our bunks from exhaustion, wrote letters, or went across the road to Tomasito's Bar and drank cheap local beer or rum and cola while listening to salsa music on our host's ancient record player with the badly scratched needle.

I quickly became a connoisseur of local beer. Rum was cheaper than soda, and I learned to drink that too. Tomasito had a very small refrigerator so old and worn rust spots speckled the white enamel. He gave priority to keeping the beer cold; rum and cola were served warm.

For at least six days of the week we were assessed at everything we did, and we knew it. There was half-hearted bantering about Tomasito being a secret spy for the staff, reporting on what we did even during our precious free time. Periodically the staff disappeared into a meeting, and shortly after one or more trainees were told they were done. We never knew exactly what the criteria were for keeping a place in the program, other than you had to put forth a lot of effort all the time and give reasonable answers to regular, pointed questions along the lines of "What would you do if ...?"

The day-to-day uncertainty was new to me, and I suspect to most of the others. Crazy though living with Margaret was, she never threw me out, or even threatened to. For her family was family, and home was where you always had a place. College was about getting grades and fitting in and paying your tuition bills. Peace Corps training was unlike either. Staying in the program wasn't about being smart or belonging; everyone seemed smart and no one belonged. It wasn't about success; no one talked about it. Staying wasn't about showing patriotism, or committing to the spread of democracy, because nobody talked about those either. Staying wasn't about demonstrating specific skills; most of us were liberal arts graduates and we didn't have many. Quickly enough, the answer emerged:

when asked what I would do in a specific case, I had to come up with something that made sense and didn't put me or someone else in danger. In negative terms, the right answer to staying in the program added up to three firm dont's: don't freeze, don't be stupid, and don't get hurt.

Figuring out how to stay was the baseline. Then I had to find a way to be successful—my need, not a demand of the Peace Corps—in a setting different from any I'd ever known and where the people around me weren't like anybody I knew. That latter challenge arose first.

Among my cabin mates were a lesbian couple who had vigorous sex most nights in the lower bunk while I held on to the swaying metal bed frame just above. People my age might have been enjoying free love on campuses in San Francisco, but not at the College of Saint Elizabeth. I dated the same young man for six years but was sexually naive, and gay and lesbian culture was entirely off my radar screen. I was wide-eyed as I held onto the swaying bed, wondering whether the activity just below was really sex. Despite my best intentions, I peeked, and hot sex it was.

Don't be stupid. Don't act naive.

I became friends with both girls in the rest of our shared daily life, and when they said they hoped they weren't keeping me up at night I managed to say sincerely that they were not.

Peace Corps kept testing that question, "What will you do?"

We were given the name of a village reachable in less than a day from our training site. We had to get there, find a place to stay for five days, and get back. We were supposed to look around the community and try to make some assessment of its needs, as if we were really there to start a project. We could say we were from the Peace Corps, which meant nothing at that time to rural Puerto Ricans. I think we had a little money for public transportation after we were dropped on the main road. That instruction was as much as we got; the rest we'd have to make up as we went along.

I was terrified.

This wasn't about Sister Alice and a pile of books and some obscure French author. This was about walking away from training camp all alone with almost no money in my pocket, minimal fluency in Spanish,

only the vaguest idea of my destination several hours away, and no plan whatsoever once I arrived, if I did.

If I couldn't find the village, or couldn't find a place to stay, I had no number to call for someone to come and get me. I knew the camp was in the mountains above Arecibo just off a dirt road, too far to walk from the main highway where the cheap public buses ran all day long but not at night. I knew where the road met the highway and how far a walk it was on the dirt road, but not much else about that part of the island.

Go. Come back. Don't get hurt.

Héctor took pity on us. "Think," he said. "Who in a village will know everyone's business, like which household has an empty bed that might be offered to you for a few days?"

We stared blankly at him, having never contemplated such a thing. With a little coaching we came up with a list: *tienda* owner, bartender, priest. Our panic lessened, and on the appointed day we gamely set out, separating as soon as we left the Peace Corps van on the main highway.

Getting to the place I'd been assigned took several hours, much longer than I expected. I finally arrived in late afternoon and sat down on a rock in what seemed to be a town center, or at least a crossing of multiple dirt paths. My anxiety soared; I figured I had at most a few hours before dark to find a place to stay. I did a quick inventory: no bar, no church. That left me with the *tienda*.

I pushed open the door and went inside. Several men were smoking and talking with someone who looked like the proprietor. In a rush of simple and anxious Spanish I blurted out, "Does anyone know a place where I could stay for a few days?"

They stared at me silently and shook their heads.

I retreated back to the rock and took a deep breath, trying to control my panic. Too fast, I said to myself, and too abrupt.

I waited until my breathing returned to normal and went back in. In halting Spanish, I ordered a soda. Picking carefully from my rudimentary memorized conversations, I tried to be part of their casual banter.

"The day is very hot."

"Yes, *señorita*, the day is very hot."

"The soda is very cold."

"Yes, *señorita*, the soda is very cold."

I took another deep breath, another sip from the glass bottle. I was just about out of sentences. Then I tried again, this time making the request just as Héctor insisted we practice it.

"I need a place to sleep for a few days. Do you know of someone who could help me?"

Tic.

Tic.

Tic.

Tic.

Tic.

Finally, the proprietor spoke. "The *señora* might take you in, if you ask her. You can try." He pointed to an uphill path just outside the store, gave me the name of the woman, told me the color of her house. I finished my soda, thanked him, and went back out the screen door.

A very kind woman whose name I don't remember took pity on my broken Spanish and dusty, bedraggled appearance. She let me sleep on a cot in her house for five whole days, in a tiny room with a baby and three of her grown daughters and chamber pots under each of our beds. I joined them for rice and beans at night and coffee and bread for breakfast. I walked around the village during the day, getting to know enough to describe the setting and some potential needs as we'd been charged with doing. I left with gratitude for the woman's generosity of spirit, pressing a few dollars into her hands to account for my stay, and hitchhiked back to training camp.

As we all met up again we took stock. A few trainees failed spectacularly, either unable to locate the village to which they were sent, or getting there but not finding a place to stay. Sleeping in an empty chicken coop or in a house filled with bedbugs or next to someone with an untreated disease like tuberculosis counted as a success. Returning to camp early for any reason did not.

By the time we were all settled we realized those rumored to have returned to camp early were already gone, washed out of the program

and sent home. The test in Puerto Rico, grueling though it was, closely foreshadowed my arrival in Panama and the village of Rio Hato.

Arriving In Country

My regional director loaded six of us into his Chevy Suburban in front of the Peace Corps office in Panama City and drove down the Pan American highway. About ninety minutes later he stopped in Rio Hato, grabbed my gear bag from the back, handed it to me and pointed toward the door of a small house right on the highway.

"There's no key or anything. The door will just push open. Good luck. I'll check in with you in about six weeks." Then he drove away to drop other volunteers at their sites farther down the peninsula.

My house was cinder block with a metal roof. Wooden slats covered the windows. Like the door, the slats simply pushed open, letting in hot air but no breeze. The loudly buzzing insects that multiplied in rainy season flew in and out unimpeded, drawn by the heat of my body. Within minutes I was covered with mosquito bites. By late morning, when I began to set up my folding cot, the place was sweltering. Sweat soaked my cotton clothing, leaving me sticky and uncomfortable. I was thirsty but didn't yet know where to get water.

Periodically the face of a woman about my age appeared in one of the windows, watching me as I tried to hang my floor to ceiling mosquito net without benefit of hooks or rope. She clearly came from the small mud and thatch house a few feet away from mine. She shared the single

room and outdoor kitchen with what looked like a small army of young children, all of whom were tumbling around the yard but not yet quite brave enough to come close to my door. The woman was just tall enough to look in through the open window. I couldn't see her body, and she appeared in the window frame like a floating head. She watched for a bit, broke into a deep belly laugh at my fumbling efforts to put together the musty cot with its warped wooden frame, and then went back to the yard where she was doing the washing. She didn't say anything, and my Spanish was still too rudimentary for me to say much either.

Finally I was hot enough, thirsty enough, cranky enough and hungry enough to go out and look for a *tienda*, a small store where I might get some basic provisions.

"Basic" was all the little store had: rice that needed to be hulled, cooking oil in five-gallon jugs, buckets of dry beans, bags of local coffee, and a few live chickens, feet trussed, screeching on the dirt floor. On one shelf sat green glass bottles of warm soda. On another were a few bottles of Miss Lydia Pinkham's Tonic and some dusty cans of Spam — the latter no doubt the outcome of barter at one of the Army bases or Panama Canal Zone commissaries that surrounded Panama City. Small loaves of bread baked very early that morning were long gone.

I bought a soda and a can of Spam and returned to the house. Starving, I peeled off the small metal strip and opened the can. Sticky black goo bubbled out, obscuring the pink, fatty meat inside.

If the woman was amused before, she was not amused then. She came marching into the house and took the Spam from me, saying in Spanish that I fortunately understood, "I'm Minga. I live over there. You'll die if you eat that. I have some soup; you can come and eat it with me."

I gaped at her with relief, near tears at the frustration of it all, and then looked piteously at the soda bottle in my hand. By now desperately thirsty, I had no bottle opener. Minga rolled her eyes and held out her calloused palm. There were no pop-off bottle tops in those days, and she didn't have an opener either. She simply twisted the top off and handed the bottle to me, throwing the cap backwards out the open window. "And I'll show you where the pump is, so you can get water."

She took a short break from washing the huge mound of dirty clothes to eat soup with me, sitting directly on the floor of the narrow cement patio in front of her house. A baby and a toddler were on the grass nearby, surrounded by other playful, wiggling small children who looked at me with rapt curiosity.

Minga didn't ask why I came, what I was going to do, why my Spanish was so bad, how long I was going to stay, or why I didn't seem to have a husband and children of my own as all the village women of my age did. She had, while watching me set up, taken the measure of what skills I could call upon to get along in the village. As I handed her back the empty tin bowl, she said quietly that she would cook for me, and that I could eat with her family. Supper, she said, was when Roberto returned from the fields. She gave me a clean, empty five-gallon can that once held cooking oil and showed me the path to the well.

I was overwhelmed with the heat and the forlorn emptiness of my two small rooms. Anxiety overshadowed my training and my excitement at having arrived. My confidence began to ebb. I didn't yet have a place to sit, just the green canvas cot, a trunk full of old paperback books, and a medical kit. I feared I'd never get good enough at Spanish to talk to the village people. I was even more hot and sweaty and still longed for a shower. I had the metal can filled with water but no glass and was still scooping water with my hand to take a drink. I started second-guessing the decision to come.

I stood in my small empty space, swatting mosquitoes and listening to the sound of chickens scratching and pecking in the hard dirt just outside my door. I had my cot set up and my few possessions stored away against marauding rodents and enough water to last until the next day. I began pacing silently in my two small rooms, wondering where to begin.

No one was coming to tell me.

No one was watching to see if I figured it out.

I got what I most longed for in joining the Peace Corps—I was completely on my own.

In the late afternoon a man arrived carrying a straight-backed wooden chair, which he left at my back door. Another man arrived with a small,

paint-chipped green table which he also left outside. I saw Minga in our shared backyard, looking at the furniture and nodding.

By the time I went to bed I had a place to hang my clothes: on the back of the chair. I put my flashlight and battery-operated small radio on the green table. I flared the big net all around the frame of the cot so no bats could brush up against me and suck blood through the net while I slept and to give me some respite from the swarming mosquitoes. Right before I dozed off I heard rustling and scratching in the far corner of the room, and saw the glint of a pair of beady green eyes. I figured whatever it was couldn't get to me, as my cot was a few feet off the floor. I ignored the green eyes and fell asleep.

A few days went by. After the intensity of our three month training, when we were on top of each other most of the time, my loneliness only grew. There was no one within miles with whom I could speak English, and stumbling along in Spanish all the time was exhausting. In Puerto Rico I could go to Tomasito's bar with male and female trainees and drink a beer and relax. In Rio Hato men hung out in the bars, not single women and certainly not the newly arrived lone single white woman. Going to a bar for a Saturday night dance to which almost the entire village turned out was acceptable. Going to a bar on my own, even for a cold soda, could have sent a very different message. There was some prostitution in the village, mostly geared toward the young U.S Army soldiers who came to Rio Hato from a small nearby training base. Seeing eighteen-year old, olive-green clad privates in the bars on Saturday nights was common. The village also had a small number of children who had red hair and freckles along with their brown skin, names like "Kyle," and a photo of a young soldier-father pasted on the wall. I had no wish to signal that I was open and sexually available to young Panamanian men, or to U.S. soldiers. Once darkness fell, I mostly stayed home.

A roving Ministry of Agriculture agent was responsible for the request that brought me to the village, but she was yet to arrive. Minga had no idea why I was there. The rest of the villagers gave no direction, waiting to see what I would do, and I was on my own to find a starting point.

After several days of fumbling around, I began in a small and

tentative way, looking for something that wouldn't exceed my still-limited Spanish fluency. Peace Corps training focused on short, intense instructional sessions. I picked among the topics in one of the large notebooks, finding a talk on nutrition for nursing mothers. The talk was short and all written out in Spanish. I understood the content and just had to memorize the words. The talk seemed like a great place to start. I asked Minga if she could gather some of her friends with nursing babies, and she said she would.

All the young women in the village had nursing babies, and anyone with a baby at the breast also had several other small children. Some had a toddler not yet weaned and were nursing both. When the appointed morning came, my tiny house was filled with smiling young women and all of their children. They listened with what felt like rapt attention, and then one of the women asked an obvious question, not about how to nurse babies but about me.

"Señorita Pamela, where is your child?"

I could hardly have felt more foolish, lecturing them on a skill that naturally passed from mother to daughter in the village and had for generations. Their nutrition was made up of what they had available, primarily rice and beans. Prenatal vitamins were not on the list of accessible items, nor was milk or other dairy products, an abundance of fresh vegetables, or foods containing iron.

I felt like an idiot, plain and simple. Fortunately Minga didn't call me an idiot. She just asked, with what I came to find was her usual optimism, what we were going to try next.

In her mind, we were already a team.

I went back to the basic premise of our training: spend time simply being in the village, talking with people and trying to recognize their most pressing needs, looking for a spot where I might help.

That process assumed far better language skills than I brought from our training in Puerto Rico. I often had to ask someone to repeat a sentence when the meaning eluded me. The person always assumed I didn't hear. He or she repeated exactly the same words, only louder and faster. Minga knew I didn't speak Spanish well, and when she was around

she simplified things for me, using easier words and grammar. But she was often busy with the repetitive tasks of her day: lugging water from the well to fill a big cleaned-out oil drum that served as the family reservoir, gathering firewood, hulling rice, washing clothes, nursing children, selling knock-off chances on the National Lottery whose winning numbers were announced daily throughout the country on their small, battery-operated radios. Miraculously for me, seven-year old Teresa understood my problem. When she wasn't in school, Teresa attached herself to me as I walked around the village, seeking people to talk with. I'd say something, and the gracious villagers got desperate looks on their faces trying to decipher what I meant. Teresa listened too, and then she'd pipe up, "Señorita Pamela means to say...", and then she'd say correctly what I thought I just said. Everyone broke into huge grins, and the conversation continued. Painstakingly, and after a few more months of modeling myself after Teresa, I learned and became fluent.

In those early weeks word spread that I gave a talk to young mothers, and one day a man appeared at my door. He said his daughter was in great distress and asked if I would come. Neither Minga nor Teresa were around; I was on my own. I followed him along convoluted footpaths to a small, dark mud house around which many people were gathered. Inside in the oppressive heat, a young girl—younger than I, perhaps in her early teens—was visibly, hugely pregnant and struggling to give birth. She lay sweating and moaning on a thin mattress on the floor, her mother and sisters and aunts gathered around. The midwife came earlier to no avail. The *curandero*, a natural healer, followed with potions and prayers and also failed. Then the girl's father came for me, the American, because they knew America was a great and powerful country and Americans could always do something. He asked if I could help his daughter, help the unborn baby. The girl looked, even to my untrained eye, nearly dead, her eyes sunken and unfocused, her breathing shallow. She looked as if she was struggling for air.

Peace Corps had medical programs, but you had to be a doctor or a nurse or an EMT to join one, not a philosophy major. I lacked the language to explain that I was a community development worker, not

someone with medical training. I knew the word for "sorry," which I said over and over. I am sorry. So sorry. I can't help.

The man nodded with sadness but without judgment and motioned for me to follow him back along the paths to my house. We were silent all the way, and when we were in sight of familiar terrain he turned with his eyes downcast and went back to his suffering child.

When Minga returned she knew about the girl and about my visit. She said the girl was already dead and the baby still inside her, and that they would be buried later that night when it was cool enough for the men to dig. People were already gathering. She was going and asked if I wanted to come. I should have gone to be part of the mourning ritual, but Minga didn't say so. She seemed to see that I was completely emotionally undone by a death that in her world, while sad, was not rare. Later, when I was more integrated into the village, I went to many funerals, sat with many families and shared their grief. But this first death of a girl younger than I loomed too large. No one in my world died because a baby was too big to be born. No one younger than I lay in pain for days on a hot, dirty mattress with nothing more than wet cloths and incantations to soothe her agony. In my world there was always someone to call, and someone would come. In this new world no one came. I simply couldn't accept what had happened, and I turned down Minga's invitation to go and join the mourners. She said the family would understand and not expect me, and went alone. I stayed with Roberto, by then home from the fields, to help attend to the children.

We didn't speak about the death of the young girl again. Life moved on in the village, and death, even of the young, was not a remarkable exception.

Minga and I were only four years apart and already on the path to being friends, although "girlfriend" was not much a concept in the village. All the young women Minga's age were busy with large families. None had the time or freedom to simply relax together, as I and my college friends might have done. There was no place to go, no money to spend, and nothing to do. There was a certain mistrust toward sharing your business with someone not a blood relative.

Minga was unlike her peers in that she had no siblings to share with, no large family around her. Her mother died in childbirth when Minga was five, along with the brother who did not survive the birth process. She was uniquely alone in her culture, and as I arrived in the village for a two-year commitment, so was I.

Our emerging friendship had to follow a path different from the one I was used to. Minga and I couldn't go out for something to eat or to a movie; there were no restaurants or theaters in the village. We couldn't swap favorite books; she can't read. We didn't play cards; rapidly counting numbers was beyond what she ever learned. We didn't exchange clothes; I'm a foot taller than she is. We couldn't voice frustration over husbands and children; I didn't have either. I couldn't tell her how much my mother frustrated me; Minga would have given anything to have a mother, even an annoying one.

We grew in friendship because of proximity and curiosity about each other and because having her there made me feel less alone and because I opened her eyes to a bigger world.

Minga shifted from friend to mother the night I got really sick. Simultaneously sweaty and chilled in temperatures that were pushing ninety-five degrees, I fumbled in the medical kit for a thermometer. My fever was alarmingly high, close to one hundred and six degrees. I fell onto my cot, suddenly too unsteady to stand. Teresa and her siblings, who ran in and out of my house all day, rushed to get Minga.

She did what she would have done for any of her children. She sat by me from late afternoon until the next morning, trying to get me to drink water and putting wet cloths on my parched lips. She bathed my sweat-soaked body with cool wet cloths, trying to get the fever to break. As darkness fell Minga lit kerosene lamps and in the dim light the villagers gathered, the women inside helping Minga tend to me and the men outside smoking. I remember the red arc of their nearly spent cigarettes being flicked into the night. I remember the soft murmur of women's voices. With the wooden doors ajar, bats flew freely in and out, and in my delirium I thought their flapping wings were angels.

I must have finally fallen asleep, and by morning the fever broke.

My body ached and I felt very ill, and I knew I had to get medical help. In an emergency we had the names of local doctors we could use, the nearest in the district capital a half hour away. I got myself there, saw a doctor, got an injection that left a bruise the size of a saucer on my hip, and made my way back. Frightened by the episode, I was soon in Panama City and on my way to Gorgas Hospital to be tested for hepatitis, a feared complication of dirty needles in the local health system. Fortunately my blood work was clear, and the bout of illness was relegated to a page of lab results in my medical file.

A friend once told me that when you save a life you accept ongoing responsibility for that life. After Minga's and my dark night, when she brought my fever under control and kept my body hydrated, our relationship changed. There is a word in Spanish, *comadre,* which has a couple of meanings. One is godmother. The other, more colloquial meaning, can be roughly translated as "God siblings." For the remaining year and a half of my time in the village, Minga and I were *comadres,* God siblings. People simply assumed that if they saw one of us, the other would not be far behind.

Coming
Into My
Own

Several people were affected by Minga's and my ever deepening bond:
Roberto, their five children, and Margaret.

Minga and Roberto were typical of couples in the village, bonded
together pragmatically as an economic unit. They had the same long,
grueling day repeated seven days a week, with few lighthearted moments
or chances to unburden. At any given moment one or more of their
children was hungry, in need of bigger school uniforms or new pencils
and notebooks, or had just fallen from a precarious perch while playing
in a banana tree and needed to have bleeding staunched or limbs bound.
Minga's aunt expected money to help with raising Ana. Roberto had
obligations to Robertito, his son with another woman. The family kept
sun hours to minimize the expense of kerosene, which meant Minga and
Roberto were up well before dawn. Minga lit the cook fire to make coffee
and walked to the *tienda* to buy bread. Roberto sharpened his machete
and fed, watered, and saddled his horse. Roberto had coffee and bread
and left for his sugar cane fields while it was still dark. One by one the
children got up, the three older ones dressing themselves in the simple
white shirt and grey skirt that was the mandatory school uniform. No one
had shoes. Ten-year old Rufina dressed the babies. They each had a bit of

bread, along with coffee for those on their way to school. Minga nursed the two littlest ones.

Roberto's day was spent cutting cane, then feeding the stalks one by one into a simple horse-powered circular press to make cane juice. From that he molded small brown cakes of unrefined sugar called *raspadura*, which he sold on his way home for five cents apiece. When he arrived around 4:30pm he sat in front of the house, sometimes smoking two cigarettes if he had a nickel to buy them. He ate his supper of rice and beans, watched his children play, and wanted Minga.

Minga, having put in her own long day, was most likely around the corner on the small concrete patio in front of my house, talking and laughing with me.

Roberto waited as long as he could, usually until just sunset, and then came around the corner and announced gruffly that it was time for bed. He took two-year old Angel, asleep on my lap, and glared pointedly at Minga who was nursing Ita. As he turned and walked toward their house Minga snapped her fingers in anger, her eyes blazing. "He always wants to be on top, on top, on top." But she invariably went.

Trying to soften Roberto's gruff annoyance, I began buying two cigarettes every evening and we shared a daily smoke. I hadn't smoked before; I started as a way of finding common ground with him. I suppose he saw that Minga was happier with me around. But that didn't diminish his feeling that she should be available to attend to him in the evening.

Minga and I could have sat on her front porch to laugh and talk, and it wouldn't have changed our conversation much. But she didn't want to. She seemed to like having our own place, fifteen feet away and around the corner of my house. The kids, young as they were, seemed to understand that once she reached my front patio, she was not to be disturbed. They stayed in the backyard or on their own front porch with their father. But her unavailability to Roberto caused stress for the whole family.

Minga had precious little extra time during her day. She never skimped in taking care of her kids. They were fed, their few clothes were always clean, they had their notebooks and pencils to go to school. She was always hard on them, because she needed their help to keep the

family going. There was no window, not even a small one, for them to act like kids and shirk their responsibilities. I can still visualize six-year old Daira and seven-year old Teresa, skinny arms pounding rice for what seemed like hours, separating the hard outside shell from the white grain to have the rice ready for Minga to cook. Ten year old Rufina often had to care for the newest baby for the entire time Minga was at the river washing clothes. Three-year old Angel fended for himself, playing with sticks and bits of string while cars whizzed by at ninety miles an hour on the highway only thirty feet or so from my front door.

Minga knew what she had to do to feed, clothe, and shelter her children. But she had no role model for warmth. I never saw her cuddle or hug or play with her children, and when they fell short of her expectations her response was swift and harsh. One day her ire turned toward Rufina, who saw the look on her mother's face and took off running across the yard. Minga reached for the wood pile and grabbed a branch two or three feet long and a couple of inches thick. She heaved it at Rufina and caught the back of her head, knocking the slender child off her feet. Rufina went down so hard I thought she was unconscious, but she got up and kept running and didn't show herself again until she was sure Minga's fury was likely to have ebbed.

If the kids got less of Minga, they got more of me. They were waiting outside my wooden door every morning when I opened it for the day, and they ran in and out of my house at will. In the late afternoon, when the men came home from the fields and the women were cooking, it was family time; not the hour for anyone to want to talk with the Peace Corps volunteer about projects. I always returned home. In dry season I hung my hammock in the yard, and, exhausted with the heat of the day, I lay reading. One or more of the kids often climbed into the hammock with me, curious about my turning the pages of a book. The local *tienda* had a generator and sold ice cream, small Dixie cups half vanilla and half strawberry with thin, flat wood spoons. Sometimes I bought that rarest of treats, ice cream all around. One of my Peace Corps friends, Carla, visited from time to time. She figured out how to make a simple oven from an empty five-gallon can and produced a birthday cake for Daira. I learned

later it was the only birthday cake any of Minga's children ever had for the entire time they were growing up. The kids and I carved papayas instead of pumpkins for Halloween, and I bought them each small Christmas presents. I found Easter egg dye in Panama City, and the kids and several of their school friends colored eggs. Decades later, on one of my return trips to the village, a grown woman asked shyly if I remembered her being on the porch that day, coloring eggs. Hers, she reminded me, was a beautiful shade of purple.

The time Minga and I spent together created something new for both of us. Minga wasn't physically affectionate with her kids, and she wasn't casually affectionate with Roberto. But she became spontaneously warm and affectionate with me, taking my hand while we walked or reaching over to touch my forearm as we sat talking, or sliding her arm around my waist as we stood in the back yard. I don't know why Minga could express physical warmth with me and not with her children or Roberto. Perhaps she saw me as a peer and not someone—regardless of my lack of skills for village life—for whom she was ultimately responsible. I soon began responding with physical affection of my own, and in the warmth of Minga's presence I felt my always vigilant body relax. Margaret used to tell everyone that I didn't like to be touched and was impossible to get close to. Margaret and I rarely hugged, not even decades later when she was an old woman, lonely and afraid to die. Minga and I hugged often, and I held and comforted her kids when they fell or were sick or when their mother was mad at them. Almost every night I rocked Angel to sleep on my porch. I loved the sensation of his sturdy toddler body relaxing, and then sinking into a deep sleep in my arms. When Roberto came to get the little boy, I hated to give him up.

Margaret was too geographically distant to feel confronted daily by my close bond with Minga or to feel shut out. I had no thought that she would ever come and see firsthand how inseparable Minga and I were. The exchange of air mail letters with my family in New Jersey was intermittent due to the unreliability of postal service, and our chances to talk by phone were rare and frequently cut off mid-sentence. That was a relief for me. I wanted to be out of range, and I was.

Then, to my absolute shock and deep distress, Margaret sent a letter which arrived safely in the village, announcing that she and Wendy were arriving in Panama for a visit. I longed to see Wendy but didn't want Margaret in this first place that felt truly my own. Overwhelmed with conflicted feelings, I focused on the logistics.

I had the cot and a hammock that hung from rafters holding up the roof. The hammock got musty in the first rainy season and smelled like mold even once the fabric dried out. Resting in a hammock is relaxing; sleeping for eight hours in the same position is extremely uncomfortable and leaves a body stiff and sore. Neither the cot nor the hammock was a plausible place for Margaret or Wendy to sleep. I was sure they couldn't use the outhouse either, which I shared with Minga and her family. I bought toilet paper for all of us, rather than the palm fronds they had been using. That made the outhouse usable during the day although in the heat the smell was rank. But after dark, huge cockroaches came up from the depths and poured down the sides of the seat, clattering around inches deep on the floor. I got a huge can of industrial strength bug spray in Panama City, and one night after returning home I went out every hour until I went to bed and sprayed. In the morning there were hundreds of dead roaches, but the next night the undaunted survivors kept coming in undiminished waves. I gave up and used the bushes after dark. As I stood with Margaret's letter in my hands I tried to imagine her and Wendy squatting behind a bush, the image providing at least some comic relief.

There was no way, I concluded, for them to stay with me at the house for more than a few hours.

I encouraged them to stay in Panama City at one of the few nice hotels and drive out for a day. Minga was excited to meet my family, and she and some of the village women planned a traditional meal of rice and chicken to be hosted in our backyard. The men agreed to come home early from the fields and participate.

I met Margaret and Wendy in Panama City. I prepared them for the forbidding armed National Guard checkpoints we'd pass along the way, saying I'd speak Spanish in answer to the questions and everything

would be fine. We Peace Corps volunteers traveled by the same public transportation, the small vans called *chivas*, that the Panamanians used. With our bad haircuts and faded and threadbare clothes, often washed at the river and cleaned by being beaten on a rock, we blended in fairly well with the poor people and drew little attention. But traveling with Margaret and Wendy in a rental car, I knew we'd look like Canal Zone residents or rich American tourists. I asked Margaret to take off her jeweled watch and wear simple earrings, which she did. But she wore the clothes she'd brought: a sleeveless green linen sheath and powder blue high heels, which made her stand out as an unlikely candidate for a visit to Rio Hato. The *Guardia* passed us through nonetheless.

When we arrived at my house and went out to the yard we found several cook fires burning directly on the ground. Each woman brought her own big iron pot. Some contained boiling rice; other pots held the chickens that were killed and cleaned early in the morning. The men carried wooden tables and chairs from various households, enough for Margaret and Wendy and me and a few others to sit. Most of the villagers simply sat in the dirt, which Minga carefully swept clean of palm fronds and fallen fruit. There were three glasses for Margaret and Wendy and me to drink water. Families contributed tin bowls and spoons, not enough for everyone. Many ate with their hands, the food placed on flat green strips of palm. The children were cleaned up and dressed in their best clothes. They were shy, playing at the periphery but afraid to come too close to the American visitors.

I'm not sure what Margaret and Wendy saw or thought or felt when they arrived; they never said, although I could see their efforts to be warm and gracious to everyone. I found the experience of trying to integrate Margaret into my life in the village jarring. On top of that I was painfully aware of how much I missed Wendy and how much I worried about her being alone in New Jersey with our mother.

I pushed the worries aside, not yet ready for a tug back to my old life.

The event was a huge hit with the villagers, who felt it a great honor that my American family chose to come such a long way to share a meal with them. One of the young men, Cyprian, was smitten by fifteen-year

old Wendy and asked me to translate a proposal of marriage. He wanted her to stay right then and there and become his common-law wife. I said probably not, but Wendy agreed to stand with him for a picture.

Margaret had a Polaroid camera, and the almost immediate photo of Cyprian and Wendy fascinated the villagers. Most had no access to photography. Their houses didn't even have mirrors to show them what they looked like. Everyone wanted a photo, and Margaret obliged.

Minga, who was busy seeing that everyone had food and that the cook fires didn't go out, saw the picture taking and called out to me.

"*Comadre*, a photo of us."

Margaret heard the "*madre*" part, and her voice grew giddy.

"I'm the mother. I want a photo of me in the middle with Pam and Minga on either side." She thrust the camera into Wendy's hands and pulled Minga to her side. Minga looked at me confused, not sure what was happening.

"Pam, get over here. I don't care if you don't like your picture taken. Minga and I are the mothers and I want a picture of us with you on my other side. I'll be in the middle."

I froze, realizing all at once that Margaret had no idea about Minga and me as *comadres*, or about God siblings, and didn't sense that she wasn't part of it and didn't belong between Minga and me. But the realization couldn't quell an upsurge of fury, and I couldn't bring myself to let the innocent moment pass. I glared at Margaret, and stalked to the other side of the yard where I sat with some of the women who were still cooking.

My visible anger came close to spoiling the party.

Margaret, Wendy, and I left in the late afternoon to get back to the city before dark. I don't remember the ride, and I'm sure we didn't talk about the tense moment. Margaret likely wrote it off to what she saw as my characteristic lack of cooperation.

I was surprised, and a little shaken, by how quickly my anger flared. Deep into life in the village, I supposed my built-up reserve of anger and frustration was much diminished, perhaps even gone. Yet here it was again, triggered by Margaret marching oblivious into the center of my

most treasured relationship. On the drive back to Panama City I wanted to regain control of my feelings. I wanted to leave Margaret behind. I did leave her and Wendy at the airport, along with the rental car. I felt exhausted by my turbulent feelings and wondered if any place I might travel to would be distant enough.

When I returned home Minga was waiting, a perplexed look on her face.

"What happened, Pamela? Why were you so angry? Why didn't you want a picture with me and your mother?"

I knew Minga was a little girl when she lost her mother, and there were no tangible mementos and precious few memories. Minga remembers her bedridden mother calling out to her, holding her, stroking her hair, telling her she would love her always. Then her mother died.

I couldn't find words to explain why I was angry and so remained silent. Minga, ever accepting, shifted the conversation to ask if Margaret and Wendy liked the food and liked coming to the village. I said yes, they liked everything very much. Minga accepted my response and didn't press further.

Wendy took the picture of Margaret and Minga. A few photos survive from that day, including the one of Cyprian and Wendy. There was never a photo of Margaret between me and Minga, and the one of Margaret and Minga alone is lost.

La
Cooperativa

The only way I could think of to regain my footing was to focus on
my work. I had about eighteen months after Margaret and Wendy's
visit to find a significant project. I was teaching English in the elementary
school, a challenge without books or materials or teacher training of
any kind. I worked on some small initiatives with Lleyda Carles, the
Ministry of Agriculture agent. But a focused project, something big and
meaningful, eluded me.

Finally, I sat down and thought about what I saw every day. Minga's
family, and the other families, didn't have enough to eat and not enough
of the right kinds of foods. They ate mostly rice and beans, bread, and
coffee. Only the kids ate fruit, filling their bellies with ripe mangoes
that dropped from the laden trees and with bananas they could pick
themselves. Nobody ate vegetables. Eating anything green was about
as appealing as eating a plate of grass. None of the families had enough
money. Scraping together the few dollars it took to buy simple school
uniforms and pencils and blank notepads was a huge strain.

More than the shortfall in those basic elements of daily life was my
sense that outside of their small community, they were treated as invisible
or insignificant. The Department of Agriculture raised the prices of staples
like rice and beans and cooking oil, causing malnutrition as large families

simply bought less. The Department of Education raised the school fees, which for some families meant sending some but not all of their children to learn. Most startling to me was an encounter between a respected older woman from the village and a small cluster of eighteen-year old soldiers from the nearby U.S. Army training base. Señora Ximena, a talented seamstress, worked on the base repairing torn uniforms and sewing on patches awarded for riflery and other military skills. Señora Ximena asked me to come and see her on the base, as she was proud of her job and of the modern sewing machine the Army provided for her use. I rode my bicycle the several miles, and moments after I arrived the soldiers banged open the screen door and threw bags of dirty uniforms at her feet. They couldn't say Ximena or anything close to it, nor did they give her the respect of calling her *Señora*. They called her Suzy, a name they must have picked out of the air, and urged her to hurry up with the repairs because they needed their uniforms clean and ironed and with all the new patches in place by the next day. Then they turned and banged out the door, just the way they came in.

Señora Ximena, moments before so proud of her work, couldn't meet my eyes, nor I hers.

Back in Peace Corps training they told us to focus on the felt needs of the community. Here they were, right in front of me.

The villagers needed more food and more food choices.

They needed cash.

They needed to be able to push back on indifferent government officials and on unruly American G.I.s.

They needed to pool their scarce resources. The villagers helped each other out informally anyway. With no government or church safety net, they were each other's fallback. Those who had shared with those who didn't, knowing that another day the tables would be turned and the givers would be in the role of supplicants.

The villagers were mostly farmers and fishermen, plus a few small business owners like Señora Cuta, who ran a juice stand. They were seamstresses and butchers, bicycle repairmen, basket weavers, harvesters of natural herbs and remedies.

On trips to the district capital I saw tomatoes and green peppers
being sold from street stalls; clearly there was a market beyond the
sugarcane they already grew. If the village farmers could grow and sell
vegetables, and if the small business people could keep track of the
revenue, we could earn a modest amount of money. Beyond that, I knew
the villagers never wasted anything. I'd never succeed in urging them
directly to eat more vegetables. But if our produce had bruised or split
skins and couldn't be sold, I knew they'd throw the tomatoes and peppers
into the cooking pot and eat them before they'd allow them to spoil or be
thrown away.

I was never a gardener, and tropical agriculture is so much harder
than tying a few tomato plants to stakes in the back yard in New Jersey.
Despite this, I asked Minga about the idea of getting people together to
plant a big garden, and she thought it could be done. She had a friend
with an empty half-acre plot. She got twenty or so neighbors to come to
a meeting after supper, and I broached the idea of forming a co-op. They
were unfamiliar with co-ops but the idea made sense. I told Minga we'd
need a little money to buy seeds and watering cans and tools and asked
her how much she thought we could ask in dues. She thought a dollar per
household and cautioned me that most would have to pay over time.

She was right. The money came in from most families at ten cents a
week. We never gave the co-op a name; we just called it "the co-op."

The villagers knew how to work the land. I didn't. With so little
money, gardening tools were beyond our reach. The men formed a line
and broke up the dry earth with their machetes. We women came along
behind on our hands and knees and broke up the clumps with our fingers.
Minga and the others carefully avoided the fire ant nests buried just below
the surface. I blundered into one, and hundreds of stinging ants raced up
my arm and onto my torso. I yelped in pain as the women rushed to slap
them away from my body.

Getting a crop took persistence. To save money I tried getting seeds
through the Ministry of Agriculture. Lleyda obliged, but the seeds were
too old to germinate. After all the hard work of cultivating and planting
and lugging water in five-gallon cans, we got nothing. I found a new

source of seeds: an international charity in Panama City. We had no luck with those either. I realized that major seed companies donate packets of seeds only when their germination dates have long passed. I didn't think the group would hold together through a third round of failure. Peace Corps volunteers were supposed to use only the resources that the villagers could access on their own. But you can't make something from nothing, and I was out of patience too. I ignored the rule and bought good seeds with my own money.

The plants began to mature and produce tomatoes and peppers just as dry season passed into the rainy months. If our first task had been to keep everything watered, our next job became keeping the plants from being washed away by drenching downpours. Sometimes the heavy rain knocked the partially grown vegetables to the ground. The co-op members did take them home to be added to the cooking pot.

Against all odds we got a crop. Two co-op members volunteered to take the carefully packed boxes of vegetables to sell at the district capital, and the men came home with a fistful of dollar bills. We distributed some money to each family and kept the rest in a cigar box under my cot.

We were in business.

Growing the co-op was painstaking and slow. The families were used to helping each other out, but they weren't used to shared decision making. At our evening meetings, everything was discussed down to the smallest detail, and everyone insisted on being heard multiple times. Then we had to take a vote, and someone would be unhappy at not being heard, so we talked more and then voted again. The meetings went on into the night as we debated every single issue and took vote after vote.

I stayed in the background as much as possible, and quite quickly the co-op members stopped looking to me. They seemed to love the simple chance to voice an opinion. Rural Panama is a gracious place; it was rare for someone to be shouted down, or for insults or arguments to flare. They wanted to talk and to have their neighbors listen.

As the co-op became more visible, we began to hit problems no one anticipated. One Sunday the local priest told people in all the villages where he said Mass that I had free food for anyone who asked:

rice, sugar, coffee, cooking oil. All week, families I didn't know showed up at my door, sacks in hand, looking for food. When I said the priest was mistaken, most went away disheartened from the time and *chiva* fare they'd spent to come, but some became angry. They saw me as an American taking advantage of them. Minga ran interference, loudly arguing and finally forcing the angriest ones to give up and go away. The priest and I never crossed paths, and I had no idea why he set me up. Minga said she thought he was jealous.

Then we had the haves and have-nots, a rift between family members who joined the co-op and those who remained outside. The co-op was open to all, but not everyone wanted to commit to work hours on top of an already grueling day. Some, like the elderly, lacked the capacity. But if a family typically had two dollars a day like everyone else, and that family on some days now had three or four dollars, that was a significant shift. Perhaps, thought the outsiders, the extra money was available to borrow. The families were used to sharing commodities, like extra rice. They were not used to being asked for money by their loved ones and didn't know how to respond. Some simply gave money when asked, then felt deprived of what they'd worked hard to earn. Some said no, and the refusal created a breach that hadn't existed before. Although we seemed to talk about everything related to the co-op over and over, we didn't talk openly about the rifts over money. People would come to me individually, almost always the women, and they seemed ashamed at not knowing how to handle their largess.

The co-op increased my visibility, which brought unexpected danger. Three miles from the village was the U.S. Army "jungle training base" where Señora Ximena worked. I rolled my eyes at "jungle"; there wasn't any actual jungle within miles. But groups of soldiers were sent there from their Canal Zone home bases for three or four week intensive training. There was an airstrip and a cluster of wooden barracks and a small number of service buildings. The base was considered a hardship post, with no recreation facilities, so on their breaks from work young soldiers flocked to village bars. Word got around that an American girl lived right on the Pan American highway, and I began to get drop-in visits

from drunk eighteen-year olds on their way back to base. At first the visits felt safe enough. The guys brought beer, which I didn't drink with them, and sometimes offered me their C-rations, which I accepted to relieve the monotony of rice and beans.

As one group of soldiers went back to the city and another came to take their place, the unwanted visits increased. I never allowed any of the soldiers inside my house, always dealing with them on the front porch and getting them to move along as soon as I could. One night after dark three very drunk guys in uniform came bursting through my door. Once I closed the door and windows for the night, which happened soon after dusk when the bats began to fly, I stripped down to cotton shorts, a thin T-shirt and no underwear to cope with the stifling heat. The doors didn't lock. I never worried about an unlockable door with villagers. But here I was, facing three red-faced, leering guys carrying beer and open rum bottles and announcing they'd come to party.

I could have yelled for Minga and Roberto, who were sleeping but would have come, Roberto perhaps brandishing his machete. The soldiers weren't armed, but they were rowdy and aggressive. I resolved to stay on my feet, feeling that sitting down or being forced down would make me unbearably vulnerable. My goal was to get them back outside and then make them go away. Somehow I did. I got pawed and had to endure a couple of slobbery kisses. But I didn't get raped. I finally thought to say that if they didn't get out of my house and leave me alone I'd report them to their commanding officer. That threat cut through their drunken haze. They called me a prude and a fucking nun but gathered up their rum bottles and left.

The next day I did bike over to the base and ask to speak to the commanding officer. To my great good fortune he was a decent guy. He asked if I could identify the men, and I said honestly that I couldn't. They were an indiscriminate bunch of sweaty faces and buzz cuts and sour breath and groping hands. But I told him I couldn't go through another night like that ever again. He thought for a moment, and then told me he was putting the entire village off limits for several months, until the story of my being in the village stopped being passed from one group of soldiers

to another. He did exactly that, and I'm sure the bars in Rio Hato and the prostitutes had no idea what happened to their business. But the visits to my house from drunken soldiers stopped.

The co-op became successful, and the members got bolder in considering what we could do. A farmer who had a cow to sell approached and asked if we would buy his cow, kill it and sell the meat in the village. He'd wait until the meat was sold to be paid. He said the sole buyer for their cows in the next town regularly cheated them, and he thought that his fellow villagers might be more honest. One of our co-op members had a brother who knew how to slaughter a cow, and after yet another endless round of discussions the members voted to expand into the meat business.

The cow-killing was a bloody affair. The butcher simply secured the animal and then stabbed it in the heart, and we all stood around until the cow bled to death, spouting arterial blood several feet into the air with each waning heartbeat. Once all was quiet, the butcher stepped into the pool of sticky blood, took up his knives and began to hack away at the carcass. We had a small screened hut to protect the hanging quarters of meat from flies, and people came all day from Rio Hato and all the surrounding villages to buy their single pound. All the co-op members took a shift selling, and by the end of the day I had dried blood embedded under my fingernails that I couldn't get out for days.

We began to kill a cow once a week, and before long all the cows in the area were promised to us. But our very success led to our undoing. No one cared if we grew and sold vegetables. But there were some very wealthy landowners who owned hundreds of acres of land just beyond the village. They were in the meat business, and they cared very much that we were competing with them. We began to get visits from bogus health inspectors waving guns, who pronounced the cow we just killed diseased and confiscated the carcass, leaving both the farmer and the co-op unpaid. We kept going, and the men with guns kept coming. Word came down that if we didn't stop, someone in the co-op would be killed because the men who sent the gun-toting thugs were out of patience.

I wasn't afraid for myself, although I likely should have been. I was afraid for the co-op members. Earlier, during a military coup that changed

the leadership in Panama from an elected president to an army general, a villager who supported the democratically elected regime disappeared. I'd never experienced such a thing, that a person would simply disappear over his political views. As I talked with the villagers I asked what we were going to do to try and help the man and his family. Minga pulled me aside and for once spoke firmly, her voice harsh with fear. The man would come back or he would not, but no one could go and ask about him or that person would vanish too. She said I must stop talking so openly, because I was putting them all in danger. The man never came back, and no one spoke of him again.

When the death threat came to the co-op, I recalled the disappeared man and shared my fears at our next meeting. The members began to argue and quite quickly the group split, some saying we had to stop the meat business, others demanding that we stand our ground and fight. I'd been there more than once when a truckload of men arrived brandishing guns, saying they were going to confiscate our cow. The co-op members had machetes but not guns. Tempers always flared, and I thought someone was going to be killed right in front of me. I sided with those who voted to stop selling meat, and once I took sides the meeting erupted in anger and division.

The threat happened just before I was scheduled to leave, near the end of my two-year commitment, and the split in the co-op made it feel as if everything I'd worked for was falling apart. Peace Corps planned to put another volunteer in my place, but they were worried too and sent the incoming volunteer to another, safer posting. The co-op fractured into angry, competing factions, and there weren't enough workers to keep even the vegetable business going.

Minga was loyal to the very end, defending me against all criticism. I was simply exhausted, tired of the heat and having rashes and insect bites and diarrhea all the time. I wanted air conditioning at night to sleep, a hot shower, a decent hamburger, and no guns or wild-eyed crazy men anywhere near me. Minga cried as the day of my departure approached. I told her not to cry, that I'd come back. I gave her all the furniture in my house, and the gas tank and three-burner cook top I never used. I left her

some money. We hugged long and hard, and then I went to the district capital overnight to say goodbye to my Peace Corps friends.

The next morning I was in a *chiva* barreling down the highway at seventy or eighty miles an hour when we passed my house. There was Minga, standing near the side of the road peering into each *chiva* as it passed by, seeing if she could catch one last glimpse of me.

I should have shouted for the *chiva* to stop so I could have gotten out and given her one last hug. I never thought she would be there, with all the work to do. Our eyes met and I waved, but by the time I thought to cry out we were racing around the corner and headed out of the village.

I left Minga there, by the side of the road, waiting for me to return.

Intermezzo

My flight from Tocumen airport in Panama to Newark, New Jersey lasted just over five hours. Peace Corps spent a lot of time preparing us to live and work in a different culture but little time softening the impact of our return to the United States. We had to write a report about what we did during the two years, which was accepted without comment. We had exit physicals. A chest x-ray showed that at some point I was exposed to live tuberculosis. I didn't have full-blown TB but was warned not to take a TB skin test in the future because it would always read positive and to avoid contact with anyone who was actively sick with the disease. I was also diagnosed with intestinal parasites, fortunately the kind you kill off with medication. Some of my friends went home with amoebic dysentery, which stays in your gut forever. The Peace Corps doctor prescribed a large bottle of noxious brown medicine, which I added to my going-home artifacts: a giant turtle shell which I hand carried onto the plane, a seven foot snake skin, several colorful hand-sewn *molas* made by the indigenous Kuna people on the Caribbean coast of Panama, my laminated Peace Corps identification card, an expandable woven bag of the kind Roberto tied to his saddle, and a statement describing a check to be sent in the mail. My seventy-five dollar monthly stipend while in-country was for living expenses. In addition

to that, the Peace Corps set aside money each month that I served. At the end of two years I got something like twenty-five hundred in a lump sum. My ragged and threadbare clothing, other than what I wore on my back, I left with Minga. My suitcase, which smelled musty from two rainy seasons, was ruined and begging to be thrown away.

Margaret and Wendy met me at the airport, and we returned to yet another new and unfamiliar apartment. Margaret prepared her favorite dinner: ham, baked beans, and potato salad with onion and mayonnaise. She invited family members and a few friends, all of whom laughed when I asked for a sweater, saying I felt cold in seventy degree weather. After two years of bland rice and beans the salty, fatty meal upset my stomach. Everything felt unfamiliar, even being surrounded by people talking loudly in English. I retreated to Margaret's bedroom, where I knew she always had a phone by the side of her bed. I tried to make a long distance call to Rio Hato, knowing that if the phone in the mayor's office was working someone would run and get Minga and she and I could talk.

The call seemed to go through, the rings sounding tinny and hollow, but even though I let it ring and ring no one answered. Finally I put the receiver back in its cradle.

I was officially home.

I had a job lined up for the summer. My friend from college, Sister Bernadette, moved on from higher education and was working in a poor Latino neighborhood in Paterson, New Jersey. She got me a job teaching English to Speakers of Other Languages, ESOL, where I could work with Spanish-speaking kids and families from a local parish. Bern lived with three other nuns in public housing projects, in a basement apartment with thick metal bars on the windows and extra locks on the door. They didn't have a bed for me, and anyway it wasn't typical at that time for nuns and lay women to live together. Margaret let me stay with her and Wendy, claiming most of my meager earnings for room and board. My sister Linda, having left the convent, was working and living on her own.

We might have knit ourselves back together as a family during that summer, all of our lives being somewhat unsettled. I think we each felt unmoored and perhaps lonely. Linda was going through her own re-entry,

making the transition from the structure of religious life to the demands of living alone and teaching elementary school in a Jersey shore town. Wendy was in her third change of high school, and was beginning to think about college. Margaret was facing her worst fear: that even Wendy would grow up and leave. Margaret was now an executive secretary to a politically well-connected partner at a law firm. She liked being around a powerful man, being the keeper of his calendar and the guardian of his important documents. She still had her married lover, although she always presented herself to others as a woman alone trying to make her way against the norm of a coupled world.

All summer long we ate take-out instead of TV dinners, but the warmth of a shared family meal didn't return. And we were three, not four, since Linda rarely came after work to join us for supper.

For the whole of my first summer home Margaret and Wendy and I muddled along. The teaching was uneventful, although for the second time I was faced with saving a life, and this time I was successful. The ESOL kids were in class most of the day, with recreation breaks outdoors on a hot paved playground with off-kilter basketball hoops and a few mostly broken swings. Two or three times during the eight week program we all got on school buses and went to a popular lake in the western part of the state. The well-behaved white families there for a day of swimming and picnicking looked aghast as our city kids poured off the buses, pushing and shoving and screaming to each other in Spanish while making a chaotic beeline for the water. None of them could swim, and they were all sternly admonished to stay in the shallow area between two docks and within sight of the lifeguards. Some of our staff were in bathing suits and in the water, and others of us were fully dressed and on dry ground, watching for problems. I was in the latter group. As I scanned the shrieking, laughing, splashing faces I caught a glimpse, beyond the dock and in the deep water where none of our group was supposed to go, of a brown face breaking the surface of the water, then submerging again. I knew it had to be one of our kids, and that no one else saw him. I flung off my watch and shoes and began running. Seeing me, the lifeguards jumped off their stands and ran in the same direction. I got as far as I

could out on the dock then dove into the lake. Several feet below the surface I saw the limp body of the boy, sinking, bubbles of air coming from his mouth. I put my arm around his waist and got both of us to the surface. By then the lifeguards were in the water, and stronger and more skilled hands than mine got him onto the dock and gave emergency medical attention.

The child coughed up a lot of lake water but seemed to recover. We called an end to the outing early, getting the kids aboard their buses for the trip home. Bern, who wasn't with us for the outing, was there in the parking lot as we pulled in. When she heard the story she said it was a miracle from God that I was in the right place and looking the right way and could swim.

I didn't think it was a miracle from God. But Bern and I agreed early in our friendship that she'd use her language and I would use mine. I never doubted that she saw something, or felt something, about an ethereal divine hand active in our daily lives. I think she knew I saw life as largely random. But the time in Panama did make my view of the world less bleak than it had been in college, when I was so enamored of the existentialists. Minga's life, and her ability to put one foot in front of the other day in and day out, had too much quiet dignity for me to call life meaningless.

And now there was a specific life, the child Moises whom I pulled from the water, who mattered very much. He was cognitively impaired and could say very few words in either Spanish or English. Before being bundled into a car and taken to a doctor he put his arms around my waist and his head against my chest. He made his little chirping noises and looked up at me with happy eyes. His warm and prolonged hug, God-inspired or not, did seem miraculous. The quick flash of his head breaking the surface of the lake could so easily have gone unseen. We probably wouldn't have missed him until the kids lined up for the buses to go home.

I wondered if life would often circle back and give me another chance at something where I spectacularly failed. The death of the young pregnant girl in the village, and my inability to help, affected me deeply.

The Peace Corps message was clear: don't freeze, don't do something stupid, don't die. But there was a fourth, implied part to the message: when faced with a difficult problem, do something to alter a likely bad outcome. At the home of the young girl I stood silent and inept. When I spotted Moises' head break the surface of the lake, I began running. I resolved to be that person whenever I could: the one who runs toward life, not the one who stands still and overwhelmed.

Meeting
Jerry

The summer passed quickly, and in September I packed my used Nash Rambler and drove to Washington, D.C. to begin the doctoral program in philosophy at Georgetown that I deferred to enter the Peace Corps. The University was glad to wait for me to return as a full-time student and offered a bare-bones teaching assistant job that covered my tuition. With my Peace Corps separation allowance I was able to pay the security deposit and first month's rent on a cheap apartment not too far from campus.

The year at Georgetown was a disaster. There was little interaction among graduate students. Almost all of us worked during the day and then rushed to classes in the late afternoon and evening, studied for hours in the library, and then went home. Doctoral students had individual study carrels, small cubicles which locked so that we could leave books and pens and notepads. Mine was on a high floor of the library, way back in the stacks, and when I worked there I couldn't hear a sound other than my own breathing.

The year was unbearably lonely. I have vivid memories of people from all stages of my life, and I still see friends that I've known since I was a little girl. But I haven't kept in touch with a single fellow student or professor from the university or neighbor from the apartment complex. I

don't remember the titles of the courses I took, only that the discussion of long dead philosophers and their abstract works fell on deaf ears.

In the village I learned about how groups work by sitting night after night with the co-op members and seeing them argue through their differences. There was an immediacy to it, and whether or not a difference got resolved mattered to real people. In the university classroom, I couldn't see what mattered or why our discussions were important to anyone other than those signed up to take the course who were working for a grade. I concluded, as the year ground on without my making much headway, that I wasn't an academic.

Whether or not I was going to stick with trying to become a professor, I needed a part-time job to get through the year and found one at a small firm that helped computer companies hire programmers. My nascent entrepreneurial skills continued to assert themselves, and this job offered the possibility of bonuses on top of my hourly wage. The firm held hiring weekends at mid-market hotels up and down the east coast. They took over the whole place from Friday night until late Sunday afternoon and created something like the employment version of speed dating. A big company paid a flat fee, and they could interview and hire as many programmers as they wanted. One part of the sales staff had to entice companies to pay the fee and come: that was me. I cold-called HR departments all day long and got a bonus based on how many signed up. Another part of the sales staff had to convince programmers to allow their resumes to be listed and get them to come and interview for a better job, even if they were already employed.

Right after I started work, the company held a hiring weekend in the very unromantic town of Saddle River, New Jersey, and everybody employed by the firm in any capacity had to go. The weekends were a chaotic riot of people in and out, wandering the long corridors looking for the interview suites. Programmers showed up for their scheduled meetings but at the wrong time or on the wrong day. Or they brought six friends who also wanted to interview but hadn't sent us any resumes. Or a company found as many new hires as they needed by noon on Saturday and went home, leaving no one to conduct the rest of their

appointments. Although we were in the business of computer jobs, we didn't have any computers in the suite that served as our command post; everything was managed by hand. There was a huge paper grid on the floor, with hundreds of boxes and everything in pencil so names could be added or erased. That grid was managed by a guy on his hands and knees, completely calm and organized in the face of frenetic activity and mass confusion.

His name was Jerry. I didn't think he noticed me. He didn't seem to pay attention to anything other than keeping track of changes to the interview schedule. But at the end of the exhausting Friday night session he asked me to join him for a cup of coffee, saying he needed to unwind before going to bed.

We talked long into the night. Jerry told me he had a day job: First Lieutenant in the U.S. Army. Everyone else in his basic training group shipped out to Vietnam. Dr. Jeremy A. Klainer, a new PhD in organic chemistry, was sent to Washington, D.C., to work in the chemical corps. His job was classified and he never shared specifics, even decades later, but I suspect he worked on Agent Orange.

During the day, while I cold called and tried to sell paid slots in our career weekends, Jerry was in his role as Lieutenant, soon Captain, Klainer working in a secure federal building downtown. Finishing at 4:30 pm left too many unfilled hours for his hyperactive soul, so he got a second job. He worked on the team that called programmers, trying to get them to submit resumes.

That first night we really did just have coffee. But we made eye contact often that following day and grinned at each other, and at noon I brought him a sandwich because he couldn't leave the master schedule, not even for a half hour. By the time the career weekend was finished we had plans to meet back in Washington for a date.

Jerry was interested to hear about Minga and the village, which is what I talked about most of the time. I learned later that he was charitable and altruistic, but he said right up front that working in the trenches in some remote village in a tropical country was not for him. He hated heat, humidity, bugs, and sand. He was intensely disciplined,

ambitious, smart, and more career-focused than I was at that point. He disliked the Army because he thought people got promoted based on keeping their shoes shined and conforming to orders not because they were strategic or bright. He knew about all kinds of things, like classical music, that were a mystery to me. He was dyslexic so didn't read as much as I did. But he was an expert at scouting out adventures, and we both liked to be physically active and outdoors. We rode bikes through the quiet roadways of Arlington National Cemetery and joined hundreds of other Washingtonians to create kites during a festival at the Washington Monument. Our dates became frequent. Soon we were spending almost all of our free time together.

I don't think, before meeting Jerry, that I believed in love stories. I didn't think Margaret loved my father, or she wouldn't have called him a lousy fucker or thrown the watch back in his face or made him say, "Jesus Christ, Marge," so often. I didn't think Minga really loved Roberto; I thought they were together because life was hard and it took two people to provide for children and keep a roof over everyone's head. I began to risk the word "love" three months after Jerry and I met, when my sister and her fiancé were getting married. I was the maid of honor and asked Jerry to be my date for the weekend wedding. He said he was on military duty but would do his best to find someone to cover his shifts. The rehearsal dinner was on Friday night; he said he'd try to be at the New Jersey hotel by 6 pm, when the cocktail hour began.

I dressed for the dinner and rehearsal and came downstairs. The wedding party's private dining room was just off the lobby, and I stayed as close as I could to the large open doors so that I could see everyone entering the hotel. The clock ticked toward six with no Jerry. I told myself it didn't matter, that he just couldn't find anyone to sub for him. I told myself I didn't care, that I didn't need a date because I was in the wedding party anyway and could rely on the groomsmen to ask me to dance. My sister called for me to come and be part of the informal photos; no one, she said, could see me standing over there by the door. I moved a few inches, but kept looking anxiously toward the front of the lobby.

No Jerry.

And then he was there, in a rush of cold air and still in his Army uniform. The guy he found to cover got to the federal building at the last possible moment for Jerry to get to the car and start driving, with no spare minutes for him to change into civilian clothes. He caught my eye and broke into a big grin, and I said to myself, "He loves me." I didn't think about another thing for the entire celebratory wedding weekend except that he was there.

I don't remember Margaret and my father talking about things that mattered, although they may have done out of my hearing. Jerry and I talked about everything. His family are Conservative Jews. At the time, a Catholic/Jewish couple was as uncommon and troubling to traditionally religious parents as a Christian/ Muslim relationship might be today. We agreed that neither his father Max nor my mother would be at all happy to know that we were dating and soon enough, planned to be married.

They were not. Margaret wanted Irish Catholic sons-in-law who would live in Kearny and come on weekends to fix things and do errands. By then her real estate savvy found its niche in a Jersey shore house, which she rented out to summer vacationers. Jerry tried to be handy although he was not highly skilled, but he did own a tool box. On one of our first weekend visits Margaret waited until about a half hour before we were to leave New Jersey for the return trip to Washington, and announced she had things that needed fixing and none of them could wait. She muttered to me that the least she expected of someone to whom she had given hospitality was that he would return the courtesy by making himself available to assist a woman alone. In his calm way Jerry said that next time he could bring his tools, and he'd be happy to look at whatever was on her list. Margaret never made lists, and she never planned ahead. If she wanted something done she wanted it done then and there, or not at all. She fumed as we got in the car and drove away and railed later on the phone that I had picked a very selfish man.

As our wedding approached, the religious differences became a deeper and more openly contentious issue, not for us but for her. Margaret was proud that my father gave in and agreed that we girls be raised Catholic, and she expected me to pose a similar test for Jerry. Never mind that I was

no longer a practicing Catholic, or that I said I'd never put Jerry in such a bind. She expected a Catholic wedding, and Catholic grandchildren, and she thought that Jerry could prove his love only by agreeing to stand aside as my father did for her.

Being rebuffed always brought out Margaret's darker side. I overheard her on the phone telling her friend Eleanor, "Well, Pam is marrying a Jew, and Linda married a Polack. All I need now is for Wendy to bring home a nigger."

I knew this side of her, having seen it when she was spitting with rage at the doctor who wanted her to see a psychiatrist. I was furious that she spoke of Jerry this way to her friend. But I was no longer alone with her in her worst moments. I had Jerry in my life, and he never said things like that, even about people he didn't much like. He never said unkind things about Margaret, only that she was my mother and we had to treat her with respect. He said it calmly, as if she was just wrong a lot of the time and we could ignore it when she went over the edge. We could simply not get involved in her rants.

It was the same message I'd always gotten from Bern. But now, he and I could go hand in hand for a walk when Margaret erupted, physically turning our backs and moving out of range of her tirade. I felt as if I never again wanted to see my mother on my own but only when Jerry was with me.

Our early trips to Boston for me to get to know his family were equally difficult, although in different ways. Jerry's mother died the year before he and I met. Berenice was a homemaker, a former teacher and artist. She was widely known as the warmth of the family, and she seemed dearly loved by everyone who knew her. Max was a physician, and he wore a business suit and went to the hospital seven days a week. He preferred that everyone call him Dr. Klainer, except for immediate family his own age and a very few close friends. He wasn't about to suggest that I call him Max. I couldn't call him Dad; I had only one father, and he was dead. I refused to call him Dr. Klainer. I wasn't his patient or a subordinate or a neighbor or acquaintance whom he preferred to keep at a distance. I was about to become family, his daughter-in-law. I couldn't

figure out what to call him, so I didn't call him anything. If I needed to get his attention I walked over to where he was standing and caught his eye.

Max was coldly correct with me, although in private he told Jerry he was deeply dismayed at the prospect of having a *shiksa* for a daughter-in-law. *Shiksa* is a Yiddish word that means "non-Jewish female," but it's not a kind or even neutral expression. The word carries the connotation of someone who tempts a devout Jew away from his religion.

Jerry and I were married by a judge, and both families came.

I think Margaret and Max were roughly balanced in their dislike of our union, but I always expected Margaret to create the greater drama. In that I was quite wrong. Three weeks after the wedding Max had a serious heart attack. While in the hospital he sent Jerry a letter in shaky longhand on sheets from a yellow legal pad. Jerry stood frozen, the letter in his hands. I asked if I could read it, and he handed it to me.

Max said the strain of our marriage caused his heart attack. More deeply wounding, he told Jerry that Berenice would be rolling over in her grave at the thought of having *goyisha*, or non-Jewish, grandchildren.

Most couples, I suspect, have a longer time in which to become a unit, to feel secure in each other and distinct from families of origin. That's the natural process of becoming a couple, at least as I understood it. My loyalty began visibly to shift to Jerry almost as soon as we became serious about being together. I listened to him instead of to Margaret when she erupted in a tirade. We made no pretense of wanting to move back to New Jersey to look for work, or to Boston either. We never even discussed with either Margaret or Max what we would do in terms of religious identity for children, either to ask their advice or to offer reassurance. We had no room for either to visit in our small apartment, nor did we make an offer of finding a nearby hotel in which they could stay for a weekend.

That process of focusing away from Max and Margaret might have continued slowly and gradually, in a way that gave everyone time to adapt. Then Max wrote his bombshell letter, which triggered every protective instinct in my body. I told Jerry I'd respond. I wrote that, as a

physician, Max knew perfectly well that his heart attack was a function of cardiovascular disease, not our marriage. I said Jerry loved his mother dearly, and I was sure she loved him as well, and that I trusted she'd have loved Jerry's children every bit as much as she loved her other grandchildren. To say otherwise was unkind to us and unworthy of Berenice.

Jerry's eyes widened when he read my draft, but he didn't ask for any changes. I cleaned up the handwritten letter, stuck it in an envelope with a stamp, and sent it off. Max never responded to either of us directly, but neither did he send Jerry such harsh accusations again. Slowly, over many years, Max and I reached at least a neutral accord despite our contentious beginning. Jerry and I were able to visit him in Boston and go out to dinner or a show and have a reasonably nice evening. Once we even arrived as a complete surprise on the weekend of his birthday, bearing his favorite kind of home-baked cake.

By the time we married, Jerry was no longer a practicing Jew, although he identified with Judaism culturally and would have responded "Jewish" if you asked him to identify his religion. But he was never open about that with Max. Max's suspicion that I was the reason Jerry moved away from an active Jewish life lingered in the air for a long time. At one point Max wanted to buy us a menorah, a sacred candelabrum used to hold the Hanukkah candles. I thought the piece was gorgeous as a work of art and told Jerry I'd be happy for us to have it in our home. His face froze, and he said he didn't want it. I told him he'd have to call his father and decline the offer, with whatever explanation he could manage. I have no idea what he said, but the menorah never arrived.

Max and I reached a sliver of common ground with the birthday cake and nice evenings out like the ones he once shared with Berenice, and finally with a trip to Israel. Jerry and I couldn't afford an expensive two week hotel stay and airfare at that point in our lives. Max could and offered to take us because he wanted to go but not alone. He gave me the task of making all the arrangements. I picked a tour advertised in the New York Times, and it was just the right thing: small group traveling in two Mercedes limousines rather than sixty people on a tour bus. Our group

had a highly educated guide, and our days were packed with intriguing things in a part of the world none of us knew firsthand.

I suspect that, as an observant Jewish man, Max had something of a religious experience going to Israel although that was beyond what he'd ever have shared with me. Jerry and his father got to spend uncontentious time together, both looking outward as travelers. I simply loved the Middle East: different light, different cooking smells and spices, different languages and dress and the culture of haggling over what to buy. I sensed the gravity of the place but also delighted in the hokum, as when our tour guide solemnly pointed to the exact rock on which the Angel Gabriel was supposed to have stood when announcing to the young Virgin Mary the impending birth of Jesus. The Israel trip was likely the best time Max and Jerry and I spent together for the entire time we knew each other.

Margaret and Jerry had a harder time reaching neutral ground. Their styles never meshed. He was the consummate planner, she, scattered and impulsive. If she asked him to help her, it would always be five minutes before we were about to leave, or when he was visibly without his tools, or when we'd just announced we had something important to do. If I asked her before a visit to let us know what she might want help with, she'd wave the suggestion away, saying she was too busy and would deal with it when we arrived. She also set everything up as an either-or choice. Once, while Jerry and I were visiting her at the Jersey shore, she and I were out in the yard and Jerry was in the house. She asked me to come with her to the boardwalk, and I said I would but wanted to run inside and tell Jerry we'd be gone for an hour or so. "No," she stormed. "Either come now or not at all." She stalked away. I headed toward the house, aware of her rapidly retreating back. When I came back outside she was far up the block, and I chose not to run after her.

Once Jerry and I were married I spent a lot more time in Margaret's doghouse, literally. In whatever kitchen of whatever place she might be living, she had a little wooden wall hanging of an empty dog house with a tiny gold hook and three little cocker spaniel puppies outside and on gold hooks of their own. The three puppies stood in for us: Linda, Pam, and Wendy. Margaret signaled her displeasure by who got placed in the dog

house. As far as I remember growing up, Wendy was never there. Linda, the most like Margaret in temperament, was often there. I was sometimes until I married Jerry; then I may have surpassed Linda in being relegated to the doghouse. Jerry just rolled his eyes and urged me to ignore it.

I'm not sure Jerry and Margaret ever found a comfort level together, not in the way Max and I did. They could be in the same house and greet each other civilly. Margaret bought him designer monogrammed silk handkerchiefs for Christmas, which he accepted without comment and put in a drawer, never willing to wear someone's initials other than his own. When she asked him for financial advice, he gave it. She cooked pots of stew with fatty beef and frozen vegetables and heavy gravy, which neither he nor I ate.

One holdover from my earlier life with Margaret remained, which both Jerry and my friend Bern helped me resolve. During phone calls, which I still made regularly, Margaret often broke into hurtful tirades about my being an ungrateful and wretched daughter. She also sent excoriating letters to all three of her daughters, which my sisters and I thought of as "the grenades." I'd open the envelope and the paper in my hands would explode in rage while she was too far away to be touched by any collateral damage. If I had Jerry's back with Max's letter, he had mine with Margaret's grenades. He asked me, very simply, why I gave her the opening to make me miserable by reading her letters and listening to her angry phone calls. His observation gave me pause.

Bern, by then a practicing therapist, gave me the tools. Bern suggested that if I opened a letter and saw it was going to be a tirade, that I tear it up and discard the words unread. She said I'd save myself a lot of anguish and churning over how to respond. She also proposed that if Margaret began to erupt on a phone call, that I break in and say it didn't seem like a good time to talk and that I was going to hang up but would call back in a week or so.

I took a deep breath and resolved to try it. The opportunity was not long in coming. When I broke in on Margaret to say I was hanging up, she hissed, "You wouldn't dare."

I did dare, and I hung up more than once over the first few months as Margaret tested my new-found resolve. Finally, as Bern predicted, our phone conversations became more civil and the hand-grenade letters stopped, at least for me if not for my sisters.

The
Doctors
Klainer

Jerry and I settled into building a life together. He accepted a job offer with a small but growing company in Rochester, New York. He worked directly with the firm's president and had a single mandate: figure out problems no one else in the organization knew how to fix. Jerry liked the flexibility of the role and being able to work across marketing and strategy and operations and sales without being tied to any one group. We bought our first home: a very modestly priced two-family in a mixed-race city neighborhood. Rochester, like other urban centers across the country, suffered damaging race riots in the 1960s. Our quadrant of the city, with a strong community association and several large churches whose clergy got out on the streets to help keep the peace, escaped fires or looting. The homes were beautiful, with gum wood trim and wide plank floors and modest prices to reflect the somewhat marginal character of the neighborhood.

We had colorful people all around. A large home across the street housed several of what were then called "ladies of the night." The girls used to sit out on their porch in the late afternoon doing their hair and nails in preparation for the evening's clients, calling out to us cheerfully as Jerry and I arrived home at end of day. When we were robbed and our house trashed not long after moving in, the ladies were the first to show

up to help us set things right, lamenting that because of their late hours on the job they slept through the morning when the thieves most likely broke in.

We also had Blanche, who lived next door with her ailing husband and very glamorous daughter. Blanche called herself the Bionic Woman; she regularly won bonuses at her job soldering computer panels because she was the fastest one on the production line. Her husband was disabled with what she called "ticker trouble." Doctors at nearby Strong Memorial Hospital's cardiac unit, where he was frequently admitted, had great difficulty regulating his blood pressure and other vital signs. Blanche never told them that her husband insisted on having his strict heart-healthy diet supplemented by her homemade pigs feet pickled in brine. One day she came to the fence between our yards to tell me in mournful tones that her son was convicted of using and selling drugs and would be sent to Attica, a rough state prison about fifty miles from Rochester. She looked terribly worried, and I said I was sorry and that I didn't know her son, only her daughter. "That's my son," she replied. A black cross-dressing drug user wasn't likely to have an easy time in prison. My heart went out to this neighborly, hard-working woman bedeviled by her fragile men.

I liked that we all had front porches and backyards, which called us to be outside and part of the vitality of the neighborhood. Much of my early life, especially after my father died, seemed to focus inward, trying to make Margaret's instability invisible to public view. Then there was the austere and bleached College of St. Elizabeth, where any drama that might have happened among the nuns took place in the Motherhouse, away from student eyes. In sharp contrast was the village of Rio Hato, where life tumbled out onto the dirt roads and everyone knew the local gossip. Then there was Washington, D.C., and the artificiality of academia. Now there was the strikingly diverse Melrose Street and the city of Rochester and the chance to become part of a new home town. I also got to try out new roles, as a newly married women with a kitchen of my own.

Our two-family had a good-sized yard for a city lot, and in the back corner grew an ancient peach tree, gnarled and bent. During our first

August the tree produced a huge crop of luscious peaches, and I bought a cookbook and took my first crack at making a pie. The tree was so prolific in producing fruit that we kept Blanche and the ladies and all the rest of the neighbors supplied and still had peaches to cut up and freeze for the long winter months. We laughed about being urban farmers with a single tree so laden that we could hardly keep up with the crop.

We had our home, and Jerry had a job from the moment we moved to Rochester. Finding my job took longer. I read the Want Ads and went on interview after interview. Finally I found work as a mental health technician with the Rochester City School District, where I assisted the school psychologist and social worker with mandated state testing for kids in special education. I was assigned to a large high school in the Northeast quadrant of the city, one that filled an entire block and had a long halls lined with metal lockers. Racial tensions frequently sent kids flooding out of their classrooms to run down the unobstructed hallways pounding those metal lockers and chanting their demands. Sometimes the pounding and screaming and thundering feet turned explicitly menacing, as the kids began bellowing the name of a teacher who'd done something to upset them. That teacher huddled in terror behind a classroom door that didn't lock, and soon enough we heard the sound of police sirens. Officers burst through the wide front doors of the school, batons drawn. Some raced to find the threatened teacher and escort her out of the building, while others tried to subdue the kids without cracking too many heads or making an undue number of arrests.

The social worker to whom I was assigned was beloved by the students, and at the first sign of trouble she ran into the corridor, arms extended, trying to slow the marauding teens down. No one ever touched her, a stocky older white woman in a sea of angry black and Latino faces. They simply parted when they saw her and ran right by. I remained cowering in our office doorway, in awe of her courage and frightened by the rampaging kids.

Most of the students remained strangers to me. I only got to know the ones with mental health referrals. As with most roles I've taken on, I was quickly given more responsibility than the job description entailed.

I did the required testing, allowing the mental health office to file timely reports with the state. But I also began making home visits, at the request of the social worker and school psychologist, to gather data on the impossibly long list of students formally referred to our office. What I found often shocked me. One young teen, written up by her teachers for being constantly drowsy in class and doing no work at all, was being pimped out by her father when one of his girls didn't show up for work. Another was trying to care for small siblings in a house with no heat in the frigid Rochester winter while her mother lay dying of kidney disease on a dirty mattress and her father, a brain injured veteran with a visible metal plate on the back of his head, wandered blankly around the house.

I hung on to my Peace Corps mantra: find something useful to do, change the likely outcome to something at least marginally better.

I made many new friends but missed Minga terribly. Jerry and I talked occasionally about visiting her in those early years, although he wasn't keen on a trip to Panama. He didn't really like travel, with all the attendant uncertainty. He liked arranging his life in predictable time blocks and eating food that was familiar and sleeping in our bed with his favorite pillow. When I did go so far as to check on conditions in Panama, the report was never favorable. One time there was an outbreak of malaria, another time yellow fever. Several episodes of political unrest made the drive down the Pan American Highway unsafe. There was still no place to stay in the village, only in the city. After trying to call several times I gave up trying to get in touch with Minga, to ask if she was able to receive us. The whole idea sounded too up in the air for Jerry, and the contemplated trip never happened.

After awhile I imagined Minga moving on with her life, remembering our friendship with fondness but not really expecting me to come back despite my promise to her as I was leaving. I suppose I came to that conclusion because I wanted to move on, to let go of my guilty image of her standing beside the road waiting for me.

I left the mental health office for a better-paid job with a suburban school district, setting up a school-based program for elementary age children with learning disabilities. The diagnostic category was new; I was

mostly referred the twenty kids out of several hundred that teachers felt were hardest to contain in a regular classroom.

The children referred to me were hard to teach. Some appeared to have mild neurological problems. Some were hyperactive. Some were what we used to call culturally deprived: they lacked the middle class habits on which success in public schools was largely based. Some were dangerous. One second grader was sent to me because he attempted to use the paper cutter in the art room to whack off another child's hand.

I had years of experience managing Margaret's rages. The same skill in a different setting made me good at providing external structure for these kids who couldn't find it within. My students and their families loved me, and I grew to love them. Each child referred to me, even the kindergartners, came with folders several inches thick with diagnostic reports, testing, and multiple long statements from various professionals detailing the child's deficits. I quickly concluded that if I went by the information in the file, we'd get nowhere. These kids walked into the building looking pretty much like any other kid. If they had problems that kept them from learning in a conventional classroom, they'd have to learn to work around them.

I created the concept of a "lifeboat experience," which I worked hard to sell to the classroom teachers and the kids' families. Instead of reciting to me all the ways the child was a failure in the classroom or at home or in Scouts or at summer camp, I challenged parents and teachers to find one thing the child could do. That was where we would start, and that's what we would build on.

One boy who did math by counting on his knuckles, had unintelligible handwriting, couldn't spell anything other than his own short name, and was so clumsy he regularly stumbled down the building's stairs and even failed gym, became fascinated by volcanoes. He built one. With the help of his father, who worked for Kodak as a chemist, the boy concocted a solution that, when ignited, showered the classroom with smoke and sparks without setting the place on fire. He read all about volcanoes, and with his capacious memory he remembered enough to present a detailed verbal report on volcano behavior. He was so good I got

him a spot in the full-school assembly, where he again did his magic in a darkened auditorium with a successful simulation of an erupting volcano. His fellow students cheered. His parents came and sat in the back of the auditorium and were proud.

Every kid got going in one way or another, but there were no miracle transformations. One boy, after leaving our elementary school and entering middle school, committed suicide. There were several divorces between parents of my students. Having the kid who got sent to the principal's office, was thrown out of Sunday school and rejected from summer camp and not invited to birthday parties was too much of a strain on marriage and family life.

There were no transformations in teacher attitudes either. Like removing a burr under the saddle, I took the twenty most irritating and failure-prone kids away from the regular flow in the elementary school day. As long as I kept these previously disruptive and bothersome kids in my area of the building nobody, including the principal, cared much if they learned anything. My students were no longer counted on the school's achievement measures because they were categorized and counted under special education. They weren't pulling down the school's overall test scores, so attention and resources went elsewhere. Everybody told me I was doing a great job, and please God don't declare the kids cured and send them back to the classrooms from which they came.

I thought people in the building should care. As a new teacher I didn't have the power to get my more senior colleagues more engaged, but I thought better leadership could have found a way to keep faculty invested in the success of my kids. After three years, that feeling only grew and pointed me to a new calling. I resolved to earn a doctorate in education and human development, become a school administrator, and find ways to make even the outliers among a school's population count.

I applied to the University of Rochester, was accepted, and resigned from the school district to begin the program. Less than a year later, I became pregnant. That prompted talk of Margaret's first visit to us in six years.

Margaret never saw Melrose Street and our first home, although she and I continued to talk by phone. She never knew I'd learned to make pies or plant flowers. She never met Blanche or the ladies. She missed the rioting high school kids and my elementary school outcasts. My life became more interesting to her only when Jerry and I were about to have a child.

Well before the due date, Jerry and I picked out names for a boy and a girl. Margaret was convinced throughout the pregnancy that I'd intentionally thwart her by having a boy, even though choosing the sex of the baby was completely beyond my power. She went so far as to buy a blue "Congratulations on your New Baby Boy!" card, just to be ready. When Sara arrived Margaret crossed out "Boy!" with a ballpoint pen and wrote "Girl!" in big block letters with many exclamation points, leaving blobs of ink that smudged across the image of the baby boy's smiling face when she shoved the card into its envelope. She said she wanted to come and meet Sara but didn't have the money for plane fare, so Jerry and I bought the ticket.

I told my friends I wanted Margaret's help with Sara while I was churning through the doctoral program. But the truth was more than that. I wanted Margaret to love my child. I thought Margaret and I didn't succeed as mother and daughter, would never succeed. We were too different and too angry at each other for our differences. But I thought Sara was a miracle, small and beautiful and with her own distinct personality. I imagined, as I stood by Sara's crib at night watching her breathe, that I had a mother standing next to me who'd slide her arm around my waist and say what a beautiful baby Sara was and so strong and determined and that Jerry and I brought into the world the most remarkable child.

When Margaret did come, she said I was starving Sara to death trying to nurse her, and if I had any sense, I'd send Jerry out for bottles and formula and give her granddaughter a proper feeding.

Somehow I still hoped that having a child of my own would give Margaret and me a new way to have a relationship. When Jerry had an obligatory business trip three months after Sara was born and very much

wanted me to join him, I asked Margaret and my sister Wendy to come to Rochester and care for the baby.

Margaret began to make regular trips to see us, and our relationship improved a bit as we were able to concentrate on Sara rather than on each other. Barely two years later Matt arrived. He was a cuddly little ball of contentment who would happily snuggle in with his thumb and his blanket for as long as someone was willing to hold and rock him. Sara was fascinated by her baby brother and he by her. I often put Matt on his back on a blanket on the floor, so he could watch her play. When he began to fuss she went over and rubbed his tummy, gently rolling him back and forth. At first that elicited his smile and then a full-throated chortle. When he began to crawl, and then to toddle, he was never far behind her. She called him Mattie, the first of many affectionate, later teasing, nicknames.

Sara called me Pammie because that's what Jerry called me. When she started nursery school Jerry and I had our first parent-teacher conference, and her teacher observed that Sara seemed to have an imaginary friend named Pammie. I grinned and said that was probably me.

Despite welcoming Margaret's visits, my orderly persona continued to struggle with her chaotic one. Having grown up in a tornado-like welter of dirty dishes, unfolded laundry, unmade beds, scattered magazines and shoes and cast off clothing and piles of unsorted mail, I kept Jerry's and my home as neat as possible with two young children. Margaret was not about neat. At each visit she poured out of the car after our ride back from the airport, trailing her handbag, a big cloth bag with her reading materials and snacks, and a suitcase held together with duct tape and identified with a large red bow around the handle so her bag couldn't be mistaken for another. Within seconds of being inside the door she re-created the physical mess I so detested. Piles of newspapers appeared next to her favorite chair, along with crumpled up articles ripped from magazines that she brought me to read, dripping paper coffee cups and snack wrappers from things she hadn't quite finished consuming on the plane and didn't want to throw out, shoes and warm socks abandoned in a random line from the back door as if she'd taken them off one at a time

and simply left each piece of footwear where it lay. She brought her own desserts. She was perpetually on a diet, having developed heart disease by that time and been told to lose weight, but she couldn't live without frosted coffee cakes and crumb buns. Jerry and I didn't buy those things so she brought them in her carry-on bag, hiding the white bakery boxes with blue writing in my cupboards, often balanced precariously so the boxes fell out as soon as I went to find a dish or a cup, not infrequently hitting me on the head as they crashed to the floor, spilling cake and walnuts and brown sugar in a wide swathe.

Sara and Matt, once they were toddlers, found it all very funny. As I stood in the kitchen with my hands on my hips, glaring at the latest mess and wondering why Margaret couldn't simply acknowledge her love of sweets and leave the boxes on the counter, Matt broke into a conspiratorial grin and announced, "Nanny hiding."

Nana hid food, or tried to. She hid her vials of tranquilizers. She hid her disputes with her siblings, most of whom wanted little to do with her. She hid the fact that the woman we called Aunty El had become her only real friend. Margaret was less successful hiding her antipathy toward Jerry, continuing to make anti-Semitic comments just under her breath. I finally told her in exasperation that if she continued, she couldn't come because this was Jerry's home. Ever the realist, she finally stopped making comments, at least in my hearing.

She made no effort to hide her insistence on having Catholic grandchildren. At the end of one visit, she told me brusquely that she'd baptized each of them with water from the kitchen sink, an "emergency baptism" allowed by the Catholic Church under extreme conditions and to prevent them from going to Limbo if they died in a car accident. She said that no matter what I did or didn't do about their religious education going forward, from the moment she stuck their heads under the faucet they were Catholic and that was that. Jerry just shook his head when I told him and remarked that Catholic beliefs, like original sin and Limbo, were really odd and nothing like Judaism at all. Then he went on his way, refusing to be hooked by Margaret's surprise announcement of his children's emergency conversion.

Many young women, I suspect, feel like a mother from the moment their newborn is placed in their arms. I'm not sure I did. Margaret so filled the space called MOTHER that I'm not sure I imagined any room left over for me. I knew that in Panama a new mother came home for the first month after the birth of her infant, where her mother and aunts cared for her and gently taught her how to care for her baby. I longed in vain for that. Instead, I took my cues from Sara and Matt and from what I remembered of Minga on the porch at night holding and nursing her babies. I remembered rocking Angel as he fell into a deep sleep, and the warmth of his soft toddler skin as his body grew heavy and still. I wanted that feeling for my children, that nurture and stillness and calm, and before Sara was even born Jerry and I went shopping for a rocking chair.

Sara, with all her wiry energy, emerged in toddler-hood as a very different child from the placid Angel. She started on my lap in the rocking chair, with the night light dimmed to its softest setting, cuddled in a blanket and listening to me sing. Within moments, she wriggled out of the blanket, climbed up over my shoulder and down the back of the rocking chair, crawled under the seat and back through my legs. She wandered over to the double-decker bed that replaced her crib, the slightly slippery footpads on her sleeper not keeping her from climbing the ladder to the upper bunk, then sliding down again to the floor where she'd begin to choose what stuffed animals she wanted to take under the covers.

At one point I stopped singing and rocking and frowned as I watched her pick among her toy friends. "Sara, you're supposed to sit in my lap and get sleepy, not wander around the room. I feel silly singing all by myself."

She faced me squarely in her yellow sleeper, little hands on her hips and a fierce glare in her eyes. "No. Mommy sing. Sara climb."

I think I started feeling like a mother when I trusted myself to let Sara be herself. And she always, after her wanderings, came back and let me hug her and tuck her in and kiss her sweet-smelling toddler skin.

By then we had moved to the other side of the city, to a larger house in a better neighborhood with a safer elementary school to which

the kids could eventually walk. I finished the doctoral program. The timing was bad for jobs in education. Schools were closing, and the few administrative openings were temporary, single year engagements. I felt frustrated, thwarted in my desire to lead a school. My realist nature told me I wouldn't be satisfied bouncing from one time-limited contract to another. I wanted to be in place long enough to get teachers to care about kids who seemingly couldn't learn, and I was sure that was more than a one-year project.

Jerry's job suddenly imploded, his boss ousted by a subordinate who maneuvered behind the scenes and won the trust of the board. Jerry was purposely oblivious to office politics, in which he had little interest, and didn't see the coup coming. By default he became right-hand man to the new guy, but the job was destined not to last. Jerry was offered the option of leaving the company with a small separation bonus, or being transferred to the wilderness of the company's plant in Flint, Michigan. He chose to leave.

We had a relatively new house with a larger mortgage, a relatively young family, and two very uncertain paychecks. After growing up in the larger urban environment of Boston, Jerry liked Rochester's small-town feel and wanted to stay. Rather than trying to find another corporate job, he decided to become a stockbroker. He always loved financial markets and was attracted to the idea that his job security would depend on his own performance, not the political whims of a boss. After a relatively short stint with a national brokerage firm, Jerry had the idea—novel at the time—that he should be paid for his financial advice, not for the act of buying or selling stocks and bonds and mutual funds. The old-line firm for whom he worked had no interest in a fee-based model, so Jerry began to think about going out on his own. By then I'd given up on the idea of getting an administrative job in education. I still wanted to organize and run something. Jerry proposed that we go into business together. He'd do the investment research, develop strategy, and bring in business. I'd hire employees, market the firm, and cope with the mountain of regulatory compliance that comes with the investment advisory business. We'd both meet with clients.

Jerry's idea was a big shift for me. I had to give up on wanting to change the school experience for marginalized kids. And I was unsure what it would be like for Jerry and me to work together. If the transition from home to work and back again was smooth and both our marriage and the business prospered, it would be great. If not, we were going all-in, and failure might happen on both fronts.

Jerry always trusted life more than I did. He wasn't ever-vigilant, living as if our lives were about to implode at any minute. For him marriage was forever, and we talked about business all the time anyway. He didn't see any reason why our working together would be other than great. I decided to trust in Jerry's trust, and we set about starting a business.

Despite my earlier failure at Georgetown I'm good at school and can whiz through requirements when I want to. I began to tackle the licenses and designations expected for my role in our new venture. In about eighteen months, I was a Registered Securities Principal and a Certified Financial Planner, and we were up and running as a fee-based financial planning firm.

Working together was great, probably because we each loved different parts of the business. Jerry was consumed by investments, market moves, and the tax system. He read a thick volume on the tax code every night in bed, while I read P.D. James mysteries. I liked the organizing parts of the business as much as I suspected I would. I also became utterly fascinated by the power of money and what people thought money would do for them.

Becoming
an Author

Jerry thought about our financial planning business in terms of numbers. I thought about our business in terms of stories with money as the theme. Asking a client to talk about that side of money wasn't hard; I simply asked. The story, along with my calculator and research reports and a yellow legal pad, became an essential part of all my client meetings. I was, at that early stage of our business, entirely focused on other people's stories, not my own.

A story that sticks with me to this day came from a young executive who traveled almost three hundred days a year and when home worked fourteen to sixteen hours. He spent almost no time with his wife and small children. He was, he admitted grudgingly when I asked if his wife would be joining any of our meetings, on the verge of a divorce. His hands tightened on the arms of his chair as he said with an edge of bitterness that she was ungrateful and had no understanding or appreciation for what he was trying to do. Having her in our meetings would be a waste of time.

"What are you trying to do?" I asked, keeping my voice light and non-judgmental.

He looked disbelieving that I too was missing the obvious. "Create

a financial wall big enough that it can't be breached so my family will be safe no matter what happens to me."

I sensed there was more, another layer beyond what he'd just said, so I asked a further question. "Why that, creating such a big financial wall? It seems as if you aren't doing much else in life, just working to pile assets upon assets. Why is that so important?"

He glared at me, and began to take quick and shallow breaths. I waited through what seemed like a very long silence. Then he spoke, gruffly.

"My father died when I was a baby. He came from a very wealthy and prominent family. He fell in love with my mother in college and married her, even though my grandparents thought she was beneath him and that he could have done better. She always knew that, and my grandparents' rejection of her never softened. When my father died he had very little money under his own control and barely provided for her. My grandparents bought expensive things for me and sent me to private school, but she always struggled to pay the bills. When I was old enough, my mother would get me to ask my grandfather for money. I hated it, hated that she had to beg. I hated that my grandfather made her beg. I don't want my wife and children to have to ask anyone for anything, ever."

I asked if I could offer an observation, and he nodded curtly. "You and your children have a common experience. You had no experience of a father because yours died too young. Your children have very little fathering because you're rarely home. Is that really your most important goal in life?"

He sat for some minutes in silence then said he would like to cut our meeting short. He wanted to go home and think about our conversation.

Not all of the stories were so emotionally charged. One client, whom I liked a lot despite his slightly shady side, told me I was as political and devious as he was underneath my good girl exterior, and that's why he liked me. He asked if I could help him figure out how to ditch his business partner without having to settle any money on the guy. Laughing, I said I probably could but I wouldn't. He'd have to find someone else to figure that one out. He grinned and said enlisting my

help was at least worth a try and stayed a client with the understanding that our focus remain on his more above-board efforts.

As I listened to client stories, I was moved to start picking away at my own. I was deeply affected, perhaps because it happened when I was so young, by my parents' fear of losing our house because of the expenses that piled up during Barbara's short life and her death. Everything I gleaned at that time was indirect; they never sat down and talked with Linda and me about what was happening. As a result most of what got imprinted in memory was feeling not fact, and the feeling was overwhelming anxiety. Later, after my father's death, Margaret's weeping and flailing over the bills reinforced my fear that we were on the verge of being turned out onto the street. Looking back with more sober eyes, I think we were never in real danger. We always lived in a decent place, even though we went from a single-family to a two-family with rental income and then to a series of apartments. I had new clothes, not things from Goodwill or the consignment shop. We belonged to the YMCA, and I had swimming lessons. Wendy went to camp. Linda stayed in college. But again, there was no conversation. Fear and anxiety migrated wordlessly from Margaret to me.

My money story wasn't only about Margaret's troubled feelings. All on my own, I had a sneaky covetous side, which emerged when I was in grade school. We lived a short walking distance from Roosevelt School, and since all the students went home for lunch I came and went four times a day. Sid's Luncheonette and Soda Shop was on Kearny Avenue, about two blocks from school. From his place behind the counter, Sid dispensed ice cream sodas and thin greasy hamburgers on buns and grilled cheese on white bread. Sid also sold toys, cigarettes, newspapers, notions, and school supplies like notebooks and pens. In the front window Sid had a cardboard box containing red plastic stagecoach pulled by two grey horses. The horses had brown rubber harnesses that looked like you could take them on and off. There was a removable strongbox under the raised driver's seat, and a plastic rifle.

I coveted the stagecoach. I had my own cowboys and Indians, a complete set. I needed the stagecoach to expand my imaginary games. I

looked at it with increasing longing as I went back and forth every day. The tag on the box said twelve dollars. I knew Margaret would never spend twelve dollars on a toy. I got no allowance and we weren't paid for helping around the house, so I had no way to save up.

My father got paid from his job as a supervisor at Dupont every two weeks. Either he got his salary in cash or he cashed his check at the bank, but he came home with a folded-over wad of twenty dollar bills. He gave the money to my mother, who divided it into long tan envelopes affixed to her budgeting book: so much for the mortgage and gas and electric, so much for the milkman and the paperboy, so much for clothes and haircuts and new shoes, so much for going to the Lincoln Theater on Saturday afternoons and buying popcorn. The mortgage envelope was thickest with twenties. The movies envelope was thin: we got in for a quarter, and popcorn was ten cents. My sister Linda and I could both go for under a dollar, and Wendy was still too young to come along.

I decided to steal the money from the budgeting book. I knew if I took twelve dollars all at once, or took too much from one envelope, Margaret would know. But I also knew how disorganized she was, and I figured that if I took a dollar here and there over time, she'd assume she simply miscounted when my father handed her the cash and she parceled it out.

My plan worked, and in not too many weeks I went to Sid with twelve dollars and asked for the stage coach. He took the box out of the window and dusted it off; clearly the toy was on offer for a long time.

I walked home with the stagecoach under my arm, feeling ecstatic. I felt not one whit of guilt, despite the Catholic upbringing that took us to confession once a month. I didn't see that the disembodied priestly voice who slid back the opaque window and listened to my sins had anything to do with my stagecoach. I didn't think I was doing anything very wrong although I took the money in secret and knew Margaret would be angry if she found me out.

She looked suspicious when I walked into the kitchen with the large box from Sid's. "Where did you get that?"

"I bought it."

Her eyebrows rose skeptically and she put her arms on her hips. "With what money?"

I was prepared for the question. "My teacher said she would pay me for clapping the erasers every afternoon. I saved up."

My response was a lie, indeed a preposterous lie.

Margaret simply said, "Hmfff...," and turned back to what she was doing. I don't remember my father expressing any surprise at the new toy at all.

I should say I grew to feel guilty after a while, that I felt remorse, but I never did. I might have found the toy less satisfying once I actually had it in hand, but I can't say that either. I loved the stagecoach and played with it for hours and hours. I might have acknowledged having committed a mortal sin. In my weekly memorization of the Baltimore Catechism I came to know the seven deadly sins by heart: pride, covetousness, lust, anger, gluttony, envy, and sloth. Stealing money from your mother's budgeting envelope for a coveted toy certainly counted. But I didn't feel sinful. I wanted the stagecoach. I figured out the only way I knew to get it. And once I had it, my solitary games of cowboys and Indians after school took on a whole new level of dramatic creation. I loved that red stagecoach and can visualize it to this day.

I didn't grow up to be a petty thief or a con artist. I pay my taxes on time, honor parking tickets on the rare occasions I get them, and tell cashiers when they calculate incorrectly and give me too much change. I work hard to speak and write the truth. But somewhere in the mix of the moral person I hope I've become there is the matter of the stagecoach for which I've never felt a moment of misgiving.

Of course Margaret had a story too. I learned it when I was older and out of the house and I thought to ask. Her father, Philip Halpin, was an inventor who owned an elevator company in New York that rivaled the better known Otis Elevator. Philip drank and was abusive at home, beating the Halpin boys with his fists and a belt when he arrived in a drunken stupor. Margaret adored her father and insisted always that he never hit her or her mother or any of her sisters, but I'm not so sure. My

very proper Aunt Ann, the eldest, told me once that when Philip died she wanted to wear red to the funeral and piss on his grave.

Philip lost the business during the Depression, not really because of the Depression but because of his drinking. He was rousted out of the clubs and bars in New York and came home to Kearny where my grandmother let him sleep in a back bedroom and later cared for him while he died painfully from colon cancer. In the meantime my grandmother, no more than a high school graduate and a homemaker with ten children under her roof, had to figure out how to keep everyone fed and clothed. The family went from having a car and a house at the lake and a radio to accepting donated food baskets, a source of deep public shame. Margaret left high school at sixteen to go to work and help make ends meet, as did her older siblings. Her sisters Ann and Gert, at least before the crash, wore fine wool winter coats with real fur trim. After, Margaret wore hand-me-downs and badly scuffed shoes that didn't fit.

Philip Halpin let her down, and so did my father by dying too young, before they could save a lot and before company pensions went to surviving spouses. She often told me that if her life had worked out she'd never have gone back into the job market. Even as she progressed in her career from entry-level file clerk to executive assistant to an important lawyer, she kept reminding me she shouldn't have had to work. That was the crux of her money story, the sense that life let her down and that other people got nicer things than she ever would, and in that way life wasn't fair.

I'm sure my father had a money story too, but he died before I could ask him about it. At fourteen I still didn't fully know him as a person, with a separate story from mine. I have a picture of Wendell York when he was about a young teen, barefoot on the farm collecting eggs. He's wearing bib overalls and looks miserable. The farm looks dirt poor and so does he. I also have an auction notice that my Aunt Edna found in a pie cupboard and made copies of for all the cousins. Newton Elbert York's farm was auctioned off for pennies on the dollar in the early 1940s, which means my grandfather went bust during or right after the Depression. There has to be a story there, but it died with my father.

The idea of pulling these stories together into a book didn't originate with me. But as I built my reputation in the financial planning world I was invited to speak at conferences and featured in trendy magazines like Fast Company and Money. Literary agents began contacting me, saying they thought I had the makings of a publishable book. I loved the idea of becoming an author. I picked an agent, settled in to write, and Jerry stayed nose to the grindstone growing the business while I sent off chapter after chapter. *How Much is Enough?* came out in 2002 in an era when New York publishing houses still paid six-figure advances and sent promising new authors on a book tour.

In the meantime Margaret's financial situation began to grow more dire. She'd been living for many years on a secretary's salary, and even executive secretaries didn't get paid very well. My father's insurance money was entirely gone. She often called me to complain about not having enough to make ends meet. Jerry was accustomed to helping older family members financially. We decided to help her and went to the effort of not making the money we sent feel like a handout. Jerry set up an investment that paid her a monthly check, just like a pension. The check came from the mutual fund company, not from us.

Her resentment spilled out anyway. Before I understood that her constant moves were in response to some inner urge and not related to having a safe place to stay, Jerry and I bought a two-family house at the Jersey shore and installed her on the first floor at a modest rent. She wanted some improvements, and I told her honestly we'd have to wait until our cash flow allowed. She went ahead and then presented us with the bills, demanding immediate payment before her next credit card bill was due. She often bought things and then insisted that I pay for them, saying that without my help her credit rating would be ruined and I could afford it anyway so what was the big deal.

Finally, after several seasons of visiting her sister in a trailer in Florida, Margaret put a few hundred dollars down and signed a purchase agreement for a trailer of her own. The contract required almost fifty percent in cash, and Margaret called from Florida and said if I didn't send her ten thousand dollars immediately she'd lose everything because she'd

already signed. I refused, and she angrily hung up the phone and then tagged my sister Wendy for the money.

Margaret was right that Jerry and I could afford to help her. Our business was thriving, and we chose a middle class lifestyle that allowed us to save a lot. Jerry was naturally frugal, although he'd grown up in a home with far more financial security than I. I was frugal too. I didn't want to spend a lot of money because I was never sure money would stay around.

Margaret's money trajectory and mine were destined to clash, and they did in a way that felt abrupt and unkind, even to me. Margaret retired in her early 60s. Without the structure of work, her always disorganized life spiraled into an almost frenetic series of moves, often spurred by an argument with the landlord. Her longtime love relationship ended, she said by her initiative, when her lover refused yet again to give her money. Her best friend Aunty El, the woman she talked with on the phone every day since high school, suddenly died. My sister Wendy, moving rapidly up the ladder of a corporate career, moved to another state.

When Margaret came to visit us in Rochester her clothing was stained and often rumpled, smelling as if it hadn't been washed for a long time, and the bright red lipstick she favored was suddenly applied crookedly. She plucked out her eyebrows and drew them back in with jet black eyeliner, giving her a startling appearance. With the kids old enough not to need her supervision, she fell back into focusing on me, often picking fights over simple things. One time she arrived for ten days and demanded suddenly on the third day that I change her flight and let her go home because she clearly wasn't wanted.

The breaking point for me came when she called from New Jersey in the dead of winter. She was living for very cheap rent in an uninsulated, barely heated summer bungalow, and she said she was freezing, only able to keep warm sitting wrapped in a blanket near the oven with the door open belching heat into the kitchen. She said she didn't know what to do and was afraid of dying of carbon monoxide poisoning.

I told her she was going to call the assisted living place not far from where she was living and see if they had an apartment she could rent.

She'd long resisted what she called the "slippery slope to a nursing home." If they had space, I said, I was going to pay the deposit and the first month's rent and she was going to move in and stay there or Jerry and I were going to stop our financial support and never give her another cent. I said she had three choices: move into a nice place and have a view of the ocean, stay where she was and freeze, leave and live on the street. I was clear and emphatic that I was only going to support the first of those choices.

Demanding that Margaret move to assisted living and stay there was likely the right thing, but it wasn't kind. A more loving daughter, a good daughter, might have understood Margaret's fears of moving into what was likely to be her final residence. I could have phrased the choice more gently than telling her she could move into assisted living or freeze to death. I could have said Jerry and I wanted to keep helping her financially, but it had to be about living in a safe place, not in an unheated house with danger of carbon monoxide poisoning. I could have said I loved her and wanted good things for her in her old age and that it pained me to think of her sitting cold and alone and scared. I could have come up with the words she always wanted to hear: that I was grateful for all she did for us as a single mother and wanted to give back what I could now that she needed me.

But I couldn't manage any of those kinder, gentler words.

Margaret protested, sputtering with rage that I presumed to interfere in her life and throw my financial weight around. The latter, she told me, was a most unattractive trait. She whined, saying nothing ever worked out in her life. She insisted that Jerry and I could make room for her in our home, as she and my father had always promised my grandmother they would do for her. Margaret was shocked, shocked, she told me, that I could turn her away. No one she knew had such an ungrateful daughter. She knew it was because of Jerry, who never liked her, and how could she be so unlucky in her sons-in-law.

"We'd kill each other, Mom. I'm sorry. I'll always see that there's a roof over your head, but it isn't going to be here. And not because of Jerry. Because of me."

Margaret raged about my insensitivity and finally slammed the phone down. But shortly thereafter she made the call and signed a lease for the third floor one bedroom apartment facing the ocean. With a rent subsidy for which she was eligible—she hid evidence of the money Jerry and I sent her every month—she was able to afford the basic expenses. She called a few days later and told me coldly how much she needed to pay for the move, and I said I'd send her a check.

She lived there for about the last fifteen years of her life, only moving out, and then back in, once. Her time in the building wasn't smooth. She argued often with the building management, and they refused to provide her with the cleaning service that came with the monthly rent because she complained so mightily about every housekeeper they sent. They said she'd have to get service on her own, and my sister Linda called around to various agencies and arranged it. Margaret refused to go to the dining room for a hot meal at midday, saying she hated the food. I think she hated walking into a large room with tables for four and not being sure anyone would ask her to sit down. She ordered take-out food a lot, her favorite being deep fried eggplant Parmesan with thick oily tomato sauce and extra cheese. She told me the dish comported with her doctor's demand that she follow a low-fat diet because, after all, eggplant was a vegetable and the cheese gave her a little dairy.

She made a few friends, with whom she went to the first floor common room most days to play bridge. The elderly ladies loved Margaret's feistiness and her willingness to mount an argument with the resident manager over complaints large and small. Margaret became their standard bearer. She began to exercise more. The building had long, straight hallways, and, when her doctor told her she simply had to start exercising or she'd become too feeble to move, she started to walk every day up and down the corridors. She joined something called the "croak patrol." Each resident had a tab on his or her mailbox that was supposed to be flipped over when the resident came to collect mail. That showed management that the resident was alive and well and in the lobby from one day to the next. If twenty-four hours passed with no sighting, the croak patrol was sent to check. When Margaret told me about her patrol

duties, I asked if she minded walking in on dead bodies. She said she did not as long as the dead body wasn't hers.

Once, many years later, she said that making her move into the place wasn't the worst thing in the world. She didn't say she was sorry for screaming at me when she called, freezing, from the unheated bungalow. I don't remember her ever saying she was sorry for anything, not in all the ninety-two years of her life. She didn't say she liked the new place, or her new friends whom she never invited to her apartment and only saw downstairs. She didn't say she enjoyed being able to see the ocean from her front window although she always took me to look when I came to visit. But she did say the move was probably the right thing, which was as close as she ever came to an apology.

For me, Margaret's move into assisted living opened up what was probably the easiest chapter in our entire adult relationship. Without the constant moves to soak up her time and energy, she found new pursuits. She became a regular contributor to Letters to the Editor columns in the local newspaper, and she was thrilled to see her name in print. I kept her supplied with nice writing paper, envelopes, and stamps. Her building was on the boardwalk, and she wanted an adult tricycle to travel up and down and get some exercise. My sisters and I pitched in to buy one for her. She and her friends went out to early dinner and got the senior citizen special. Sometimes they went to play bingo, and she was lucky and won a few bucks. The activities director in the building planned bus trips to the casinos in Atlantic City, and Margaret signed up and learned to gamble.

With Margaret more content than she'd perhaps ever been, the kids graduating from college, and our business as solid as any small entrepreneurial venture is apt to be, Jerry and I were free to rediscover our lives as a couple. Whoever came home first started dinner, and then we shared a glass of wine as the meal cooked. We talked about each other, and our life together, and what we hoped Sara and Matt would do with their futures. We talked about the more interesting clients at work, like the elderly Jewish man who'd made his way out of Germany ahead of Hitler with rolled up artwork and jewelry hidden among his possessions. At every appointment he grabbed Jerry's arm and reminded to have

something valuable put aside, something you could get to quickly and carry away. Jerry didn't live every day with that kind of fear, but he was sobered by his client's inability to leave early trauma behind.

Jerry and I took long bike rides on the weekends, and he came up with the idea of joining a group for a coast-to-coast bike ride to celebrate turning sixty. He didn't ask me to join. He was much the stronger rider, and wanted to test himself without having to worry about my lagging behind or needing help changing a tire. Planning for the trip, he became lighthearted like a kid going off to his first camping experience. Small packages began to arrive daily in the mail: a super lightweight rain jacket, extra spokes, a variety of protein gels and bars. He ordered a new bike, custom fitted with the best components. He began to train daily, going out after supper for an hour or two before dark to pedal as hard and as fast as he could. He lost weight and was in great physical shape. I teased him about his sexy washboard abs.

I initially felt left out, so intense was his new focus, and I was hurt that he hadn't invited me on the trip. I wondered about our being apart for almost the whole summer, the longest time we'd each be on our own since getting married. We talked over a glass of wine, and he pleaded with me to understand this as something he needed to do for himself. I did understand, and finally I joined in his excitement. I grew busy with the book tour and with new consulting opportunities apart from our financial planning business. Two audiences in particular were interested in the intersections between money, success, and happiness: entrepreneurs, and Protestant stewardship groups. I began to get invitations to speak at church conferences or to work in the for-profit sector with entrepreneurial leadership teams.

One mid-April day Jerry and I had a quick lunch at our favorite Japanese restaurant, just before my trip to fulfill a consulting engagement in Wisconsin. We kissed in the parking lot of our building, and I said I'd call him on my cell phone that night when I arrived. He smiled and told me to do my usual great job and said he planned to really push his training schedule while I was gone.

The
Remaining
Dr. Klainer

At 6 am on April 17, 2002 Jerry arrived at the gym and completed his endurance spinning class. His young trainers called him Jeremy; he was always Jerry to me, to our family, friends, and co-workers.

Later that morning Sara took a quick break from work to call her father from Boston about a possible error in her tax return.

America by Bicycle mailed the updated list of forty-one riders who would depart from Astoria, Oregon and ride three thousand six hundred and twenty-seven miles to Portsmouth, New Hampshire through the heat of summer. Jeremy K., Rochester, New York, was number twenty-four.

Matt called after supper and talked with his Dad about girls, work, and the Red Sox.

On the morning of April 18, Dr. Jeremy A. Klainer, President of Professional Planning Associates Inc., uncharacteristically missed his morning appointments. Staff calls trying to track him down at home went to the answering machine: Jerry didn't pick up. His concerned staff left a carefully worded message on my cell phone.

At 3 pm I arrived home from the consulting trip. Even with the cell phone call, I missed obvious signs: the empty garbage can still by the curb, the morning paper untouched at the front door.

I found Jerry on the floor in our bedroom. His body was cold, his skin a dusky red where gravity had caused the blood to pool, and one side of his face distorted where flesh had pressed for hours against the hard floor.

Over the next hour—in deep shock but somehow knowing what I needed to do—I called 911, then two people I wanted with me, then the kids in distant cities, and then the office. Cars pulled up in front of our home: the police, an ambulance crew, and the medical examiner's staff. My younger sister Wendy called from New Jersey about something else, and I cut short her question to say that Jerry was dead. I called Jerry's brother in Maine. Word began to go out to both sides of the family. Neighbors, seeing the commotion and emergency personnel not moving quickly, gathered across the street. A friend in Rochester heard via a call from her daughter in Boston who knew someone in Matt's office near Harvard Square. From that one point, the news spread to our circle of friends, and those closest to us simply walked through the door.

The staff called late afternoon clients and said that due to an unforeseen event—the word "dead" was too sudden and too hard for anyone but me to hear or say—Jerry's financial planning appointments needed to be rescheduled. The firm's Director of Operations arbitrarily postponed by three weeks his upcoming negotiation with Midwestern real estate developers, as if the mere act of setting a future date would signal a return to normalcy.

The process of losing Jerry began.

When a death is both sudden and unattended, the police do not assume natural causes. The first to arrive in response to my 911 call were two very young officers, probably because their patrol car was closest to our home. More police quickly arrived, including someone with a lot of stars on his cap and braids on his uniform. The officers who stayed with me were respectful but firm in their barrage of questions, as others on their team moved about the house. Where had I been for the last few hours, when Jerry probably died? Had I come directly from the airport? What had been the destination of my business trip? Is there any chance I could have come home last night, instead of being in a hotel room in the

Midwest? Would my airline ticket and hotel receipts confirm where I said I had been, and when? Was there anything about the house when I first entered that seemed unusual or displaced or out of order?

I wondered if they meant the unusual silence that attends when a loved one is there but no longer living. I wondered if they knew that everything in our home, even the most familiar sights like Jerry's neatly stacked piles of market research and business journals, suddenly seemed disrupted and out of order.

The ambulance crew waited, just in case I was wrong about Jerry needing resuscitation. They stayed outside, ready to come in or be dismissed. The 911 operator asked if I wanted the crew to attempt to restart Jerry's heart, and I said she didn't understand, that Jerry was really dead. She answered by saying that I needed to say precisely whether I wanted resuscitation or not. She reminded me that for legal purposes, my words were being recorded. I took a deep, strangled breath and said no, I wanted no efforts to revive my husband's cold and rigid body.

The medical examiner's team asked me to remain downstairs while they went up to our bedroom to do a preliminary assessment. I felt a sudden surge of protectiveness for Jerry, lying alone and vulnerable to their strange hands. He suddenly became "the body," something to be spoken of in clinical, impersonal terms and without a name. Within moments people were moving overhead in our bedroom, our most intimate space, strangers with cases of equipment and heavy feet.

Friends began to arrive, and someone made me a huge mug of strong, hot tea with spoons of sugar—good, she said, for a person in shock. The April day was unseasonably warm, but I was chilled to the bone. Shivering, I held the cup between my hands and drank the tea. I always drank tea plain, without milk or sugar. But sweetened tea has become attached in my mind with being comforted, and I take my tea with sugar to this day.

As it became clearer that our home was not a crime scene, that Jerry died from natural causes, the tone among the emergency personnel began to shift. I had a sense, even through my shock and disorientation, that they were trying to help me regain control. A young police officer said

113

that trauma counselors were available for situations like this and could be called. Would I like him to do that, or would I prefer to rely on the friends who were slowly arriving and trying to help? A member of the medical examiner's team came downstairs and said they would remove Jerry's gold wedding ring before taking the body. Would I like them to place the ring on his dresser, or would I prefer that they bring it to me? Their gently phrased either-or options required a response and broke through my frozen state. I wanted Jerry's ring in my hand. I asked them to bring it to me, and I held it tightly for the remainder of the afternoon.

I felt another intense surge of protectiveness when the medical examiner's team told me that they would be removing the body, and that perhaps I would like to go into another room rather than stand by the stairs and watch. I began to reach for my things, saying I must go with Jerry, that he couldn't be alone and unable to speak for himself. A friend gently pushed me into a chair and said that I needed to stay, that the kids' flights would be arriving soon, that I needed to try and eat the toast someone had made with my tea, that the medical examiner's office knew what to do in cases like this and would take good care of Jerry.

Jerry came downstairs in a stiff and clumsy black body bag with handles, not on a stretcher. The team who carried him were right to suggest I not watch as they strained to balance on the stairs and make carrying a shifting dead weight look dignified. And I was right in knowing I needed to watch Jerry leave our home for the last time. The men were silent and respectful and averted their eyes from mine as they carried Jerry out the door and laid him in the back of a Chevy Suburban with darkened windows.

Sara and Matt arrived on flights from Boston and New York; friends went to the airport to meet them. I wanted to go, but felt too lightheaded to stand. Immediately after getting my call, Jerry's brother Paul and his wife Jeanne began the six hour trip from Maine. My sister Wendy and her husband George arrived by plane. My sister Linda and her husband Ron offered to drive Margaret and came the next day. Margaret, then in her late eighties, had long since stopped traveling. I fully expected, when she arrived, that she would put Jerry's death in the context of her own life,

and say that now I would finally understand what she had to cope with
all those years as a woman alone. But she didn't. She simply said, with
what seemed like genuine sadness, that she was sorry Jerry died. She went
once to the funeral parlor on the afternoon of the wake, and then was too
exhausted to attend anything else. I could see what the effort cost her and
was moved that she made the effort to come. I think it was the best and
most loving moment of our entire life as mother and daughter.

My sister Linda remembers that when they came into the kitchen
after the long car trip, I wept in my mother's arms. I don't remember that
happening. Instead I remember feeling achingly frozen, with a grief so
deep and penetrating I despaired of ever reaching through to let it out. I
rarely cried later, not even in the office of a skilled therapist. I know that
Margaret, in the remaining years leading up to her death, was unable
to relax her body into the kind of warm and enveloping hug I often felt
Minga give me, the kind of hug you would give someone in great pain
or great joy. Instead, on the rare occasions when Margaret tolerated my
attempts to embrace her, she bent forward from the waist, her shoulders
stiff and bunched, hands at her sides, cheek averted if I tried to kiss her.
I don't remember her ever initiating a hug, not even in the kitchen as
they came into the house from the driveway. But Linda is as sure of her
memory as I am of my doubt. I can never know which story is true. My
memory of their arrival is too deeply muddled, all mixed up with grief
and lack of sleep and ongoing shock. My memory is fixed in a certain way,
never to grow more clear.

The kids and I were faced with deciding how to honor Jerry's life and
complete the process of his death. Our family's deeply secular lifestyle
did not include having a rabbi on call. Years before, when Jerry and I
thought to prepare and sign advance directives, I asked him if he wanted
a rabbi when he died. He thought for a moment and said yes. Curious
at the time, I asked why, since he chose not to do anything at all by
way of Jewish practice. He responded that he didn't know, but if a rabbi
could be found to officiate, he'd like that. I found Jerry on a Thursday
mid-afternoon, and the kids and I began to plan his funeral on Friday
morning, which is the Jewish sabbath. Local rabbis were deep in the

throes of planning for shabbat services, not taking calls from mourning strangers seeking help to bury their non-practicing Jewish dead.

One of the many friends who arrived wanting to do something, anything, to make the terrible time less so, asked if I needed groceries or laundry done or errands run. I remember saying, "No, I need a rabbi."

She nodded and said, "I can do that." She did. She called her own rabbi, a soft-spoken, compassionate woman who met with the kids and me and Jerry's brother Paul and went step-by-step through the ritual of a Jewish burial.

Jewish rites don't include the Irish wake beforehand, but I knew my side of the family would need that for the sudden death to become real. The rabbi graciously agreed that as long as she could preside over a burial done in accord with Jewish tradition, what we did the day before was up to us. I arranged with a local funeral parlor for a wake, and that allowed the kids and me to gather a small table of things that spoke to us of who Jerry was, chief among them his biking jersey and helmet, and the geeky white plastic pocket protector filled with pens he always wore, even with casual shirts, since his days at MIT.

Jerry was a public figure, widely known in the business community, which meant colleagues and competitors came to pay their respects. One of them approached me with an outstretched hand as I stood in front of Jerry's casket, slid his business card into my palm and leaned over to whisper, "If you're selling the business right away would you call me first? I'd like to make an offer."

The wake, and the houseful of people, was a drain on my introverted soul. Upon returning home I retreated to our bedroom, where I sat on the edge of the bed with my arms folded across my waist, rocking back and forth. Matt knocked softly on the door and came in with a small plate of food. One of our neighbors brought a pan of stuffed shells with her homemade Italian sauce. Before the dish was entirely gone, Matt grabbed a serving of the warm pasta and brought it to me. Suddenly starved and in his soothing company, I ate.

We chose the interfaith chapel at the University of Rochester for the memorial service, an architecturally attractive but religiously neutral

space. Jerry's older sister thanked me for not adding to their grief and disorientation by bringing them into a church filled with plaster statues and hanging crucifixes and incense. A friend who was a Presbyterian minister conducted the service, offering to wear robes or not as we preferred. I asked her to wear robes for reasons that escape me even now.

The rabbi came to the funeral parlor on the morning of the burial, ready to escort us and Jerry to the cemetery. Sara and Matt were both pallbearers, helping carry their father to his final resting place.

Part of the graveside ritual in Jewish tradition involves mourners dropping a small shovelful of dirt onto the already lowered casket: first me, then Sara and Matt, then Jerry's siblings, then anyone who wanted to participate. I stood next to Jerry's sister Sheila, arms around each other's waists, as the clumps of earth fell. With each thud Sheila jolted slightly and murmured, "Now it's real, now it's real."

We had a reception for mourners after the burial, which I don't remember at all.

Before returning to their respective cities, Sara and Matt went into the refrigerator, a jumble of partly eaten leftover food, and restored the shelves to the neat and precise order in which Jerry always kept them.

In Jewish tradition a family sits shiva for a full seven days, marking the period of acute mourning and allowing themselves to be cared for by others. The Irish drink Jameson's Whiskey, neat, and a lot of it. Two days after the funeral, out of sheer necessity, I put on my blue business suit and went into the office. Our firm, now my firm, was in free fall.

Jerry generated fully sixty percent of our revenue, and a financial planning firm is a personal service business. That means clients pay fees because of the relationship they feel with a provider whom they decide to trust. Jerry's death was not only a staggering loss for me, but it threw those longstanding client relationships into disarray. I had to act calm, and confident, and assure everyone—employees, clients, colleagues with whom we did business, the real estate developers whose appointment with Jerry had only been postponed—that I had matters in hand and could carry the business forward.

I went to our favorite Japanese restaurant for lunch that first day. Our regular server arrived at the table weeping and with two cups of green tea, one for me and one for Jerry. "Very hot, the way Jerry like it. You drink two cups, one for you, one for Jerry."

Projecting a calm and assured demeanor was hard to sustain. Every client who came in wanted to tell me how much he or she or they respected Jerry, loved him, trusted him. Jerry was the person husbands told wives to seek out if something happened to them. "Jerry Klainer is an honest man. He'll take care of you."

Sometimes clients brought things. One elderly woman pressed a pink knitted square into my hands. "I had to do something for Jerry, and knitting is the only thing I know how to do." Another silk screened Jerry's entire obituary onto an oblong white pillow.

My most immediate business challenge was the four-hundred-pound man, whose name I should remember and don't. One of Jerry's endeavors, beyond working with financial planning clients, was to serve as general partner for small, rural subsidized housing projects serving mostly frail elderly residents and disabled people of limited means. On Jerry's death, I became general partner for the entire portfolio.

One project, located in a small town about two hours from Rochester, was home to a four-hundred-pound man with myriad health problems. His presence was a terrible dilemma for the on-site building manager and her staff. The man smoked and sometimes fell asleep with a burning cigarette in his hand. One time he burned his abdomen and came close to setting his pajamas on fire. When he slid out of his wheelchair, the staff couldn't get him up. They had to call the fire department, placing an undue burden on the village's small and partly volunteer force. Most problematic, the man was too large to fit properly on the toilet in his standard-size bathroom. Urine and feces slid onto the floor. No cleaning service would agree to come on a daily basis and cope with the mess. The manager had to clean the bathroom herself, and she was unwilling to do it much longer.

The manager wanted him out, but so far he'd steadfastly refused. I called and asked for a meeting, and he agreed. I drove to the development,

not even seeing the gently rolling upstate New York countryside. I was instead trying to master my anger that this man, whose medical problems were legion, was still alive while Jerry, who took impeccable care, was dead. I knew the comparison was unkind and deeply unfair. I drove, hands clenched on the wheel, trying to will my emotions back to neutral, trying to be securely in the role of general partner and not a grieving wife before I walked into the man's home.

With the help of his daily aide the four-hundred-pound man was neatly dressed in shorts and a clean shirt, his hair combed. His legs from the knees down were swollen and purple, and his facial features all but obscured by mounds of protruding flesh. He smelled medicinal, or astringent, and his pudgy fingers were nervously twisting in his lap. I tried not to stare. I explained carefully that he needed a higher level of care than we could provide, and that we'd located a long-term care facility that would accept him and be able to offer more support for his many health needs. I acknowledged that he'd so far refused any suggestion of moving, and I asked if he would tell me why.

He hesitated for several long moments, looking down at his lap. Finally, still without looking up, he said, "They won't give me as much as I like to eat. I like to eat all day. And they have lady nurses and aides, and I don't want a woman to see me naked."

I was pretending with just about everyone in my life, telling the kids when they called that I was taking life step by step, telling friends I was managing, telling clients and employees that we had an exciting, if different, future ahead of us. Everyone was pretending in return.

But the four-hundred-pound man was not pretending. He gave me an honest and deeply vulnerable answer. When he talked about being naked in front of a woman his face filled with shame, and my lingering anger vanished. I told him not to worry, that he could stay and no one would bother him until we worked something out.

I met with the building manager and told her I would find a solution. I sat with the elderly residents, who put out sticky sweet pink lemonade and dry, store-bought sugar cookies, as they apparently always did when

Jerry came. They told me they loved Jerry because he was never too big and important or too busy on his visits to sit and talk with them.

I smiled, privately wondering how he ate the cookies and drank the sugary lemonade, something he'd never allow himself on his training regimen at home. But I couldn't stay long as I felt my thin emotional reserve begin to teeter.

After the long drive back to Rochester I went home to our dark, empty house. Our home was a comfortable place to raise our two kids, with ample space for their friends to hang out and sleep over. After Sara and Matt left for college the space still felt right. After Jerry died, the rooms felt cavernous and bare. My footsteps echoed on the wood floors. I began to turn the alarm system on at night, which we never bothered doing. I hired someone to mow the lawn. Jerry loved grocery shopping. Now I was too exhausted at night to master the layout of our large local grocery store and figure out where everything was. I made do with yogurt and canned soup.

The kids called often, and Matt seemed to sense I wasn't eating very much. He said that with two parents, he and Sara felt very secure. With one parent, they were one death away from being orphans. He asked me to please take better care of myself. I resolved to cook a real dinner, as Jerry and I would have done, and went to the market for a piece of fresh fish. I bought broccoli to steam and couscous and a bottle of white wine. After preparing the meal and pouring myself a glass of wine, I sat on a high stool at the island in the center of the kitchen--I had given up eating at the table where I had to look at Jerry's empty chair--and turned on the evening news. After about fifteen minutes, unable to take a single bite, I scraped the food into the disposal and took out a cup of yogurt.

Without Jerry my heart wasn't in the financial planning business anymore, and I decided to sell the firm. I offered it to two key employees, who didn't want the risk of ownership but were unhappy that Jerry's death upended their smooth glide path to retirement. In secret, they began negotiations to join a competitor, who offered them a big cash bonus, and schemed to take as much business as possible with them. They jumped to

the new firm almost on the eve of the sale, having spent months after the office was closed secretly copying confidential information and files.

That set off a furious battle for client business. Although bound by contract to us, a client always had the right to leave and work with someone else. The sale price was predicated on a certain amount of business transferring, so as clients wavered, the new buyers and I had to forge a different kind of agreement. The four new partners, to their great credit, jumped in to help me save as many clients as we could, and after the sale I had an office in their space and an informal consulting role in helping incorporate our clients into their system. Whenever a matter came up that we hadn't been able to nail down, they decided after the fact in my favor--something they didn't have to do and which is rare in the cutthroat world of financial services. I remain not only a colleague but personal friends with them to this day. I came away with enough, but certainly not all, of what Jerry and I had worked our entire professional lives to build.

Most of my staff were able to get jobs with the new firm. One of those who didn't, later developed a brain tumor, and she'd been unable to replace her health insurance. The health crisis devastated her family financially. Before her death she told me she had no rancor because she knew how hard I tried. But Jerry would have been heartbroken at the outcome, and I was too.

Almost at the same time, my corporate attorney finalized an agreement for a national developer to buy the entire subsidized housing portfolio, including the residence of the four-hundred-pound man. The developer assured me they'd dealt with problems like this before, and that they would take care to find a decent solution and not force him out abruptly.

I wanted to ask if their regional manager would take time to sit with the residents and drink lemonade, but I knew the answer and didn't. I called the building manager to tell her of the sale, and she decided to retire rather than deal with a big, impersonal boss. I called the four-hundred-pound man and wished him well. I'd begun talks with an agency

in the area to ask them to help me find an alternative for the man. Now I called my contact and asked what he thought would happen.

"A big national firm? They're going to call adult protective services and tell them the guy is a danger to himself and others. And you know what? The guy is a danger, especially with his smoking. Adult protective can force him to move into a nursing home, and they will. You have too soft a heart to be in this business."

One other legal matter, left up in the air since Jerry's death, reached settlement at about the same time. The day after finding Jerry I called his doctor with two burning questions: was there something I missed that might have saved Jerry's life, and what did his sudden cardiac event portend for the future health of our children? Was anything about Jerry's death inheritable?

The doctor didn't return my call, not then and not when I called back a few days later. Curious, I wrote and asked for Jerry's medical records. The doctor didn't send them. I followed with a very formal business letter, insisting that the records arrive in my hands within ten days or I'd make a complaint to the state medical board.

A thick envelope arrived, and inside was a manila file folder. I sat down to read, and right on top was an EKG taken a few months before Jerry's death and as a precaution in advance of his strenuous bike trip. A handwritten note entered by the clinician said the test showed Jerry at some point had suffered a heart attack. The doctor, an internist, crossed out that interpretation and wrote "lead placement," which meant he attributed the suggestive result to incorrect placement of wires and pads during the test. The doctor didn't tell Jerry of the finding, didn't repeat the test, and didn't order follow up by a cardiologist. In addition to the prior heart attack, Jerry also had at least one coronary artery that was ninety-five percent blocked.

People in Jerry's condition have cardiac bypass surgery all the time, and the result is often many more years of productive life. I thought what I held in my hands was evidence of medical error, and the doctor didn't have the courtesy or the courage to call and talk with me about it. I decided to file a medical malpractice lawsuit, in part to get justice for Jerry

and in part to make the point to his doctor that when a grieving widow calls, the doctor should pick up the phone.

The dynamics of finding an attorney to take such a case, which is handled on a contingency basis, are stark. The deceased has to have made enough money to make the loss, and the lawsuit, worthwhile. Both the deceased and the party bringing the suit have to have absolutely clean histories relative to litigation. A lawsuit is about finding fault. The doctor's legal defense team, in order to deflect the question of blame, had to make the case about someone else's failing. Perhaps Jerry knew something was wrong but concealed pertinent health information from his doctor. Perhaps I had a history of filing cheap lawsuits and was simply looking to make some easy cash from the misfortune of my husband's death.

My attorney warned me that the process of the lawsuit would be grueling and sometimes ugly. The doctor's defense team would comb through everything, trying to find some act on my part or Jerry's that would support a different conclusion from medical malpractice. My attorney said the case would likely settle, but not until the very last minute, and that the pre-trial maneuvering would go on for about eighteen months. Many survivors, disheartened, drop out. He asked me not to start the case if I didn't have the persistence to finish it.

I talked with Sara and Matt, making clear that the decision to go forward or not was mine, but I did want to know what they thought. Sara was firm in wanting me to proceed so that no other family would have to suffer a similar, perhaps unnecessary loss. Matt was more ambivalent. He said he didn't want me to file a lawsuit in anger. I responded that I had a whole range of feelings about Jerry's death, and that anger was one but not the only or dominant one. With that, he agreed to support my taking legal action.

My lawyer was right on every detail as the lawsuit unfolded. Opposing counsel requested information on Jerry's health all the way back to college. Both sides took depositions. I wanted to be present when my attorney deposed Jerry's doctor, which was my legal right. The attorney, whom I trusted, advised against it.

"I have to take Jerry's doctor, step by step, through his decision process. And I have to do it over and over, from various vantage points, in order to make an iron-clad case. You'll have to listen to the doctor say, again and again, that he misjudged the findings of the electrocardiogram, that he didn't follow standard of care, didn't order any follow up. Why do you want to be present for that?"

Finally I agreed.

Attorneys for the doctor floated alternate theories then dropped them. They deposed me for several hours. Did I really not see any signs of Jerry's serious, advanced cardiovascular disease? Surely there were signs. How could I miss them? Did my husband and I have a close relationship, a good one? Would I have said something if I knew he was ill? Was there any reason I might have stayed silent, even knowing something was wrong?

My attorney prepared me well: Keep it short. Answer the question. Don't embellish. Don't react to provocation. If I hear you beginning to rise to the bait I'm going to suggest that you might need a short restroom break. Get up and go to the ladies room. Take a deep breath. Wash your face with cold water. Come back and give simple answers.

No, I saw no signs.

Yes, I would have said something if I saw Jerry was ill.

No, I had no reason to remain silent.

Eighteen months in, on the eve of jury selection, we got a decent offer of settlement and I took it.

I don't think Jerry's doctor was evil or incompetent. I think he allowed his perception of Jerry as a vigorous man to override the medical findings of the electrocardiogram. Jerry did appear to everyone to be vigorous and healthy. He walked briskly. He rarely sat. He exercised every day. After the autopsy, the medical examiner called me and said that if he'd only seen the results of the after-death examination, which showed the extent of Jerry's advanced cardiac disease, he would have expected the deceased to be much older than Jerry and sickly in appearance.

The successful conclusion of the lawsuit was a release of sorts. I felt I'd made my points to Jerry's evasive doctor: follow the evidence. And, if

something untoward happens, take the grieving widow's call. But in what seemed like an all too sudden resolution, I had nothing left to fight. The business was sold, the real estate portfolio was transferred to a new owner, and the lawsuit ended in settlement.

I was a fifty-seven-year old woman, unexpectedly single.

A widowed neighbor left a message on my phone, asking if I'd like to go out to dinner, just dinner, nothing more complicated than a nice evening out. I shuddered at the thought of dating again, and waited until I saw his car leave his driveway before leaving a message back. Thank you for the invitation. I'm not ready. The terse rejection hurt his feelings, and he avoided me as much as he could thereafter.

I slowly resumed consulting on issues of money, success, and happiness, responding to opportunities that came to me from people who'd read *How Much is Enough?* A few years in, a colleague called. He had the prospect of a good consulting job in Panama City with a wealthy family who wanted a better balance of opportunities in the family business for their equally well educated sons and daughters. The family spoke both English and Spanish, but preferred that the consultation happen in Spanish. My friend didn't speak Spanish but knew I did, and he called and asked how I would fancy a trip to Panama City.

Amigas
Para
Siempre

In Spanish "*amigas para siempre*" literally translates as "women friends forever." As I began to live my new identity as an older single woman, I turned to women friends. They became the equivalent of life support. Some were like me: well-educated professional women with money for travel and good clothes and dinner out. Some were creative, living a threadbare but fulfilled life. Some were remarkable for their kindness. Some were married. Some were dating. Some left happy or unhappy relationships with men and were in romances with women, although they often had trouble saying the word "lesbian" or "bisexual" out loud. Some lived what looked to me like rich and full lives without benefit of a consistent partner.

My best friend, Sally, was divorced and in a relationship with a man she met through an online dating site. She encouraged me to try, saying we'd break out a bottle of wine and it would be fun. "You have to kiss a lot of frogs, but here and there a prince will turn up." That didn't sound like fun, and I pushed the offer away with what became my standard response: Not ready. Will let you know when I am.

Warily and somewhat nervously, I remembered Margaret in the months right after my father died, before she started the affair. She bitterly resented losing their couple friends and always said she didn't

126

want to hang around with a bunch of man-hungry dames. She and Aunty El talked on the phone every day but didn't seem to go out together or visit each other's homes, and Margaret never invited Eleanor and her husband Jim to our house for dinner or to celebrate the holidays. It was a confusing message.

When Jerry died some of our couple friends drifted away. I annoyed others, appearing ungrateful by taking a firm line about invitations to be the companion to a single visiting male business associate already invited for dinner. I didn't want to balance out anyone's table. I wanted to be with people who found me interesting in my own right, not as the remnant of a couple or suitable fill-in.

Being an introvert, content in my own company, made that stance easier to take. Being introverted didn't serve me well as a child, when my teacher was concerned about my not talking. But it did serve me well in early widowhood. Being alone gave me time to figure out what kind of single fifty-seven-year old I wanted to be.

That didn't mean I escaped thoughtless comments, some delivered at the hands of other women who simply didn't know what to say. At one point quite soon after Jerry's death I arrived at a backyard barbecue at the home of a friend, who introduced me to a couple and then walked away to get something for another guest. The couple apparently knew the circumstances of my loss. After mumbling their greetings, the wife threw her arms protectively around her husband's neck, flinging a verbal dagger that went straight to my fragile heart. "My husband had a heart attack too, but I was right there next to him and got an aspirin in his mouth and called 911 and here he is right next to me today." My hostess, apparently seeing the color drain from my face, came quickly back to pull me away and guide me toward more sensitive guests.

Slowly, my new life began to take root. Mostly through business and non-profit board service, I met some new couples with whom to socialize, people who'd never known me as part of a husband and wife duo. I widened my circle of women friends even further. I joined a members-only city club, so that I'd have a place to entertain. I quickly understood that I couldn't be the wounded bird forever, that people would extend

invitations once or twice out of sympathy and then I would have to step up and host an enjoyable social occasion if I wanted the relationships to continue. I couldn't face entertaining at home. Jerry did so much of the preparation and planning and shopping, and even the cooking, when we had people over. After the dinner party, when the guests were gone, he preferred to clean up before going to bed. We poured another glass of wine, loaded the dishwasher, and then tackled the pots by hand, all the while dissecting the evening's relative points of interest. None of that felt good to do alone. The city club offered another benefit: only the member could pay. By inviting people to the club, I could simply sign for the evening and avoid that moment when the bill came and the men would each throw in a credit card and ask for an even split. With a singleton at the table the financial division could never be even, and then an intolerable discussion would ensue about how to make it fair to me. At the club I was the host, and there were fewer awkward moments.

Sara and Matt didn't much like the idea of my joining a snooty old-line Rochester club because they said it wasn't me. They seemed more perplexed than critical or judgmental, but they pointedly never found their way to the club for dinner or used the outdoor pool on sunny Saturdays when they were visiting. When given a choice of places to eat out, they invariably chose our friend Be's Vietnamese restaurant or Jeremiah's Tavern, the corner bar that Jerry always said had the best wings and burgers in the city.

The kids were right that the club wasn't the "me" of "Pam and Jerry." Jerry would never have joined the club, knowing its past history of blackballing Jews and African Americans. Nor did he like to dress up for dinner. He probably would have found a lot of the members too impressed with their own exclusivity. I saw all of those things, and joined anyway. I didn't really expect to make new friends there, and I didn't. Joining gave me some cachet in the business world; most members were male, and the women who came to lunch at the club were often trailing spouses. Joining was a statement of my financial clout; the invitation came with an upfront ten thousand dollar non-refundable fee. I began to be courted by Rochester charities as a potential major donor. I used the

club as a place to take friends for dinner. I went to the pool on summer weekends, sitting by myself and bringing a good book. I could walk into the bar alone as a business woman, by far my more confident role, not as a vulnerable widow. That was good practice for later when I mastered going into a fine restaurant and insisting on a good table rather than one in the noisy back corner by the kitchen.

I continued to build my consulting career, traveling often for work, and didn't hesitate when my colleague asked if I'd like to take the job in Panama City. That Sara had free time and wanted to come was a bonus. Having her with me when I found Minga after such a long time apart was precious. Showing our adult offspring the places that were formative to our younger selves is hard, because those places usually have changed too much with time. But the village of Rio Hato didn't change very much. Minga didn't change either, older but looking much as she had forty years before. She still wore flip-flops, or went barefoot. Chickens still ran free around her yard, and if we were going to have traditional Panamanian sancocho for dinner, that meant one of the grandkids was going to nab the slowest bird and wring its neck before bringing it to Minga for cleaning and cooking.

I asked Sara, always an astute observer, if she could imagine my living and working in Rio Hato for two years, and she carefully considered the question before admitting, "Not really." The mother she knew wore a Rolex and drove a Jaguar, bought Picasso prints, ran a business, wrote a book, and flew business class. Sara and I stood in the sweltering heat next to my house from all those years ago. One of Minga's daughters lived there with her family and eagerly welcomed us in. With the zinc roof baking in the sun the house was, as I recalled, unbearably hot. There was still no running water and just the one low wattage electric bulb hanging by a wire from the ceiling of each room. The two rooms were small, much smaller than I remembered. There was still no mail in the village, no land line phone service, no place to eat out, no movie theater or other diversion. I struggled to find the right words to explain to Sara.

"I didn't come for what I knew, living at home with Nana in New

Jersey. I came for what I didn't know and could hardly even imagine. That I became friends with Minga was a miracle."

There was nothing in my background to suggest that women as different as Minga and I could be real friends, not in the Peace Corps days and perhaps even less so when I returned and our friendship began to develop anew. For me, real friendship presumes some common ground and some degree of mutuality. One sided giving, or one sided taking, is not friendship. Minga and I created that balance, first in 1967 when we met and then later when I returned. I bring her the larger outside world. She brings me mothering. That was the dynamic in the beginning, and it's the dynamic now.

In college I relied on my intellect to get by, using it as an intimidating force when I felt threatened, and that normally worked to keep people at a safe distance. My well-honed strategy has never worked with Minga. I'm not sure she even thought, when we first met, that I was smart. I spoke Spanish like a child. I couldn't kill a chicken or cook rice. I was terrified of rats and bats. Interestingly, she never looked at me with eyes that were judging my intelligence or critiquing my performance. I think she simply wondered why I was there.

I was emotionally disarmed by a perfect stranger taking me under her wing. I felt safe with Minga, in a way I only had with my friend Bern and a very few others in the time since my father died.

When I returned with Sara, the differences between Minga and me were much larger. That first visit was brief, because I was committed most of the time to working with my clients. But I promised Minga a future visit and said I would stay longer. I decided to go for a month the following January, knowing that our forty-year gap would not be bridged in a week or even two. I told friends in Rochester I needed extended time out of the cold winters, but that was only partly true. I was going for a month because I longed to recreate the time on my friend's front porch.

Minga wanted me to live with her when I returned. There are two bedrooms in her home, each with three or four narrow single beds. One room is for her and whatever female relatives might be staying over. The other is for male relatives. I knew she would make up a bed in her

room and cook for me and wash my clothes by hand. She would never ask me for grocery money or inquire how long I planned to stay. She would simply welcome my presence and enjoy our being together day by day. But there's no air conditioning in any of the village houses, and the temperature typically hovers around ninety degrees both day and night. Nor do the houses have glass in the windows or screens. There's no longer malaria in Panama but there is mosquito-borne dengue fever. There are scorpions and bats and chickens walking freely in and out of the houses leaving wet droppings underfoot. With age and affluence I've become used to a certain degree of comfort. The army cot I slept on during the Peace Corps years would be intolerable now. So would staying in the village, although I know how much Minga wanted me to.

I stay in a villa in a gated community at the nearby beach. Minga and I spend time on her porch in the morning, and then I bring her back for lunch and to spend the afternoon in the hammock on the large sheltered patio facing the ocean. She often falls asleep, lulled by the gentle swing of the hammock and the cooling ceiling fan.

She's never said directly how she feels about my not staying with her, or what she thinks of the villa. Since the day I met her, Minga has been remarkably non-judgmental of me personally, although she doesn't hesitate to speak up, often forcefully, when she thinks I should change my behavior. Once I biked from the villa to her house in the mid-morning sun. The distance of four miles wasn't daunting, although I arrived red faced and sweaty from the baking heat. She simply refused to let me ride back. She sent a grandson to the highway when I was ready to leave, ordering him to flag down a taxi and bring it back to the house to transport me and the bike to the villa. She said sternly that I must never ride so far in the heat again. She's also adamant, if I'm at her house near dusk, that I drive back to the gated complex the long way, via the highway, and not through the back roads of the village. The drug culture has invaded even rural Panama, and she says the loutish youths drinking and smoking pot in clusters along the roads would not respect a white woman driving a shiny rental car.

But she doesn't ask why I'm not at church on Sunday mornings, or

if I really need air conditioning when there is often a breeze, or if I'll ever change my mind and stay with her. She never asked why I left her by the side of the road, or why it took me so long to honor my promise and come back.

There's something restful in that kind of friendship, to be able to trust that despite differences and missteps I'm not going to trip over her feelings in a way that risks breaking our bond.

When I sit with Minga now, in plastic chairs on her narrow concrete patio, there's much in terms of social expectation that I leave behind. I don't expect Minga to offer me anything to eat or drink; she has food for her own three simple meals, and no extra. Because of the heat I always come with bottled water in hand, and it grows warm as she and I sit and talk. She has a small refrigerator now but no freezer, and there is no ice on offer. Our conversation is interrupted by villagers walking by, who shout out "*¿Doña, que hay?*" "*Doña*" is a term of respect, a way of honoring Minga's advanced age. "What's up?" is a way of acknowledging me, as in, "Minga's American is here again." That's what they will tell the others when they arrive at their destination. Our Minga is important. Her American has come back, all the way from the United States. They don't think it's rude to interrupt, as we might. They think it's the right way to show they understand that something out of the ordinary is happening.

What I leave behind in social expectation is more than offset by Minga's welcome. She still sits close to me, much closer than we North Americans find comfortable in terms of personal space. She reaches over as we are talking to stroke my arm, touch my hand or rest her palms on my knees.

"Ay, Pamela..." she says. Oh, Pamela. What a miracle it is that we are together again.

I didn't expect to forge a new relationship in the village. That I did came as something of a surprise. That first year Sara, my experienced world traveler, helped me find the villa, which came with a servant to cook and clean. I negotiated the rental online, and invited several family members and friends to be with me for varying lengths of time during my stay.

132

When my guests and I drove up, Gloria, the servant, needed only a few cues to put me into a familiar category: Rich. White. American. Tourist.

If Gloria knew, or thought she knew, what to expect from me as the latest *Señora* to occupy the house, I had much less to go on when it came to "servants." When I first read the description of the villa online I liked the idea that there would be someone to cook and clean. With guests coming and going for four weeks I didn't want to spend a lot of time washing loads of sheets and towels and cooking big meals. I wanted to spend time with Minga and her family and walk on the beach and swim. I simply assumed that "full time" meant during the work day, five days a week. That the housekeeper would stay twenty-four seven during my rental and be available in the middle of the night to bring me a glass of water if I summoned her for that purpose, never crossed my mind.

Within minutes of our arrival at the villa, Gloria showed us what a servant does. As I and my guests got out of the car and tried to cope with the heat, she went to the open trunk and began dragging big suitcases out. My brother-in law Ron and I immediately jumped to help. Gloria frowned and motioned for us to go inside out of the sun. Getting all the suitcases upstairs, she said, was her job. Gloria is short, several inches shorter than my five foot six. She's wiry and strong, but the thought of her wrangling all the bags to the second floor made no sense. We continued to help, and got everything inside and to the right bedrooms within a few minutes.

While Ron and my sister Linda and friend Sally were exploring the house, I asked Gloria about grocery shopping. Gloria replied that the market in the village would not be much help as it carried things like chicken feet and cow hearts and tripe, not the food I and my guests were accustomed to eating. But there were two large supermarkets within a half hour's distance. If I made a list and gave her money for the taxi, she'd go and get groceries and bring them back. Again I felt perplexed, pointing to the car right outside. I can drive, I told her, and together we'll get the job done much more quickly. I asked her when she had to leave to return to the village, as it was already early afternoon. She responded that she slept

at the villa, in a small room off the kitchen, in case she was needed during the night.

I asked her to show me, and she led me to a truly tiny, very hot room with metal bunk beds, a battered fan, an ironing board, and a small bathroom with toilet and sink. Her few clothes were piled up on a small straight-backed chair. Her room and the back hall to the carport were the only parts of the villa not air-conditioned. I asked if she had family in the village, and she said that she did: her common-law husband, three teenage sons, and her elderly parents. Gloria came from a large family, and many of her sisters and their families lived nearby. While she was working, they pitched in to wash clothes and bring food to her family. *Abuela*, the boys' grandmother, kept an eye on them, and they were all quite accustomed to having Gloria away for long stretches while she was working.

I was certain Gloria didn't need to stay overnight. I planned to have our big meal in the middle of the day, to get everyone out of the scorching sun for at least an hour or so. Given that, I thought we could make do with something lighter in the evening. Ron, Linda, Sally, and I were all capable of putting together a simple meal. I asked Gloria how she came and went from the village. She said that there was an inexpensive transport that went back and forth between the village and the development, bringing the day laborers who were building out other parts of the complex. The last transport left about 6 pm, gathering up the straggling workers from a spot not far from the villa. I told her we'd be squared away by then and that she could plan on being at the pickup spot to go home to her family. She looked at me, somber and confused and perhaps even worried. I looked back at her, puzzled and having no idea what might be upsetting her.

Gloria was quiet during the ride to the supermarket, and for all the time it took us to do the shopping, return home, and put away the groceries. She prepared a big salad and left it in the refrigerator for supper, then gathered her things to go home. She assured me she'd come on the first transport in the morning and be in the kitchen ready to cook breakfast before any of us would likely be awake.

I came down the next morning about 7:30, dressed in a bathing suit and hoping for breakfast and swim before going to the village to see Minga. Gloria was there. She was seated on a chair in the living room, a bloody dish cloth wrapped around her toes and tears streaking her face. She pulled back the cloth to show me. The nail on her big toe was ripped halfway out of its bed, and dangled precariously by the few remaining roots. The toe was oozing blood. While lifting the heavy patio furniture to clean underneath, she somehow caught her foot in the bamboo. The nail ripped off when she lost her handhold and the piece of furniture fell.

"*Me duele mucho.*" It hurts a lot.

Before I could say anything Gloria jumped up and began to hobble toward the kitchen, drops of blood from her foot leaving a trail on the clean white floor tiles. The coffee was made, she said, and she would fix me whatever breakfast I might like. I shook my head, speaking to her retreating back. I responded without thinking much, saying what seemed obvious to me.

"Of course not. You need to have that toe attended to. I'm going upstairs to put more clothes on, and then I'll take you home. I'm giving you money to go the clinic to have the nail treated. Whether or not you come to work tomorrow depends entirely on how you feel. That toe is going to hurt for awhile, and you probably won't even be able to wear your flip-flops."

Gloria turned, hands on her hips, and glared at me through her newly falling tears. "*Señora*, you don't understand. I have to do the work while the renters are here. If I can't work I will lose my job. I have to cook for you, and clean the house, and wash your clothes. I can do it. The toe doesn't hurt that much."

I was beginning to understand. Gloria was working, quite appropriately, to the owner's expectations. The villa belonged to a wealthy Cuban-American couple who lived in Miami and rented the place as an income property. Periodically they came and stayed in the villa as well. When that *Señora* was in residence, Gloria brought all the bags in by herself, no matter if there were able-bodied men who could have helped. Gloria went in a taxi to get the groceries. She was available in the middle

135

of the night in case the *Señora* or any of her guests might want something to eat or drink. And Gloria stood by the stove every morning to cook breakfast.

I softened my tone from the matter-of-fact voice in which I told Gloria I would be taking her home. "I think your employer and I have different expectations, and we can talk about that when you return to work. But right now you need medical treatment, and I'm taking you back to the village. I'll be down in a few minutes, so you need to get your things."

Gloria was silent on the way, holding the cloth tightly around her toe to keep the blood from getting onto the interior of the car. We turned right off the highway onto a paved road that passed the village school, and then she pointed to a bumpy dirt road that led to her house. I slowed the car to a few miles an hour, trying to avoid the worst of the ruts. As we painstakingly moved forward I felt every eye on us. Clearly the early morning arrival of a small SUV with a white woman driving and one of their own in the passenger seat was not a common occurrence.

Gloria pointed to a cluster of small houses. In front of one sat a group of young men in a circle, waving their arms and shouting. In the middle of the circle two cocks with razor blades attached to their feet were screeching and flapping, fighting each other to a bloody death. Gloria muttered under her breath, "*Ay, Dios.*" Oh my God.

She spotted her boys among the group. "They know very well that they are not allowed to gamble on cock fights, and here they are. Their father has left for his day's work, and abuela is getting too old to supervise them. They thought I would never come at this hour, and that they could do anything they want."

We pulled up near the boys, and Gloria reached to open the door. "Thank you *Señora*. I will be there early tomorrow." Then she flew out of the car like an avenging angel, sore toe or not, scattering the other boys and the bloody birds while her three sons stood shamefaced, waiting for her fiery rebuke.

When I returned to the villa the on-site rental agent stopped by, just to see how things were going. Seeing me standing in the kitchen pouring

a bowl of cereal, she asked where Gloria might be. I explained about the injury, and said I drove Gloria home to get medical treatment. The rental agent nodded, with a bit of a frown.

"And I heard you let her go home yesterday, before supper was even prepared?" I said that was true, marveling at the ability of gossip in any small closed community to make the rounds.

The rental agent, a pleasant young U.S.-born woman who lived in the complex and had her own household help, chose her words carefully. "This might cause trouble, you know. When the other girls hear of Gloria's special treatment, they'll want to go home early too. And that isn't going to happen."

Gloria did return as promised very early the next morning. Her big toe was encased in a bandage; she told me the nail had to be removed. She was taking antibiotics. She was standing barefoot in the kitchen. As I had suspected, the toe was too sore even for flip-flops. She directed me to a chair at the dining room table, and said that she would bring the coffee and then see what I wanted for breakfast.

She brought cereal and milk and coffee to the table, along with some hot toast. Turning to go back into the kitchen, she suddenly stopped, turning to face me. Then she pulled out a chair to the right of where I was sitting and sat down. She stared at me for a few moments, eyes welling with tears, and then began to talk in such a rush of rapid-fire Spanish that I could barely follow. Her story poured out without interruption for almost half an hour. My brother-in-law Ron came down, sat at the table, took a cup of coffee. She hardly seemed to notice, and kept on talking. Ron and I were transfixed by the intensity of her emotion.

"I started working for people, rich people in the city, when I was sixteen. Now I'm thirty-five, and I've been working for rich people all of that time. No one has ever been kind to me, treated me as a person, in the way you did yesterday. The *Señora* in my first house said I could have one piece of toast for breakfast, and one coffee. If I was hungry and ate more, she took money away from my pay. The other girls and I, we got to eat what was left over from their lunch or dinner. If there was nothing left we got no food. Every month I worked for two weeks straight, day and night,

to have one day to come back to the village on the bus to see my baby. Then I worked two weeks again, just to have another day."

Gloria gave birth to her son Raoul when she was barely sixteen years old. Raoul was premature and weighed only a little more than two pounds. He was born in a rudimentary clinic, and the staff handed her the tiny newborn swaddled in a blanket and said he needed "special milk" to stay alive. Gloria and baby went home to her mother. Within days Gloria developed mastitis, and she was unable to nurse Raoul at all. She and her mother tried giving the infant weak tea to assuage his hunger, but he screamed constantly. That's when she went into the city and into service, to earn money for formula.

"The rich family had children who came home after school and dropped everything on the floor, and I had to pick up after them. If their mother yelled at them they pointed to me and said 'It's her job, keeping the house neat. Why are you yelling at us?' And then she turned and yelled at me.

"I had to wear a uniform, even when I was out on the street, so that everyone knew all the time that I was just a servant. I never got to be Gloria, a person like they were. It was as if I always belonged to the rich family, no matter where in the city I was, and I felt so ashamed."

At some point Gloria met Luis on one of her trips back to the village, and he took her as his wife and accepted frail little Raoul as a son. Gloria and Luis had two more boys together. Their youngest, named Luis like his father, was born with a clubbed foot. He needed many surgeries, all within the public health system used by the poor, and the time it took for his care meant that Gloria had to leave her job in the city and return to the village. She found work here and there, and eventually when the beachside complex was built she got the job with her current *Señora*. Gloria was required to be there whether the landlords or renters were in residence, and her husband and children could not visit. That meant she might go for weeks without seeing her family. Her current job, when the *Señora* was there, sounded to me little easier than her first.

"I work for twelve or more hours and go to bed exhausted. But the *Señora* expects to me get up at 11 pm or midnight if guests arrive from

the airport. The men stand there while I carry all the bags, and then I have to fix them dinner and serve drinks and clean up and wait until they all go to bed before I go back to bed myself. And then I have to be up again early in the morning."

The cruelest thing, it seemed me, was the hint the *Señora* gave Gloria that she might be able to get medical help for young Luis' clubfoot in a Miami hospital. That never happened, but Gloria continued to work without complaint in the hopes that it might.

Finally Gloria finished her story. She retreated to her small hot room off the kitchen for a few moments of privacy. My brother-in-law and I simply looked at each other, drained by the intensity of Gloria's story.

Becoming
Tiá Pamela

Minga expected me to come and get her in the late morning, along with several of her grandchildren then on school break. The plan was to return to the villa for lunch and a swim. The kids had shorts and cotton shirts but no bathing suits, so we set out for the district capital to buy swimwear. Minga demurred on my offer to buy her a bathing suit. When she was a much younger woman, she reminded me, she went to the river with the others and got in the shallow water in shorts and a blouse to cool off. But swimming pool water was bound to be cold. And she would certainly not go in the ocean, where there were waves and bad currents and where manta rays and other mysterious creatures lurked under the surface.

Despite living within walking distance of a white sandy beach and calm surf, Minga was terrified of the ocean. She knew neighbors, or their fisherman sons, who fell from their small boats and drowned. When the bodies washed up on shore they were bloated from days in salt water, with faces and fingertips partially eaten by crabs and small hungry fish. Minga saw enough of that horror to know she never wanted to set foot near the sea.

Her grandkids held no such reservations about the beach or the big swimming pool, and they were thrilled with their new bathing suits.

140

They already had flip-flops, which they wore most of the time in the village, and there were plenty of big towels provided by the villa. The kids chattered excitedly all the way back from our shopping excursion until we were quite close to the security gate which marked the entry to the complex. Then their voices fell to anxious whispers.

"Tiá Pamela, should we try to hide on the floor of the car so the guards don't see us? We can't go in here, you know. Only the workers can go in."

I responded that they were my guests, and that the guards would indeed let the car enter. The kids fell absolutely silent. As we approached the guard station I smiled, lowered the car window and showed the pass the rental agent included in my welcome packet. The guards looked long and hard at the inside of the car filled with dark, unfamiliar faces, but finally said, "Good day, Señora," and waved the car through. Ten feet beyond the guard station, the kids resumed their excited chatter, and Minga waxed nostalgic. As we drove past the mostly empty building lots she asked if I remembered that this was the land on which Roberto and other men from the village kept their cows. Then a wealthy group of Panamanians from the city bought up all the fields, created the security gate, and started construction that would include villas, some condo buildings, and eventually the hotel, a riding stable, and a golf course. A few villagers made some money, not a lot, on the sale of their land. Now there are laborer jobs for the men and maid and nanny jobs for village women. But they can no longer access the beach or take shortcuts through even the undeveloped land. Security guards on all-terrain vehicles quickly chase them away.

When we arrived at the villa I told the kids to feel free to explore the house. They were fascinated by the stairs to the second floor; none of their houses have more than one story. They were also intrigued by the bedrooms having sturdy wooden doors with locks. None of their bedrooms have doors of any kind, just curtains for privacy. The kids all sequestered themselves immediately in one of the bedrooms, turned the lock, and then shouted for me to come and knock. They giggled uproariously when I did, and one of them got to ask, "Who's there?"

before turning the lock and opening the door. We had to repeat the game until every kid had his or her chance to be keeper of the lock.

After I saw one of the boys pee in the bushes just off the patio I realized I needed to show them how to use the flush toilet. Hand washing followed; I demonstrated how to turn on the hot and cold water together to create warm. I cautioned them against using only the hot, as they might burn themselves. They practiced a few times, then said it was too complicated and that they could use the cold since they were accustomed to it anyway.

Minga didn't attempt the stairs as she said her knees were hurting. But she did marvel at the kitchen with the huge refrigerator and free-standing ice maker. I explained that Gloria hurt her foot and was back in the village getting care, but that she would be with us tomorrow. Minga told me that she and Gloria's mother were around the same age, although they didn't know each other well because they lived on opposite sides of the highway. She knew Gloria and her mother and the boys by sight from church.

Done with their explorations upstairs the kids raced into the kitchen, where they grabbed glasses and began to play with the ice-maker. I had bread and peanut butter and jelly for sandwiches, which was a treat. Any prepared food, like peanut butter, was typically too expensive for their mothers to buy. The kids piled chips next to their sandwiches, and turned up their noses at the offer of a diet cola, choosing lemonade instead. I told them to write on the grocery list anything they'd like me to get, and Gloria and I would buy it next time we went to the store. A highly sugared cereal, *Zucaritas*, was first on the list along with full-sugar soda in fruit flavors like strawberry or orange.

I have many nieces and nephews, now grown. I've shared their growing up, celebrated holiday dinners with them, fed them peanut butter and jelly sandwiches in my own kitchen. But my relationships with the American nieces and nephews bore no relation to the gaggle of wide-eyed children now sitting at the big dining table and looking at me with both eagerness and doubt. Most of Minga's family members are dark-skinned as she is. As they sat eating their sandwiches, one tiny girl slid

out of her chair and came to put her thin forearm and delicate hand right next to mine. She looked at my stark white skin next to hers, then looked quizzically up at me.

"Are you really my Tiá Pamela?"

"*Tiá*" in Spanish can mean blood relative. It's also a term of respect for an older woman. In Minga's and my case, having her family call me "*Tiá*" meant something slightly different: family not of blood but of choice.

I nodded and stroked the soft skin on the back of the little girl's hand. "You have *Tiás* that are your blood family. That's your Tiá Daira and Tiá Teresa and Tiá Rufina. And you have family of the heart, and that's me. Your grandmother and I are sisters in our hearts, and that makes me your *Tiá*."

The child nodded and smiled and returned to eating her sandwich.

We next went to the pool, sparkling blue with a swim-up bar and surrounded with high end lounge chairs and umbrellas. The kids froze. Their questions came in a rush.

"*Tiá* Pamela, whose chairs are these? What if we sit in them and get them wet? Will the man with sunglasses in the high white chair be angry? Is he the boss, the *jefe*? What if we sit down and a rich family comes? We have to get up and give the other family our chairs, right?"

Clearly our simple arrival at the pool was far from uncomplicated for them. They stood out, and they knew it. The other guests, mostly wealthy Panamanians and American expats, were all light-skinned. I was aware of disapproving glances coming our way. I hadn't thought of bringing the kids to the pool as making any kind of statement, but clearly it was. Quickly, sensing their growing awareness of the stares and whispers, I gathered them close.

"I know you haven't been here before. But this is Panama, and you are Panamanians. As long as you behave the way your grandmother teaches you, you are welcome in any part of your country. You are welcome to be here at the pool with me."

I explained that the lounges were for anyone who was a resident or guest in the community. I suggested they put their towels on the fancy

cushions before sitting down with wet bathing suits, but assured them that the fabric was a special one and not harmed by dripping water. I said the man on the high chair was a lifeguard and that his job was to help if someone got in trouble in the pool. I showed them the dividing line between the shallow and deep ends of the pool as none of them could swim. I took them inside the poolside bathrooms and said they had to get out of the pool and use the bathrooms if they needed to go. And I said that once we had arranged our space, we didn't have to move for any new family that might arrive. Newcomers would find their own place by the pool.

They had a wonderful time. The pool wasn't crowded, so we managed to commandeer most of the flotation devices that were scattered about and they were soon kicking with their arms stretched out in front of them, kept aloft by small boards or tubes. They stayed in the water for hours and later giggled with delight when I had them all swim up to the bar for frozen strawberry daiquiri mixed without the liquor. When Minga said it was time to go, they climbed instantly out of the pool and gathered their things with no "five more minutes" and no whining about setting our area to rights even though they were exhausted.

On Friday of that first week I got an email from the villa owners in Miami. Someone informed them that I was bringing undesirable guests to the complex and allowing them to use the pool. I was asked to cease and desist, or my rental would be in jeopardy. They reminded me that if I was turned out for violating the by-laws, a copy of which I could find in a drawer of the kitchen, the landlords were entitled to keep the entire fee paid for the month's rental.

I was furious. I said explicitly in communicating with these owners prior to committing to the rental that the attraction of the villa for me was its location so close to the village. I mentioned being in the Peace Corps and said that I'd have friends from the village coming back and forth. I had no idea who might have complained or what the issue might be. The kids behaved impeccably for the entire time they were with me.

Minga and the kids happened to be in the house, and she could see my anger. She asked what was the matter, and I told her. She seemed

unsurprised that their presence in the complex was challenged.

"Pamela, have you paid the rent?"

"Of course I paid the rent."

"Then by the laws of Panama you are entitled to all the rights of a householder. You have to fight for us."

If my spine needed any stiffening, Minga's response to the email from Miami provided it. I knew she didn't grasp the difference between a freestanding home and a gated community that had its own layer of regulations on top of Panamanian law. But no matter; her point was fairly made and taken.

I found the book of by-laws and read the section on "undesirable guests." Those were defined as people who disturbed the peace or created a public nuisance with alcohol or drugs or loud noise in the middle of the night. There was nothing in print that seemed to apply to Minga and her family. I told Minga and the kids I needed to take them home early so I could think about this and craft a response.

The right approach occurred to me later that night and involved the shameless dropping of my wealthy client's name. I wrote back to my landlords, saying that I certainly wanted to follow the rules but was unclear what the rules might be. Were "undesirable guests" dark Panamanians, poor Panamanians, or any Panamanians at all? I said that I invited prominent clients to visit me at the beach—true—and that I had no idea what the range of skin tones among their grandchildren might be. I said I would be mortified if this family were subject to any disrespect due to my invitation. I asked the landlord to clarify what he was asking me to do.

I was sure the landlord knew the name I mentioned. The über-wealthy in Panama are known by name in all circles, including among those wealthy Americans who own property and hold resident status. My name dropping was an attempt to put my landlord in a quandary, and the tactic worked.

The response came via email a few days later. The admonishment had certainly not been directed toward the family I mentioned, and indeed they would be welcome at the villa and it would be an honor to have

them there. The note went on with vague generalities about the world not being as we all might wish it would be, and the landlord said he was sure I knew what he meant. But he didn't repeat his cease and desist demand, or threaten to turn me out. I decided to keep doing what I was doing, and I never heard from him again.

Just beyond the pool was a deck area offering lunch. The kids looked at me longingly, never having eaten in that kind of setting and longing to. None of them ate in restaurants, of which there were few in the village anyway. I requested a large table with menus all around. They invariably chose hamburgers and fries, or pizza, and full sugar cola. Since we were not going to be in the house for lunch I invited Gloria to eat with us. At first she was hesitant and self-conscious, fearing that someone would come up and order her sternly back to her place inside the house. But she quickly became comfortable, perhaps taking her cue from Minga who is always comfortable even in an upscale hotel restaurant where she can't read the menu.

As the lunches came I was surprised to see each child carefully segment a part of the hamburger, a handful of fries, or two or three slices of pizza. I asked what they were doing, and each responded, "For papi and mami." They wanted to take part of their wonderful treat home, to share with parents left behind and hard at work who never got to eat in restaurants either. Later in the day, to supplement the cold food, I ordered several pizzas to go. As each child got out of the car back home, he or she carried a white cardboard box, slightly oily on the bottom, redolent of pizza smell and with the contents inside still warm.

To say that Gloria and I became friends that first year in the way that Minga and I are friends is not exactly true. Minga and I started from a different vantage point, and Minga has never been my employee. She and I are close in age. We shared that early two-year period of Peace Corps service during which the differences between us were somewhat less vast and certainly less apparent. Minga calls me Pamela, and uses the familiar Spanish grammatical form *tú* when addressing me, not the more formal *usted*.

Gloria is a little more than twenty-five years younger than I am although we're both grandmothers. I came into her life as the lady of the house and therefore properly addressed as *Señora*. Gloria always uses *usted*, the formal version of "you," when talking with me. She explains that it's a sign of respect toward an older person, and indeed Minga's grown offspring refer to me as *usted* as well.

But *Señora* carries a connotation of class difference, something I didn't want to emphasize. I asked Gloria if we could come up with something other than *Señora* Pamela for her to call me. She said she couldn't just call me Pamela, as Minga did, because of our age difference. We went round and round with possibilities, then Gloria brightened. "I know. Can I call you Tiá Pamela too?".

"*Tiá*" puts Gloria shoulder to shoulder with Minga's nine adult offspring, who call me *Tiá* along with the grandkids and great-grandkids. Eventually I became *Tiá* to Gloria's husband and their three sons as well.

Perhaps "aunt" is the best way to describe Gloria's and my relationship as I mentor her in a similar way to the mentoring I offer my stateside nieces and nephews. As I grew to know Gloria better, I found her more and more interesting and much more capable than her initial subservient demeanor suggested.

Her first accomplishment was getting my friend Sally's luggage delivered after it was lost on her flight from the United States. Once the bag turned up at Tocumen Airport, the airline was reluctant to deliver the bag to our location some two hours away. They kept insisting we return to Panama City to get it. Seeing me struggle on the phone and make no headway, Gloria motioned for me to hand the phone to her. She then delivered a rapid barrage of Spanish and didn't get off the call until she had heard the assurances she wanted. Barely two hours later a taxi pulled up at our door and the driver handed Gloria the wayward suitcase.

Gloria was an expert at getting people into the villa to fix things, like the air conditioning, that constantly decided to quit. She is a masterful cook, having learned purely by experimentation. And she is very funny, with a dry wit that was hardly visible when her shoulders were hunched and her eyes downcast to the floor, waiting to be rebuked or given orders.

In our culture, with a little education, Gloria would have surely been a supervisor or manager, broadly capable in any job built around problem-solving and execution. But she doesn't live in our culture.

Part of what I committed to do, for Minga's family and for Gloria, was model as many of the skills of gaining access as I could. Our outings became intentionally more wide-ranging, as I sought to expose them all to new things. I'm still astonished and deeply touched at how much trust the parents of Minga's grandchildren and great-grandchildren place in me just because Minga does. They let their kids climb into the car early in the morning, with no predictable sense of all the places we might stop or when the children might return or whether they will have eaten supper. My cell phone doesn't work in Panama, and only the older kids have cell phones that activate with one, three, or five dollar time cards. Often no one in the car had a phone, or if someone did, the phone likely had no minutes left. There was no way to call back to the village and say we were taking a drive to the district capital for ice cream, or heading to the fishing village to buy fresh catch for supper at the villa, or driving to the big grocery store in Coronado to replenish the groceries.

"It's fine Tiá Pamela. Mami said it's fine. We can go anywhere as long as we're with you."

My greatest challenge in being Tiá Pamela was how many kids I could be Tiá Pamela to at any one time. That first year I rented a five passenger small SUV. Cramming everyone in and having several ride in the back, I could accommodate as many as ten, just for the short trip to and from the villa. If we were going on the highway, I insisted on taking only as many as had seat belts. Often, when I arrived at Minga's, there would be many more that I could take under any scenario. We had to set up a system of turns, and some days not everyone got to go.

These are not children who whine or complain or say that life isn't fair. The ones left back simply nodded and said "*mañana*." Tomorrow. Tomorrow it will be my turn, or the next day. If one did verge on showing disappointment, Minga was right there to curb what she saw as disrespect. A ten-year old grandson kicked the dirt upon learning he couldn't go, and

Minga immediately grabbed his shoulder, fixing him with a blazing stare. He froze and melted back into the midst of the small group left behind.

Deciding who could come to the pool or not on any given day was a minor affair. Much harder, in my role as Tiá Pamela, was seeing the myriad needs each of the families faced and knowing I could help some but not everyone. Some of the needs were simple and relatively inexpensive, like bathing suits, or for one of the adolescents, a coveted jar of hair gel. But most needs were more costly, and of far more consequence, often involving an unresolved medical issue. I began to help slowly, saying I'd buy a computer for any family that had access to Internet and could pay the monthly charges. I intervened in medical emergencies, which seemed to occur fairly often. I steered clear of lengthy or very costly problems, fearing that helping one family in a big way but not others would show a hurtful favoritism.

At one point Gloria had an abscessed tooth that was sending shooting pain up into her sinus cavity. I sent her for a first dentist visit ever, and the dentist confirmed the seriousness of the problem. He said that untreated much longer, the infection could have reached her brain and killed her. He treated the infection, but also said she needed work on every tooth in her mouth, projected to cost in the thousands of dollars. She didn't ask me to take that on, and I didn't offer.

Minga makes my dilemma easier by never asking me for anything, although she accepts gifts—like a comfortable rocking chair—when I bring one. I'm fairly sure she's laid down the law to her extended family that they're not to ask either. Minga's youngest son works as a day laborer and drinks up most of his wages. He waited carefully until his mother was out of earshot. Then he asked me, eyes averted, if I could possibly give him twenty dollars to buy uniforms and school supplies for his child. I don't approve of his drinking but I worry about little Nati not going to school, so I gave him the money. Minga came back outside just in time to see him walk swiftly away.

"Did he ask you for money for Nati? Did you give it to him?"

I never lie to Minga, and I admitted I had. She said nothing to me, but I'm sure her wayward son got an earful the next time she saw him.

If my role as Tiá Pamela was constantly evolving, so was my friendship with Minga. One day, I was there with her in the morning while she was caring for her small great-grandson, Josue, while his mother worked a long day as a maid at one of the local hotels. Minga adores this little boy, but he was being especially rambunctious. Perhaps she was more tired than usual. Perhaps she didn't feel well. I suddenly saw her patience snap. She grabbed a belt and struck him, not brutally but hard enough to make him scream. She raised the belt to hit him again, and he ran sobbing and threw his arms around my legs.

I never place my judgment over Minga's, or presume to know better than she what's right in village culture. But I also have a small grandchild. And I know what it feels like to lose patience with a child who's merely being childish and then to regret it. I thought for only a second and then reached down to pick Josue up. Minga stopped, her hand with the belt still raised. I spoke quietly.

"This isn't a good day for Josue to be with you. I'm going to take him back to the villa, and I'll return him to his mother when she gets home from work tonight."

Minga's hand dropped to her side, and I could see the fury evaporate. When she spoke she simply sounded tired.

"No, Pamela, it will be all right. You can leave him."

I had to be sure. "I'll only leave him if you promise me you won't hit him again."

She nodded and laid the belt aside. I sat down again, cradling Josue in my arms until he stopped weeping, slid down, and went off to play. Minga and I talked on, with no mention of what had just transpired. Pushing back on a friend on something as personal as her supervision of her grandchild is risky. I wanted to feel sure she knew I acted out of love and empathy, not judgment. When I left she embraced me as usual and smiled and said she would be waiting for me tomorrow.

Not all of my days in Panama are so emotionally intense. In large measure I slide quickly into a very different pattern from my life at home. I wake early, before dawn, and slip out onto the beach to watch the sun rise over the ocean. Gloria brings breakfast things to the covered patio,

the table set under ceiling fans already circulating to counteract the heat of the day. She makes coffee Panama style, thick and dark, which I drink with milk and sugar just the way they do.

I swim.

I go to the village.

I return and pass the time with my American guests.

Sunset comes surprisingly early, around seven.

By nine we are all in bed.

Because there is only email, no phone, I tell everyone I'm out of range for the time of my Panama visit, and they will have to cope as best they can without me until my return. That means Margaret calls upon my sisters, not me, for the duration.

Losing
Margaret

In her waning years Margaret settled into a pattern too. She played bridge downstairs in the club room of her building. She ordered take-out for her supper rather than cooking. She did crossword puzzles. She was a great reader of Maeve Binchy novels. Margaret fired off letters to the Editor of the Asbury Park Press, the New Jersey legislature, the management company who ran her building, and anyone else she could think of. She exercised up and down the long hallways of her floor. She still sent birthday cards to her favorites among our cousins, now adults and some with grandchildren.

Margaret became a little more withdrawn with Linda and her husband Ron and me, although not with Wendy. I think Margaret and Wendy spoke by phone every day. When I came to New Jersey, Linda and Ron often hosted a family cookout at their backyard pool. Ron or I would drive the half hour to get Margaret, and as soon as she arrived she found a comfortable rocking chair, put in her ear phones, closed her eyes and listened to a Yankee game. Once eager to take a dip, as she called it, she stopped putting on a bathing suit and declined to get in the pool. As soon as the meal was done, she asked to be taken home. She got out of the car in the parking lot of her building, declining our offers to see her safely upstairs.

She seemed not to want people coming into her apartment, and I worried about her being too solitary. I asked if she'd like me to set up a pastoral visit from the Catholic church in her neighborhood. She looked at me as if I were insane. She was staunchly Irish Catholic and we knew she wanted a Catholic funeral with as many priests on the altar as possible, but she didn't go to Mass anymore. She hated all the getting up and down of the post-Vatican II Catholic ritual and thought "passing the peace" with people you didn't even know was a dreadful idea.

Her outbursts were less frequent, although not entirely extinguished. When my cousin Adrienne's husband Mario died, Ade asked Margaret to produce the deed to the Halpin family cemetery plot. Our grandmother Mary Halpin is there, and Adrienne's parents, and Ade will be buried there too. Grudgingly, Margaret complied. She didn't like Mario, and didn't like the idea of an Italian surname on the all-Irish Halpin/York headstone. When the funeral cortege arrived, everyone saw that the gravediggers opened a spot among the graves in front of the stone, not one to the back. Margaret threw an absolute, public, unrestrained, spittle-flying, arm-flailing fit. My father is buried in the front, and Barbara, and that's where Margaret staked out her spot. She was not going to rest for all eternity side to side with an "eye-talian."

I will never understand why everyone indulged my mother's fits of rage. But everyone always did. The funeral concluded with Mario's casket still above ground. After the mourners left, the gravediggers filled in the front grave and opened one in the back, where Mario's casket was finally lowered. Margaret's relationship with Adrienne, once one of the cousin favorites, never recovered.

Margaret's visits to doctors and to the emergency room of the nearest hospital only accelerated. She continued, most of the time, to gain admission for a day or two or three. She was feisty in claiming her rights to care. At one point, a young social worker handling Margaret's discharge planning suggested that a mild antidepressant might decrease the number of ER visits and was worth a try. Margaret was incensed and demanded to see the head of patient services. She said the young social worker so upset her she was on the verge of having a heart attack and dying on the

spot and it would be their fault. She insisted the young woman never be assigned to her again and that no one in the future so much as mention an antidepressant. Despite the pressure hospitals are under to reduce repeat admissions, I think the staff finally just gave up on modifying Margaret's behavior.

Linda and I told Margaret all the time, and not altogether kindly, that she cried wolf too often. We said the day would come when she'd go to the emergency department with something dire and no one would take her seriously. Margaret also continued to hoard pills. I told her that piling up antibiotics and taking them at will was a big mistake because she was going to develop an antibiotic-resistant infection and it would kill her.

Neither dark prediction came to pass. Margaret lived to be ninety-two, going to the hospital when and where and as often as she chose and dosing herself with bootleg medications to her heart's content. Behind her back, hospital personnel called her a "frequent flyer," and it was so noted on her chart. She knew and couldn't have cared less.

In February, five years after Jerry died, she was in the hospital for several days being treated for a serious ailment: leaking diverticulitis. Doctors sent her home on a Friday with medication and instructions for self-care. I called from Rochester both days over the weekend, and she said she was feeling better.

When I called on Monday morning, her tone changed. She said she felt as if she'd taken a bad turn. She couldn't put her finger on an exact symptom, but she just didn't feel right and had a profound sense of foreboding. While we were on the phone a nurse arrived to take Margaret's vital signs, part of a wellness program provided to area seniors. I asked Margaret to put the nurse on the phone and described what I was hearing. I asked the nurse for her opinion on what we ought to do, since she had eyes on Margaret and I didn't. The nurse became very anxious, saying she couldn't do or say anything unrelated to taking my mother's vital signs and that, in fact, she had to move along because she would receive a written rebuke if she spent too much time with any one patient.

I adopted my firmest executive voice and asked her to please stay until I could make a determination of whether Margaret needed an ambulance.

Reluctantly, the nurse agreed. She put Margaret back on the phone, and we talked for a few minutes. I heard a note of alarm in my mother's voice that was new to me. She had decades of mad dashes to the hospital and years of insistence that she had some mysterious medical condition whose discovery and treatment would change her life. But to me she sounded different: not as if she were faking or trying to get attention. She sounded terrified.

"Mom, I think you need an ambulance."

This was the first time, in all the hospital runs over the years, that I made the call.

Margaret was readmitted to the hospital, and when I spoke with her Monday afternoon she said they were running blood tests. On Tuesday morning her voice was chipper and she said she felt better. Whatever might be wrong, she felt certain she'd be home again in a day or two. She was receiving intravenous antibiotics, and with her great faith in drugs she was sure they would turn back whatever rekindled infection she might have. On Wednesday morning, Linda called with two simple words: "She's gone."

Somehow, at the critical moment, the only number the hospital could find was Ron's cell. He told Linda, and she called Wendy. All three set out for the hospital, where they arrived well after Margaret failed to respond to attempts to restart her failing heart. They had a private room in the hospital's morgue and some time with her body before the process of finalizing a cause of death and releasing her to a private mortuary began.

Margaret died of cardiac arrest, her weak heart unable to hold up under the onslaught of sepsis.

I was too far away, in upstate New York, to be there with my sisters and brother-in-law. I had no need to be. In life Margaret hated me to touch her, or embrace her even after a long hiatus, and my doing so at her death would have felt like an intrusion. I could imagine her rising one last time from the cold metal mortuary table to push me away while asking what in the world I thought I was doing.

I did gather my things to drive to New Jersey, leaving within an hour or two of the call. I phoned Sara and Matt, both working in other

states, and told them they needed to be in Kearny in short order for their grandmother's funeral.

I called Bern.

"I don't feel much of anything. Not sadness. Maybe relief. Is that normal when your mother dies?"

Bern was reassuring. "You'll get there. Just let the feelings be, whatever they are."

On the long winter drive down Route 81 I had a lot of thoughts about Margaret but still not much feeling. I began to think of a eulogy and called my sisters along the way to tell them them I was writing about our mother. They didn't object when I said I wanted to give the remarks at Margaret's funeral.

For Jerry, the kids and I created a funeral that was personal and idiosyncratic and non-religious. But Margaret wanted the full-on Roman Catholic rite. Over the years she wrote and re-wrote her funeral instructions, right down to the bowl of gardenias she wanted at the head of the casket. She made endless drafts of her obituary. Before she owned a computer she used to send me the handwritten versions and I'd type them for her. Once my secretary came upon the latest draft of Margaret's obit in my "saved" document file, and she said with shock, "I didn't know your mother died!" I replied that she hadn't, she just wanted to have the most perfect version ready when the time did come.

Margaret chose Armitage Funeral Parlor in Kearny, across the street from the competing Eddie Reid's where my father was waked, because she said over the years Reid's had gone downhill. While still in Kearny Margaret was what the Irish call a "wake wag." She attended every wake where she could find the remotest connection to the deceased and even some where she couldn't. I didn't know she was secretly keeping score, assessing which funeral parlor would give her the better sendoff. Our home town of Kearny was the location for the filming of much of the HBO mob drama *The Sopranos*, and Armitage was where they held all the faux crime boss funerals. I'm sure Margaret knew that, and I think it gave Armitage the edge.

Margaret chose Queen of Peace Church in North Arlington for

her funeral mass, instead of St. Stephen's in Kearny which we attended growing up. She and my father were married at Queen of Peace. The priest preparing to conduct the funeral mass, Father Tony, came to see us just before the wake. Our mother was a complete stranger to him, but he said he'd do his best if we would tell him a few things about her. He also told me, with a note of regret in his voice, that in the Newark diocese no women are allowed on the altar during the Mass so I couldn't offer the eulogy unless I wanted to wait until the Mass was over and the priests left the altar. Then I could stand in front of the communion rail, not on the altar itself, and speak. He hoped I wasn't angry.

I have something I call my "evil twin," which often gets triggered in matters regarding the Catholic Church. I smiled thinly at Father Tony and tried to keep my voice neutral.

"The Church hasn't done anything in forty years that I think well of, so this isn't a surprise. Say whatever you want during the Mass, and I'll give the real eulogy at the funeral parlor."

Wendy brought some of Margaret's card playing friends to the wake in a limousine. The New Jersey cousins were there and my mother's only surviving brother Walter. I made my remarks light and funny, reminding everyone of Margaret the actress and teller of great Irish jokes and maker of spicy pot roast and organizer of extravagant children's birthday parties which many in attendance would remember from firsthand experience.

After the wake the family members gathered our things to return to Linda and Ron's, but with a long drive ahead of us I suggested we get something to eat before setting out. None of us knew any Kearny restaurants any more, but the cousins did. They told us about a Portuguese bar across the street from our grandmother's old house on Kearny Avenue and said, "Tell the owner Michael Halpin sent you." Michael Halpin, my cousin Joe's son, is a cop, and clearly his name held sway.

As we pushed open the door, coming into bright light out of the cold and dark, conversation among the regulars stopped. They were drinking and watching Sunday night soccer and eating bar food, and we were in formal funeral attire and standing stiff and uncertain of our welcome. I

caught the owner's eye and said the magic words.

"Michael Halpin sent us."

The owner leaped across the room to welcome us, motioning the bartender to pull two tables together so we'd have more room. As the owner handed out menus, the bartender went back and got shot glasses and came to the table with a bottle of Portuguese liquor that is traditional at wakes and funerals. He poured shots all around on the house, and by the time we downed one or two we felt like Sunday evening regulars. Conversation resumed around us. We had a good meal, and were warmed by the drinks, and the owner said he was sorry for our mother's death even though he didn't know her or us. For me, that supper at the Portuguese bar was the most comforting moment of the entire wake and funeral.

At Queen of Peace the next day Sara and Matt walked beside the casket as pallbearers when Margaret's body was brought in. Linda and Wendy both did readings. I stood and sat as required during the Mass, but didn't kneel or take any other role. In addition to Father Tony, Wendy's husband George came through with four white haired Jesuit friends who concelebrated the Mass. Margaret would have been thrilled. Her friend Eleanor was buried by a Lutheran minister who happened to be Korean, and Margaret was aghast. She wanted Irish priests, and in force. She got four, plus one short, unassuming, soft-spoken Italian.

All of our cousins in the area attended both the wake and the funeral, and Father Tony observed that the deceased must have been well loved as a mother, grandmother, and aunt to have so many family members come to pray for the repose of her soul. I heard the male cousins shifting in their seats, as most of them had been forced into labor far too many times over the years as her moving crew. But she was also the Aunt Margaret who tucked five or ten dollars inside their birthday cards, and I think at the end of the day they were there because they wanted to be, not just out of obligation. If showing up is an act of love—and I think it is—then Father Tony was right. Margaret was honored by the family who showed up to see her into eternity.

We three sisters had one other immediate task: cleaning out

Margaret's apartment. The assisted living building had a waiting list, and after the building manager expressed quick and superficial condolences he moved on to the fact that they wanted Margaret's stuff out within three days so they could clean and paint the unit and have a new tenant in by the first of the month. Linda, Wendy, Ron and I set to work.

I tentatively opened a hall closet door. Empty boxes and cartons precariously balanced on an overfilled shelf fell, whacking me on the head and shoulders on their way to the floor. The deluge was reminiscent of being hit in the head by concealed crumb cake boxes when the kids were small and Margaret came to visit, and I thought how little people really change.

I did find one treasure of sorts, in an old mostly empty purse stuffed in the back of the same closet. When Linda and I were little and going on an errand with Margaret on the bus, I remember her standing up in a burst of anxiety, pulling the bell for the driver to pull over at the next stop, and then the three of us getting off mid-journey and in the biting cold. Margaret reached into her purse for a little white ampule that she broke with her finger. A sudden acrid smell burned my eyes. She took deep, heaving breaths, and then we stood there freezing without talking much and waited for the next bus. She was, I imagine in hindsight, having panic attacks.

Linda never remembered the ampules or getting off the bus in the cold, and whenever I brought it up she told me I was delusional. Yet there, in Margaret's purse, I found one of the little white ampules. Whatever was inside had long dried up, but the evidence was real. Sixty-two years old, and I grabbed the ampule and ran into the bedroom where my big sister was working, shouting, "See, see...I told you!"

Some families have an almost mystical experience going through their dead mother's things, and they turn the experience into essays or books or plays or films. I don't think that happened for us, at least not for me. My younger sister Wendy, the executor, already had the jewelry and sentimental things like tea cups from Margaret's china collection that she wanted each of us to have. What we did was shovel out all the rest: the worn underwear and empty boxes and stacks of newspapers waiting to be

159

read and the canned goods and all the bathrobes she requested over the years for Christmas and never wore, jammed in the back of the closet on hangers and some still with the tags attached. My brother-in-law made endless trips to Goodwill, as Linda and Wendy and I boxed things up. Wendy took all the bills and banking records and check books and old tax returns and anything else that looked legal or important. The furniture stayed right in the building. Other residents began to circle once word of Margaret's death made the rounds, asking if we had anything to sell cheap or give away.

That's how an ordinary life ends, with trips to the jumble store and furniture dispersed and someone to tidy up the loose legal ends and maybe, if we're lucky or observant, a childhood memory or two confirmed.

On the drive home I still wasn't feeling much, but I had a lot of thoughts about my mother's life. She struck me as something like a doughty little tugboat, scraped and battered from long years on the job. Ignoring the harbor master's rules about going slow near the mooring to create less wave action, the tugboat always revved up and went faster. The other boats rocked and banged against the docks in her wake, but the tugboat never looked back. Fuck the rules. They never worked for her, were never fair. The tug chugged blithely across the ship's canal, ignoring big cargo vessels criss-crossing the harbor, any one of which could have taken her out. None ever did. Other tugboats grew decrepit and were put into dry dock and cut up for parts, but not this tugboat. She went on longer than anyone. Musing about the tugboat was satisfying, like creating a character for a new short story, but far removed emotionally from the feelings Bern assured me would come.

Later, Linda sent black and white photos from the lot she'd sorted through, pictures of our parents' honeymoon. Our father is sitting in an Adirondack chair at a modest resort in the Pocono Mountains, looking up at Margaret. She's next to him on the wide armrest. His expression mingles both love and lust. She's smiling, although her expression is enigmatic.

Looking at the photos I missed my father terribly. I missed holding his hand and his sense that the world is a big and exciting place that I could run toward and explore, always secure in knowing he was there, waiting for me to return. Looking at Margaret made me take a deep breath and exhale. She was exhausting, and I didn't miss anything about that.

Some of my friends have things that belonged to their mothers, clothing or jewelry or treasured possessions that they hold close in order to remember and fill a void. Sometimes it's only the memory of something cherished. Minga remembers a brush her mother used to comb her long hair, all the while looking at her small daughter with loving eyes. Minga doesn't have the brush. She has the memory.

I don't have many things of Margaret's. She once gave me two cut glass bowls, one belonging to each of my grandmothers. I think the bowls are merely old, not valuable, but I like having them and they've survived two downsizings since I left Rochester. I didn't know my father's mother, Ada Owens York, who died before I was born. I did know Mary Halpin, who already seemed old when Linda and Wendy and I came along and tired of having her ten children or her myriad grandchildren around at all. I don't remember Nana Halpin ever giving us a birthday card or cookies and milk on the Sunday drives we took to visit her or her asking us about school.

I have some good memories of my mother, more in the later years. She and I got on the phone every May when the Kentucky Derby horses ran, and wagered five dollars. Her pick usually crossed the line first, and I always got a new crisp five dollar bill and sent it to her in an envelope with a funny card. She tried hard to be a good grandmother, although she was more successful bonding with Matt over baseball cards than she was trying to get Sara to like bride dolls. Margaret came when Jerry died, even though the trip sapped her energy and cost her considerable effort.

Margaret did get us to college. In the months before our father died, when Linda was a high school senior, he sat down with her and said he just couldn't swing it. Maybe they could send Linda to Katherine Gibbs, a secretarial training school. But college cost too much and was out of

the question. Margaret was having none of that. She knew that rich lady from church who was a graduate of the College of St. Elizabeth. Margaret wangled a meeting with Mary McKeown and asked her how to get Linda in and get her a scholarship. When my father died Margaret asked Mary McKeown for help again.

Among us the three York girls have multiple advanced degrees, and we've all been professionally successful. Margaret opened that first door, the one that lead to our undergraduate degrees. I'm not sure I ever thanked her clearly and explicitly enough for that.

Despite our chronic tensions, when I asked Margaret about her life in later years she usually tried to answer and didn't just brush me off. I once asked how she wanted to be remembered, and she said, "I want to be known as someone who did the best I could with what I had."

She did that. She was also a survivor, in the sense that nothing ever permanently held her back. Persistence is an undervalued trait. All of that adds up to remembrance and respect and gratitude, but perhaps fails to trigger in me strong emotions of grief and loss or even filial love. Margaret never gave me the kind of wide-armed, warm, loving embrace that Minga offered upon my return to Panama. I never offered that kind of embrace to Margaret either, not even in death.

A favorite writer of mine, Tillie Olsen, has a short story entitled *As I Stand Here Ironing*. There's a line in the story, when talking about her small daughter, that goes like this:

"She was a miracle to me, but when she was eight months old I had to leave her daytimes with the woman downstairs for whom she was no miracle at all...".

The line haunts me. My life was no miracle for Margaret. But it is for Minga, and she lets me know it every time I return.

Back
to the
Village

Jerry and Margaret were gone. The kids were, quite appropriately, focused on their careers. I was still advising people about their work lives through my consulting practice, but my schedule was entirely my own and I could communicate with clients via Skype. Rochester still had cold winters. I decided to go to Panama for three months.

I'm different in the village than I am in the rest of my life. Perhaps it's the heat. I forget to be so serious, so vigilant. No one really expects anything of me; they're just elated I've come. Creating a fun experience is relatively cheap; taking ten kids for ice cream cones costs three dollars and fifty cents. They have a different grasp of personal space and discretion and privacy than we do. When I showed the kids the huge master bedroom with its king sized bed, one of them asked me, "Tiá Pamela, why do you sleep in this big bed all alone? Why don't you have a man?" What a good question but one that my U.S. friends tiptoe around, not wanting to offend or cut too close to the core of my ever-present struggle with loss. I teasingly tell the kids they must find me one, but he has to be very handsome like their fathers, and they laugh.

In the U.S. my aging friends and I worry about our sleep patterns. In Panama I don't do hard physical work the way the villagers do, but by 9 p.m. I'm as exhausted as they are and fall into a sound sleep. I eat well

because Gloria cooks for me. I get sun but not too much, taking care with what my dermatologist called "that vulnerable Celtic skin." I swim a lot, good for older joints and muscles.

Most of all I have Minga, who loves me dearly and shows it. We walk around the village arm in arm, or arms around each other's waists, her black umbrella over our heads to protect from the sun. I'm almost a foot taller than Minga. If I hold the umbrella, she doesn't get enough shade. If she holds the umbrella, I get whacked in the head. We are a sight to behold. People smile when they see us, and wave. Her friends are happy for her: I'm Minga's American, and I'm here again.

Now, as women of a certain age, she and I talk about everything. Back in the Peace Corps days I was dying to know how Minga got pregnant all the time sleeping with Roberto in one tiny room with two short, narrow beds and all the kids. Did they have sex with the kids right there, maybe asleep and maybe not? I wanted to ask and as a single twenty-two year old never did. In my sixties, I did ask, and the answer was yes. Minga went on to say she is so done with sex. She is still a beautiful woman. Now and again, some old man in the village proposes that he move in with her to the be protector of the house. She snorts and breaks into a deep belly laugh at the very thought.

"I'm cooking no man dinner, washing no man's clothes, and having no man in my bed."

I can't help laughing too. In fact, in Panama I laugh a lot, much more than I do at home.

Staying in Panama for three months also gave me time to learn more about Gloria's family. Her husband, Luis, worked in a fish processing plant near the city from Monday morning through Saturday noon, the standard Panamanian work week. Their eldest son, Raoul has kidney damage from his premature birth and that early diet of weak tea. He can't work in the hot sun and risk dehydration. Eventually, perhaps soon, he'll need dialysis. Gabriel, son number two, was out of high school and looking for work. Youngest son Luis, named after his father, was in high school. When I met young Luis, his leg was in a cast from the knee down to his toes. Gloria explained to me that the many surgeries to repair his

clubbed foot left one leg shorter than the other. The imbalance created a lot of pain in his hips. His leg was also badly withered. He often sustained stress fractures simply from walking. Gloria was sick with worry that he'd wind up in a wheelchair. Luis, unable to keep up with the other young teens, stayed in the house, sitting morosely on a kitchen chair while he looked out at the others kicking a soccer ball or chasing girls.

One day Gloria asked if she could take the following day off to take Luis to the free public clinic in Panama City. A metal pin inserted in Luis' foot worked its way to the surface under the cast. Luis was in pain and bleeding. I told her of course she could go.

When Gloria returned, the news was not good. They left Rio Hato at four in the morning on one of the small public buses that run all day up and down the highway. They waited at the clinic until six in the evening, twelve hours from the time they arrived, without being seen. There were too many orthopedic cases that day and no room for her and Luis. They arrived home after nine at night, exhausted and dispirited and with the very sore foot still oozing blood.

I didn't go to Panama with the idea of being a benefactor. But I cared about Gloria and her family. I thought of my own son, Matt, what I would have done if he had a piece of metal sticking out of his foot. I know how the system in Panama works. I called my wealthy client and asked if he could get a family from the village and me in to see a private orthopedic doctor, preferably the next day. I said that I would be responsible for the cost. My client was most gracious and said he could do that very easily and would be happy to make a call. He took Gloria's cell number and said she would be hearing from someone that afternoon. He told me that when we got in to see the doctor, I was to use his name and remind the doctor of his personal interest in the boy.

Gloria's phone rang not very long after. She had that perplexed frown that I saw earlier, the one that meant something was happening that didn't quite fit with her experience of how the world works. After talking for a few minutes with the doctor's office she told me we had an appointment in Panama City for early afternoon the following day. I said that I would be at their house at 9:30 in the morning, ready to drive them to Panama

City and that it was important for both her and Luis to accompany their son for this doctor visit.

I didn't want the appointment to seem like magic to Gloria, or like something that had fallen randomly from the sky. I wanted her to understand how it had come about and why. We started a conversation about money that has gone on between us for the last many years.

"Money does some things very well and other things not at all. But money does this thing that you need right now—an appointment with a competent orthopedic doctor—very well indeed. And we are going to use some of my money to have that appointment and to ease Luis' pain and yours."

Gloria, Luis, young Luis and I arrived in Panama City with time to spare. I could see that all three were deeply nervous and unsure what was to come. I spoke to young Luis but really to all three.

"The doctor is a person worthy of respect. You need to look him in the eye, not down at the floor, and keep your back and shoulders straight, not hunched over. But you are a person worthy of respect too. You are the patient, and this is your body. You can ask any questions that you want. We are paying for the doctor's time and expertise. While he is with us, you get to have all of his attention."

Papá Luis said nervously he thought he should stay with the car, to be sure it wasn't stolen. I said no, that he needed to be with his son. I suggested gently that he too might have questions to ask the doctor. He took a deep breath to calm his anxiety, nodded, and continued walking with us. We went up in the elevator and entered an uncrowded waiting room. Gloria was handed some forms, which she began to fill out. "Does this really happen," she whispered to me, "that people come in and the doctor is waiting for them to arrive?"

Within moments of handing back the forms we were called into an examining room, and within moments of that, the doctor knocked on the door and entered. He focused on young Luis.

"Take off your pants, and get up on the examining table".

I turned to go, knowing how my son would have felt standing in his underpants in front of a woman not of his family. But Gloria grabbed my

hand and asked me to stay. I asked young Luis if that was all right with him, and he nodded.

Gloria brought copies of the x-rays that had been taken over the years, showing the repairs of the clubbed foot and the current leg fracture. After he looked at them, the doctor picked up a small buzzing hand tool and slit the cast open, putting it aside. He cleaned young Luis' foot with antiseptic, applied a topical anesthetic, took another tool and in seconds had the metal out. He covered the small wound with a simple band-aid, then asked Luis to hop down from the table and walk back and forth across the room, carefully observing his gait. He then told Luis to put his pants back on, and to come sit with his parents so that they could talk.

I was happy to see that the doctor spoke directly with Luis the patient—treating him as a young man and not a child—and with Gloria and Papá Luis. The doctor said the clubbed foot repairs done over the years were as they were, and it made no sense to do further surgery. That was true even for the extra digit that protruded at something of an odd angle from Luis' foot. The sixth toe might easily have been removed in infancy, but it made little sense to touch it now. The cast could not be put back on. The current fracture was healed, and the cast was on too long as it was. The skin underneath was turning soft and spongy and needed access to air to dry out and repair itself. But there were things that could be done. Luis should not be wearing flip flops, but instead good leather tie shoes into which a lift could be inserted to equalize the length of his legs. That would help even out his gait and lessen the pain in his hips. The shoe could also be fitted with a soft front piece that would close the gap between his shortened toes and the tip of the shoe, and that would help with balance. The fit of the shoes should be evaluated every six months until Luis stopped growing, and he would need new shoes and a new prescription for lifts and the frontal orthotics each time his feet got larger. Most important, the doctor said, Luis needed physical therapy to strengthen the withered leg. Ideally, he'd have had physical therapy since infancy. But he absolutely needed to have it now, before his final adolescent growth spurt. Otherwise the weak leg would never support an

adult body. Physical therapy three times a week for six months was the minimum, and then the doctor would see him again and re-evaluate.

Gloria looked at me in a panic. Young Luis wore flip flops because they were cheap, not because they were good for his feet. Physical therapy, aside from the cost of the sessions, involved a thrice-weekly trip to and from Panama City, the only place such services were available. Luis had to be accompanied by someone from the family who was over eighteen, which the doctor said was a requirement for him to be treated. The trip to Panama City on a public bus was apt to take two and a half hours each way, plus the hour for physical therapy. They needed to buy food while in the city. And all of that travel had to be worked in after Luis' school day, which ran from seven in the morning until one in the afternoon. When he got home around nine at night, he would be faced with homework.

My relationship with Gloria was as renter of the villa where she worked and emerging friend. I looked at young Luis and again thought of Matt. Surely the life of this boy was no less precious than the life of my son. I nodded at Gloria, signaling that the discussion should continue, trusting her to understand that I'd come up with the money. She told the doctor that they'd find a way to get Luis to the city for physical therapy, and that they would buy the good shoes with lifts and inserts. The doctor reached for his prescription pad and began to write.

Gloria's curiosity was piqued by that first doctor visit with young Luis. Suddenly it was clear to her that some people in Panama, those forced to use the essentially free public medical system, wait in hot, crowded rooms for hours or months to be seen and treated. Others go to air conditioned offices and are seen promptly and by appointment. Treatment in the private system is based on what is right for the patient, not what is available for free. The difference is not need or severity of the condition or intelligence or hard work or the measure of love one has for one's child. The difference is money and the sheer good fortune of being born into the right social class.

Gloria didn't respond with anger to her new awareness or with a sense of injustice. She reached for her faith. Like Minga, Gloria is deeply religious. She comes to work every day with her rosary and a small, well-

worn book of devotional prayer. Several times a day she takes a break from cooking and opens her little book to pray. She tells me she couldn't survive without her belief in God. During the hardest periods of her life, and there have been many, she was able to get up in the morning and keep going because she knew that no matter how bad her suffering, God would not abandon her.

Growing up, Gloria was one of nine children in a desperately poor family. They often went for two or three days at time, the whole family, with nothing to eat at all. She remembers crying from hunger and watching her mother cry because she had no food to give her children. Then came Gloria's years of service in Panama City, when her small son Raoul essentially grew up without her. When he became a teenager Raoul grew very difficult and resentful toward Gloria, not understanding her sacrifice but only that his mother left him and came to see him only rarely. Gloria showed me a cracked and yellowed photo from those days, when she was back in the village on her one day off after two weeks of work. She is sleeping soundly on the dirt floor of their small house, curled up on an old blanket. Her three little boys are standing above her in their underpants, looking down at their mother with somber faces and waiting for her to wake up.

Gloria's conclusion about her suffering, and what God might have intended, is this: God has been testing her faith. Now that she has shown her faith through the darkest of nights and for a very long time, God has sent her an angel, and I am that angel.

I don't like the theology, which suggests that God intentionally creates near starvation and children with clubbed feet as a test of faith. I don't like the time-worn message of the Catholic Church to the poor: accept God's will now, and you'll be rewarded in heaven. That's pretty much what Padre Gennaro says during his homilies when I've attended Sunday Mass at Gloria or Minga's invitation. But Padre Gennaro has no answer for Gloria as to why her life is so hard other than that it's God's will, and the will of God is a mystery.

I'm loathe to inject my cynicism into Gloria's faith experience or Minga's. They simply assume I'm Catholic, as everyone they know is

unless the person has become Evangelical. Protestant Evangelical churches have made great inroads in villages like Rio Hato, a trend beginning in the 1960s. Three of Minga's grown daughters have become Evangelical and are raising their children in that faith. Minga is having none of it.

"Catholic they were born, Catholic they were baptized, and Catholic they will die." My lovely Panamanian sister folds her arms across her chest, juts out her chin, and frowns, her dark eyes glowering. Her daughters, who want to be respected as adult women and mothers, wave their arms in frustration and appeal to me.

"How can you put up with her? She never listens to us, and she treats us like children." Sometimes frustration drives them to tears.

At the root of it, I think they want Minga to say they are good mothers. She withholds her approval over their religious choices, even when they are manifestly responsible and loving toward their children in every way, and I don't know why.

To tell Minga and Gloria that I don't believe in either a Catholic or an Evangelical God would be like telling them I don't believe in the air around us. They would find my disbelief incomprehensible. I understand that God is a last resort for them, a need that exists less in our culture where there is a wider safety net. They live every day with no safety net other than their belief that God will not abandon them, and I will never say or do anything to challenge that entirely necessary faith. When Gloria tells me somberly that I am the angel God sent to make her life a little easier, I simply nod.

Happily, not all of my moments with Gloria and Minga and faith in God are so serious. Minga loves to gamble; her daughters call it her biggest vice. She painstakingly saves up five dollars and grabs the public bus to the district capital where there's a casino for the locals. She plays the nickel slot machines, and can make five dollars last a long time. Sometimes she comes away with a few bucks. I never gamble, because I think it's throwing money away. But Minga wanted me to come with her, and she demanded I try my luck. I hit with my very first nickel. Bells clanged and lights blinked and the machine spat out a great wave of nickels, seventy dollars worth. The flood of nickels banged out of the tray

and onto the floor. Local people gambling nearby were thrilled for me and got down on their hands and knees to help me scoop up my winnings. The casino produced a plastic bucket, which we filled with handfuls of change, and I took the bucket to the grilled window and exchanged the contents for seven crisp ten dollar bills. Emerging from the dark casino into the light of day, Minga and I went to pay her accumulated electric bill. Then, on the drive back to the village, she said we had to swing by the church.

"Okay, but why?"

"Pamela, we have to thank the Virgin del Carmen for our winnings."

In short order there I was, on my knees again in front of a seven-foot tall plaster statue, not the statue of Sister Jane Marie and her evening rosary, but the statue of the Virgin on whom Minga relies for good gambling fortune. The Virgin came up big for the God siblings, and it seemed only right for Minga and me to be there giving thanks.

My three months in Panama all too soon came to an end. I always leave Minga with several hundred dollars in cash, in twenty dollar bills. She squirrels it away and doesn't tell anyone in her family she has it. I suspect she uses part of it to make more frequent trips to the casino, which is fine with me.

Having deepened my relationship with Gloria, I wanted to do something for her too. I pay her well, so didn't think of leaving her a similar cash hoard. I asked if there was any one problem I could help her solve before I left. I don't know what I expected her say, but what she did say took me completely aback.

"Dust."

I looked at her, perplexed. She explained that there was an outbreak of Hantavirus in the village, spread by rodent droppings left in the dust. Her boys slept on the dirt floor, on blankets. With the open nature of their houses it was impossible to keep all of the rodents out, and she was terrified that the boys would breathe in the virus while sleeping and become ill or even die. More than anything, she wanted simple metal bed frames and mattresses to get the boys up off the floor.

Once again, like young Luis' physical therapy, this was a problem

solvable with a credit card. Off we went to the district capital, climbing to the sweltering third floor of a furniture store to find bedding. Getting three bed frames and three relatively decent mattresses back to the village was an adventure, since nothing in rural Panama is delivered. We crammed what we could in the back of my small SUV, tied down the hatch with a bungee cord, and slowly drove back down the highway with mattresses bouncing out the back. We paid a villager with a small pickup to drive to Penonome to retrieve the rest.

Money always intrudes when I'm in the village despite my wish that class differences were less important in my relationships there. Everything is more openly talked about, so money is too. Minga and Gloria's families see me drive up on a shiny rental car, which tells them I have far more money than they do. They see me withdraw cash with a debit card. None of them have credit cards or checking accounts or even simple savings accounts. Nor have they ever rented a car. They operate in a cash culture, saving up worn bills and using those to pay for their needs. My bank cards seem magical to them, and I'm sure they think my financial resources are endless.

I try to lay down clear ground rules for when I will pay for something and when not, and I want my decisions to seem basically fair among all the families. I think that's a pipe dream. But because we talk more openly, Minga and Gloria and I can struggle together, and on much more transparent ground than I have found possible in the United States, to find the right thing to do.

The following year brought a new struggle: an abandoned boy named Arturo.

Lost
Boy

When I returned to Panama the following year, young Luis had a full round of physical therapy behind him. The difference was striking. He was free of bone fractures, remarkable in itself. But there was more. With the orthotics and lifts in his shoe he was walking with a relatively even and pain-free gait. Because he could keep up with the other kids his social life was much improved. His entire personality was different, no longer somber and depressed. He emerged as funny and outgoing, and girls suddenly found him attractive. He sported two girlfriends, not one, telling his mother he had a lot of lost time to make up for. Gloria rolled her eyes in mock disapproval as she recounted seeing one young lady disappear around the corner of the house just as the other walked up from the opposite direction. Actually Gloria was elated, so worried was she for so long that a disabled young Luis would never find a mate. He was intentionally protecting the leg by avoiding soccer games in which he'd have to kick a hard ball, but he could shoot hoops in pickup basketball games and ride a bike and walk to the market for a soda with his friends. Gloria was happy and relieved and newly hopeful.

She said Luis wanted to talk with me. I agreed to drive her home that afternoon and to sit down with Luis then. He was waiting in the shade of a palm tree, sitting on a stump, when we arrived.

He looked worried. "Tia Pamela, you bought me a bicycle and a basketball and new shoes. You paid for all the appointments in the city. We can't pay you back. It's too much money. My friends say rich white people don't do this. They say you'll help us, and then you'll take my mother back to America with you and make her work for free because of our debt to you, and you'll never let her come home."

Where to begin. I started with what he was most worried about: losing his mother. "Luis, I will never take your mother back to America. And I'll never ask her to work for free. Your mother and father both work to support your family. I respect that. What your mother does for me at the villa is a job, and she gets paid for her work. What I did to help you is something different."

Gloria takes the boys with her to church. I thought I could use that context without going overboard on Gloria's thinking about my being an angel.

"You hear Padre Gennaro talk about being a good person in the eyes of God, right?"

Luis nodded.

"Good people help each other. You see your mother and father helping when they can, don't you?"

Again he nodded.

"There are lots of ways to help. Sometimes it's with food when someone runs out. Sometimes it's by washing someone's clothes, like your mother does for your grandfather since your grandmother died. Sometimes it's by helping fix a net or a hole in a fishing boat, like your father does when a neighbor needs his special skills."

Luis was listening intently.

"Sometimes help is with money. It's not different, to help with money or to help in some other way. What you needed took money. I was able to help, and I did because I'm trying to be a good person, just like your mother and father, just like they want you and your brothers to be."

Luis was clearly listening, and what I said seemed to make sense to him. But I could see the circle wasn't yet complete in his mind.

"But we can't pay you back."

"I don't expect to be paid back. But I will ask something. When you are older, you'll come upon someone who needs help in some way. If you are the one who can help, I'll ask you to do it. Can you promise to do that, if someone around you needs help and the help is something you can give?"

He smiled broadly and nodded.

He didn't wait very long. Days later, he showed up at his house with an abandoned twelve-year old boy, Arturo.

Luis told Gloria he was doing what I asked of him: helping someone in need. Arturo had no family and needed one. The Samañegos were a family. Arturo, Luis proposed, should live with them and become the youngest brother.

Luis knew Arturo from hanging out at the basketball court in front of the village elementary school. Arturo's mother abandoned him as a little boy, literally left him on the streets, when she moved to Panama City to live with another man and have his children. Arturo's addicted father used him as a drug mule, knowing the police were apt to treat lightly a skinny, undersized boy caught with pouches of drugs tied under his shirt. Arturo never went to school and was completely illiterate. He slept in empty houses or in the fields. He begged or stole food. He hung around with the other boys on the courts, and when they went home at night for supper Arturo went off alone into the dark.

Taking in a young person who no longer has immediate family is not unusual in Panama, but it's typically done with a blood relative. Taking in a stranger is rare. Gloria and the older Luis talked about it and decided they could make room in the family for Arturo. There were some hurdles, like having Arturo's father agree to the arrangement. Somewhat to Gloria's surprise, the man gave his assent.

Gloria needed money to help Arturo, which made me part of the project too. Arturo needed a bed and mattress. He needed clothes. He'd never been to the doctor, and since he drank water from any available source his intestines were filled with parasites. Gloria enrolled him in school, where he was placed in a classroom with other twelve-year olds. He could do nothing that involved reading or writing or computing; he

never learned. Gloria found a tutor, a retired teacher, who agreed to work with Arturo every afternoon on basic skills.

Arturo was undersized; he looked eight, not twelve. He was withdrawn around me, refusing to make eye contact. But he quickly warmed up to Gloria, asking if he could call her Mami like the other boys. She said yes.

Gloria and I wondered together whether being chosen at the age of twelve might someday overcome the deep wound Arturo's absent mother left on his young heart. The teacher at Arturo's school had doubts. She urged Gloria and Luis to hold back from formally adopting Arturo in case things didn't work out.

Gloria and I immediately went to the district capital and bought Arturo six pairs of underwear, three shorts and T-shirts, some flip flops, and a basketball of his own so he'd have something to bring to the pick-up games with the other boys. Gloria explained to him that in their family people didn't walk around dirty and disheveled. He had to bathe every day and wear clean clothes and brush his teeth. The day after Arturo got his new clothes, I drove Gloria back to her house after work. We found Arturo wrapped in a towel sitting anxiously on the porch. Draped over the barbed wire fence, drying in the sun, were three pairs of underwear, the shorts, and shirts. Every time he got dirty during the day, he came home and bathed, washed his clothes, and changed until he ran out of clean things to put on. Now he was waiting for something to dry, so he could dress in clean clothes and go out to play again. Even Gloria was flabbergasted at how little he understood of what she said and how hard he was going to try to do what he thought she wanted.

Arturo's life with Gloria's family was full of ups and downs. His mother came back to the village for a visit. She made no effort to see her son, and Gloria found him huddled on the floor next to his bed, sobbing. Then he would brazenly stay out late at night, well past the time the Samañego boys were expected to be home, and young Luis told Gloria he thought Arturo was running with his old crowd. Gloria asked Arturo directly if he was using drugs, or dealing them, and he looked her in the eye and innocently responded, "No Mami."

Then some teens high on drugs broke into the church after dark and stole food bags assembled for distribution to the poor. Word had it that Arturo was involved.

Sometimes Gloria wept with frustration and worry. Her boys, whatever their adolescent antics like gambling over cock fights, didn't lie. Arturo did, glibly and without hesitation. Young Luis became angry at his new younger brother because Arturo made Gloria cry.

Gloria and her family fought hard to keep Arturo with them. Gloria enrolled him in religious instruction at the church, sure that if he completed the classes and was baptized and received his First Holy Communion his innocence could be reclaimed. I believe Arturo fought hard too, wanting very much to be part of a family. Every night before going to bed, Papá Luis would sit beside each of his boys, talking about their day, then he bent over to kiss them goodnight. Gloria told me that she always saw Arturo peering out from under his sheet, waiting anxiously to see if Papá Luis would come to him. Luis always did.

Arturo ran away for good the week before his baptism, which broke Gloria's heart. There was a robbery at a local *tienda*, and one of the thieves waved a gun. Arturo was among them although not the one armed. The village police arrived at Gloria and Luis' door and asked if they were the responsible parties for this wayward boy, the ones who would be asked to make restitution. Gloria took a deep breath and said they were not. She told me it reminded her of the story in the bible where Peter denies Jesus, leaving Him to face his accusers alone. She felt that Arturo was testing them, to see if they would stand by him no matter what. She wasn't willing to when Arturo placed her sons at risk by bringing drugs and guns to their very doorstep. But denying him to the police came close to breaking her heart.

Arturo was arrested and thrown into a holding cell in the village police station. Jail in rural Panama is a cold, tough place. There is a concrete floor and an outhouse that can be used upon request. There's no bed, no blankets, no food, no chair. You sit and sleep on the floor. Your family can bring you food and blankets, and if they don't you do without. Arturo asked that Gloria and Luis be told of his arrest, and they went to

bring him what comforts they could. Because he was still a minor Arturo was eventually released with a stern warning not to get into more trouble before his court case came up. He slipped back into his life under the stars, trying to avoid the attention of the village police and continuing to commit petty crime. He didn't appear for his court case.

Occasionally he came to Gloria for food, and she always cooked him a hot meal. She listened to what he wanted to tell her but didn't ask where he was staying or what he was doing. Gloria didn't ask him to come back to live with her family. Arturo and his crew, she told me sadly, represented real danger to her boys.

I was back in the United States when Gloria called, sobbing. Arturo was shot in the chest and killed by village police while he was robbing a store. He was fifteen and looked twelve. He had no weapon and was facing the police when shot. Gloria suspected the officers were simply fed up with him, saw an opportunity to get rid of a problem for good, and did. She was incensed but without recourse.

Gloria and Luis went to claim the body. Dead criminals are not cleaned up at the police morgue. Gloria and Luis carried Arturo to their home wrapped in a clean blanket, still in his bloody clothes and with gaping gunshot wounds in his chest. They washed his body and dressed him in a white shirt, pants, shoes and socks. Gloria said he looked innocent, and so young. He was laid out in their living room.

Padre Gennaro refused him a Catholic burial, because he wasn't baptized and because, Gloria thought, the priest was still angry about Arturo robbing the church. Arturo's mother got wind of his death and showed up for the simple service in Gloria's home. Gloria told me she had to summon all of her Christian charity to let the woman in.

I wrote about Arturo on my blog, and several kind readers bought Mass cards. My friend Mary, who belongs to a progressive Catholic parish in St. Paul, arranged to have a funeral mass said for Arturo. He had his Catholic rite even if not in the village before his burial, and Gloria was comforted.

I was most worried about young Luis and told him on the phone that we would talk more about his impulse to help Arturo when I returned to

Panama. I said trying to make things better is complicated, and I urged him to look at the modeling of his parents. They didn't let Arturo hurt him or his brothers. Nor did they abandon Arturo in the end. Young Luis asked me over and over, his voice frustrated and angry, how his attempt to do good could have gone so wrong. Luis asked me if he screwed up by helping Arturo. Luis said he wasn't sure he ever wanted to help someone not of his family again. I told him honestly I had no easy way to make sense of Arturo's choices, why he had to flee from the family's warm embrace and offer of a better life.

Gloria has her three sons around her and loves them dearly. The boys love her in return. Arturo loved her. I could see it in his eyes when he looked at her, and hear it in his voice when he tentatively and gingerly asked if he could call her Mami. Gloria loved Arturo, and I suspect he'll always be an ache in her heart, the one lost boy.

The Big
Move

The dramatic year of Arturo also brought a big change in my life back in the United States. I moved to the Pacific Northwest, to a steel and glass condo in downtown Seattle, choosing to leave the place Jerry and I lived and worked and raised our family. I wanted to be nearer to Sara and Matt and his wife Amy, to be part of their lives without hopping on a plane and structuring a ten day visit. I felt drawn to new geography, but I was also ready to let go of things that were secure and familiar and so important to my emotional stability in the years after Jerry died.

For eight years after that life-altering day in April, I felt comforted living in our home in Rochester. I could feel Jerry's presence everywhere. I could close my eyes at the end of the day and envision his silver gray Audi pulling into the driveway, see him reach into the back seat for his daytime planner and stack of folders and research reports, watch him stride briskly to the back door and hear him call, "I'm home." I cleaned out his closet and dresser within days after he died, but I left his desk untouched. He could have gone upstairs after supper, sat down to pay the bills, and reached into the upper right hand drawer for his stockpile of stamps. I bought a new computer, but worked from his big table on the third floor. I kept his worn and comfortable slippers in the bottom of what was now my second

closet. I wanted the remnants of him around me. As time passed, my heart healed and I needed these bits and pieces of Jerry less.

Sara and Matt came home infrequently, having lost contact with high school friends and being deeply engaged with careers in their vibrant new city. I love the adults Sara and Matt have become, and deepening my relationship with them is important to me. My friendship circle in Rochester diminished as people decamped to warmer places like Florida or South Carolina. The house on San Gabriel Drive, once sheltering, suddenly echoed with empty space. I liked Seattle. The city has all the neighborhoods I love about New York, but is smaller and more manageable and a shade less expensive. I decided to downsize dramatically in favor of a condo, and to relocate across the country.

Friends and my financial adviser were concerned that I was taking too many big steps too quickly and thought I should look at a condo in downtown Rochester as a first step. I didn't agree. It's not my nature. If I'm going to make a big change, I make it all at once. If the change doesn't work, I trust in my ability to regroup and make a different one. Perhaps all the coming and going with Margaret contributed something too. I learned at an early age to root myself quickly wherever I land.

I went from about twenty-six hundred square feet of living space, plus a basement and garage, to twelve hundred square feet. That meant getting rid of a lot. The process was physically demanding, but not hard. I was highly motivated to begin what I call "de-nesting." I simply didn't want anything around that I wasn't going to use on a regular basis. I pared ruthlessly, even relegating my toaster to the Goodwill box. I asked the kids what they wanted from our family home and said that on a one-time basis I'd ship it to them, whether the shipping cost the earth or not. If there were things that held important memories, I wanted them to have those things.

Among their choices were Jerry's tools, even though the whole lot could have been replaced easily and inexpensively in Seattle. Jerry wasn't really handy, he just wanted to be. He kept thinking if he got the right tool, his modest home improvement projects would succeed. He once

spent a couple of hours installing a towel rack in the bathroom, only to have the rack and the screws fall right out of the wall when I placed a single dry hand towel on it. I was glad the kids wanted the tools.

Everything else found a new home. I called Goodwill and had them come and pick up Jerry's and my five piece heavy wood bedroom set. Friends were aghast that I'd give away such a symbolic and intimate part of my life with Jerry, but the pieces wouldn't fit in my new condo, other than perhaps the bed. They were a set. I was actually at the Goodwill office collecting the tax receipt when workmen began to move the bed frame and chests and side table and mirror out onto the display floor, pricing each at pennies on the dollar. A young couple was there, with what looked like the young man's parents. I think the young people were newlyweds, or about to become so. The older couple immediately claimed the set. I didn't say anything to them, not wanting to intrude on their moment of family joy. I'm quite sure the elders were gifting the bedroom set to the young couple. I was happy for them to have it and silently wished them a married life like Jerry and I had.

I was again aware, as I was making decisions about what the movers would pack, of the few things I have from Margaret. She once gave me her wedding ring, which I kept but don't wear. The ring reminds me of that photo of their honeymoon in the Poconos, when she and my father looked happy. I have the two cut glass bowls and a tintype photograph of her mother, Mary Halpin.

None of the objects carries the kind of emotion I hear in Minga's voice when she talks about her mother's hairbrush. Bern assured me that more layered emotions about Margaret would come, perhaps when I went through this process of sorting out what to move, or when my grandchildren were born, or when I visited the grave in North Arlington where both of my parents and Barbara are buried. But my feelings about my mother's life and death have stayed mostly the same. I'm grateful she got us to college. I appreciate her coming when Jerry died. I recognize how hard she worked to be a good grandmother. What Margaret wanted most was for me to say she was a good mother. I never did. I never do. I say, using her own words, that she did the best she could.

The hardest thing to leave behind in my move to Seattle was Jerry's tree. Some years before he died, the service we hired to care for our lawn and shrubs and flowers planted a weeping cherry in front of the house. The winter was especially long and cold, and by spring the little tree looked nearly dead. The service offered to yank it out and plant another one, but Jerry said no. He said to give it another year. Sure enough, by the next spring it looked much sturdier, and actually put out a few blossoms. Within a few years the tree was simply beautiful, with long, graceful branches and a profusion of soft pink blooms. That was like Jerry, always willing to give the struggler another chance, a little more time. I loved Jerry's cherry tree, and hated to let it go.

Here in Seattle I don't have trees or plants or pets. My space is spare and almost obsessively neat and simple, and when I leave for a few days or weeks I just close the door. Nothing begs to be cared for while I'm gone. I like it that way. Every so often I spot a lush African violet in the plant section of the market, and I'm tempted. I had lots of African violets in the sun room of San Gabriel Drive, and I'm good at growing them. But then I remember the ease of just walking out the door, and I hold back.

Moving to Seattle pushed me to embrace my identity as a single older woman even more deeply than before. No one here, other than Sara and Matt, ever knew me as part of a couple. I reference my late husband, and people nod and smile but have no face, no personality, no little quirks to attach. They don't know about Jerry's geeky pocket protector, or about the stash of fruit and nut chocolate bars he kept in his desk at work to hand out if someone was having a bad day. They don't know he bought the newest technology ten seconds after it was out and pushed me to buy an expensive Jaguar that I'd coveted for years, but that he kept his leather wallet together with duct tape. When he got a moth hole in his blue blazer, he colored the white lining underneath with blue ink rather than buy a new sport coat. They don't know his generosity was quiet rather than self-serving, and that he never wanted his name on anything.

We're shaped by the people we allow to be formative in our lives. I'm a better mother and grandmother because Minga and I became *comadres*, God siblings. I'm a better human being because I was with Jerry for

thirty-two years. I never had to compete with him for the air in the room as I always felt I had to do with Margaret. He encouraged me to grow and smiled with quiet pride when I did.

Jerry left me suddenly, as if in mid-sentence. Minga will too, in the sense that I will likely not be able to get there before her funeral. They don't embalm in rural Panama, so interments are held the same day. She will leave me standing by the side of her grave, as I once left her on the side of the road, wishing she could see me one last time.

On the Cusp of Elderly

Prior to July 4th, 2013, three years into my new life in Seattle, I would have said that I'm the most blessed of nearly seventy-year olds. Then came that sunny, hot, festive afternoon. I was sitting on a backyard deck with friends and family, my kids and daughter-in-law and grandson within easy calling distance, sipping a frozen strawberry daiquiri and loving the day, when I suddenly passed out. I remember being in the chair. Then I remember my son Matt holding firmly onto my shoulders, supporting my head to keep it upright, asking in a worried voice if I knew where I was, if I knew I just fainted.

I did know where I was. I didn't know I lost consciousness. Later I found out out that I slumped in the chair for about a minute, my head rolling back and my breathing becoming louder and irregular due to the constricted airway. This was not a ladylike faint, if such a thing exists. Moments after I regained awareness I felt violently sick, and my daughter Sara helped me to the bathroom. I barely grabbed hold of the sink when I suffered intense vomiting and diarrhea, right where I was standing and all over the floor. In the background I heard sirens. Someone called 911, and emergency personnel soon arrived. One medic came into the bathroom to see to me, and I heard others talking with my son.

"How long was she out? Were her arms and legs still, or was she flailing around? Was she alert and aware when she regained consciousness? Did she know you? Did she know what just happened? Are you sure?"

The medics determined that I needed to go to the emergency department, but not necessarily in an ambulance. Matt could drive me. Sara got a clean pair of sweatpants from the friend hosting the picnic. Sara also gave me her flip-flops. My badly soiled pants and underwear and sandals had be thrown out, and Sara stayed behind to clean up the terrible mess.

I don't remember feeling frightened. I remember trying to focus on staying alert, staying conscious. I felt horribly nauseous and clammy and wobbly on my feet. I threw up again in the car. I was able, with Matt's help, to walk into the emergency department. We were taken in immediately, and in moments I was in a bed being hooked up to monitors and an IV, getting blood drawn. Now the questions were directed to me.

"Do you know where you are? Do you know what just happened? Do you have any chest pain, any trouble breathing? Has anything like this happened to you before? Do you know how long you were out? Are you nauseous now? Are you dizzy?"

Fainting is not all that unusual. By itself, a faint can be relatively insignificant, like a quick power outage where the lights go off and then on again almost without the brain registering an interruption. You have to go around and re-set the digital clocks that are blinking, but no lasting damage occurs.

The emergency room team did not begin with that benign assumption. They asked if I went into cardiac arrest while being treated, did I want attempts to restart my heart? That startled me. Of course I wanted my heart restarted.

Matt and I waited. We waited for the results of the blood test that could have signaled a heart attack. We waited hours for the monitor to show any sign of an arrhythmia. We waited to see if I'd pass out again or become disoriented, or if I'd show any signs of a seizure or a stroke. Someone came to do a neurological evaluation, then left. Someone came to check the IV line. Someone brought more blankets as I was shivering

with cold.

As we waited, Matt and I talked. Oddly enough, despite the sterility of an emergency room, the hours together were a gift.

After about five hours, the attending emergency room physician came back in. He said that my tests so far were normal, and if I were forty-five he'd send me home and ask that someone stay with me overnight to observe. At the age of sixty-eight, he thought I should be admitted and be on a heart monitor overnight and into the next morning. Then he'd feel more comfortable ruling out an arrhythmia. He said it's what he would do for his own mother.

Matt and I looked at each other. He said softly, "Mom, of course you're going to do that, right?" I said of course, and hospital staff began to prepare me for the move upstairs.

I spent the night on a hard mattress in a chilly room, with monitors beeping and the sound of the crash cart rumbling down the hall. As I began to doze off someone shrieked "Oh, no... no... no." I heard the sound of sobbing. Hospital staff came and went from my room, checking the monitors and taking my vital signs. At 3 a.m. someone in a blue maintenance uniform turned on the lights to change a battery. Barely three hours later, before the sun was fully up, someone in flowered scrubs gave a me a menu of breakfast options.

My eventual diagnosis, when I was released later that morning, was a one-time event caused by an unfortunate confluence of risk factors: slight dehydration, the onset of an acute gastroenteritis, and sitting in the hot sun with a strong alcoholic drink. As long as I didn't have another episode, I shouldn't worry too much about having fainted. On a follow up visit to my primary care doctor, she agreed: I was free to reclaim my sense of being normal.

Feeling normal again has taken time. In the first few days after I was home, I hesitated every time I went out. What if I fainted in the market, at a concert, while driving the car, or at home alone taking care of my grandson? What if I was giving him a bath, and I fainted, and he drowned? My mental anxiety spiraled out of control. I decided I couldn't live like that and resolved to stop myself each time my brain went into

overdrive. After about a week, especially with no recurrent physical symptoms, my anxiety slowly lessened. I began to smile more, to talk more openly with friends about what happened, and to feel my healthy, vigorous self.

That is not the same as saying I felt as if the episode never happened. Two things are different. One is that I feel vulnerable and have a new awareness of my impending mortality. Perhaps, having entered early old age, it's time.

The other new awareness has to do with my experience of Jerry's death, a day that is always with me. I wrote earlier of feeling that I let Jerry down by not being with him as he began to die. I felt that as he lay on the floor of our bedroom he might have looked for me, looked for someone to help him, perhaps tried to get to the phone. But now I've had the experience of slipping into unconsciousness. The faint happened so fast, so completely, that I didn't know what hit me, didn't look for anyone, didn't feel afraid. Happily, my terrible moment had a different ending: I woke up. But I no longer fear that Jerry had extra time to feel afraid and alone. I think he just died.

Without a set of religious beliefs against which to place my feelings about mortality—my own and Jerry's—I'm left to construct a meaning. I spend more time thinking about death, reading stories of public figures like Oliver Sacks who lived with and wrote about terminal illness. I push myself to remain engaged with friends who are dying, instead of subtly withdrawing as I might have done before. I look to the people I care about and respect, those older than I, for received wisdom. I'm beginning to build my own sense of what it means to live knowing we all die.

From Minga I've learned that death is not strange or unfamiliar or frightening. She washed and dressed Roberto Delgado's body for burial, an event that came long after they were no longer a couple. When she went to visit him a few days before his death she promised she would see to it, as a last gesture of respect and compassion for the father of five of her children. I think how different that was from having Jerry's body whisked away in a body bag, only to reappear again in an expensively lined casket, neatly attired in a suit and with make-up trying to create

some normalcy in the color of his skin. When I touched his chest I could feel some sort of bolster underneath his shirt to make viewers unaware that a chest caves in after organs are removed during an autopsy. I think I like the Panamanian way better, touching death directly and letting a body be what it is.

What do I believe happens then, when our mortal remains are safely tucked away? In recent years I was part of a master class in poetry with then-U.S. poet laureate Kay Ryan, who had just lost her longtime partner and was clearly using her poetic gifts to come to terms with the grief. Ryan is a genius of simple verse. She showed us how moving one letter can create a profound shift in meaning. On the classroom blackboard, she wrote two lines in chalk: "Now here. No where." I don't know if Ryan believes in such an ephemeral ending, but I do. I think that's the "and then" after death. We're here, and then we're nowhere. Minga lives secure in a different belief. She has a small altar in her home, with votive candles and statues of Jesus and the Virgin Mary. She believes they will both come to her at the moment of death and ease her into heaven, the Virgin especially, because they share a bond as mothers. That thought comforts her. The rawness of Ryan's poetic image, if not exactly comforting, makes sense for me.

Margaret was terrified of death, and her Catholic faith seemed to assuage her fear not at all. After her heart attack she suffered progressive, although fairly slow-moving, heart failure. I'm quite sure that moments of feeling light headed or having her heart race prompted the frequent calls for an ambulance and the many visits to the ER. She had enormous faith in doctors and wanted them to do something more than relieve her immediate symptoms. I don't think Margaret ever felt, as Minga does, that she and the Virgin Mary were going to walk arm and arm into heaven. Margaret was a believer in a traditional God the Father, and since her own father was a big disappointment, I wonder if she feared the heavenly Father might be judgmental and dismissive of her too.

When the prospect of death seems too bleak, I reach for a bit of humor. A colleague from Rochester, diagnosed with lung cancer, announced her terminal prognosis with an email heading of "Wowie

Kazowie." Her opening line was, "Now I know what I'm going to die from so I can stop worrying." I had to smile. The email was so like her. At a point that I may get bad health news, I might send an email like that too, and it would be like me.

Minga is what's called a "cradle Catholic," and Margaret was too. If I describe myself as anything, and no one usually asks, I'd say secular humanist. I think we're here, together, trying to make a better world. That's what I said to young Luis when he wondered why I helped him rebuild his withered leg. It's what I believe, what I taught my children, and how I act.

If the Catholic faith I've long ago left behind doesn't help me deal with death, it does come in handy on other occasions. In 2014 I gave a wedding for Gloria and Luis in the 19th year of their being together as a couple. Being formally married in the Catholic Church was important to Gloria, and they never had the money to hold a wedding themselves. Her mother was dead, and she asked me to stand in for her mother and serve as her matron of honor, an invitation that touched me deeply. I arrived in Panama on a Wednesday, and on Friday in the village we all met with Padre Gennaro to run through the ceremony, scheduled to take place the next day. During the rehearsal I saw my role in a way I hadn't before, as an actor in a traditional Catholic rite. I had to sign some sort of book, witnessing before God and the faith community that the marriage was legitimate. I leaned over and whispered to Gloria, "Do you have to be Catholic to be a matron of honor and sign the book?"

She looked at me with alarm. "Yes. You are Catholic, right?"

With respect, and because it was too late to change the wedding party and just seemed right in the moment, I whispered back, "Absolutely."

An Imagined Future

As a four-year old I imagined my sister Barbara coming home from the hospital all fixed, and my parents would no longer have a broken baby.

At fourteen I imagined my father's death a bad dream, from which I would awaken.

As an adult I imagined Jerry and I would grow old together, and that we would attend to each other's growing frailties with a tenderness forged by long shared history. I expected him to come back from the cross country bike trip loving everything: the physical challenge, being with similarly active people, seeing the United States from the slow-moving vantage point of a bike. He always said he didn't think he'd ever retire because he didn't know what else he'd enjoy doing other than work. Biking might well have been that other thing. I believed that after successfully rising to the challenge of testing himself, he and I would go back to riding together. I thought we might even do that Cairo to Capetown trip, which sounded to me both exciting and terrifying in its length and in the challenge of riding across remote parts of Africa.

I imagined that with the successful publication of *How Much is Enough?* I'd continue the life of a writer, not knowing I'd be drawn back into the financial planning business, the emotional turmoil of the medical

malpractice suit, and the need to rebuild a life as a single older woman. Jerry died in 2002; I didn't start writing again until 2009 when, on a trip to visit Minga, I began a daily blog.

I thought there might be some discontinuities between my need for long, solitary periods in which to write and Jerry's desire to be out on the bike. I didn't fear it. Marriage is full of times when life partners are out of sync. We had a short period, after both kids left for college, of feeling slightly out of step with each other. But new rhythms quickly emerged. Life seemed easy.

Then Jerry died.

After that first year of terrible grief when I did nothing but try to hold myself together, I assembled a new life. I continue building that life, one very different from my imagined future growing old with Jerry. I don't think often about that other life, the one that didn't happen. But sometimes I do. In 2015 I returned to Rochester for a donor event, and I saw friends and visited familiar places. I went by San Gabriel Drive and saw Jerry's cherry tree, still thriving. Jerry was everywhere, and I could barely endure missing him and what we might have shared.

On the six hour flight home to Seattle, I turned with steely determination back to the life I have.

I still imagine a future, even though my imagining has so often been upended. I imagine attending my grandchildren's high school graduations, being able to walk unaided to a seat, being able to follow the ceremony and stand and cheer at the end. That's about another fifteen years, which makes me eighty-five. Margaret lived to be ninety-two and didn't have her first heart attack until well into her eighties. I may actually have inherited my father's temperament and my mother's physical longevity, which I call winning the genetic lottery. I imagine going to Panama for as long as I can, even after Minga dies. I think my old house in the village will soon fall down. The roof is gone, and grass is growing through the cracked concrete floor. The space has been empty for some years, and with no one to care for it nature is taking over. I imagine that when Minga dies the family will sell her house, even though her dream is that they keep it and use the property as a place to gather. My attachment there is to place and

people, not to physical structures. The village is where I found Minga, and where I got the first glimpses of how to be a good mother.

My life will come to its natural end when I can no longer imagine, which may or may not coincide with my physical death.

On a trip to Ireland I was in a very old cemetery attached to a small, rural church. Some of the headstones were toppled by age and lay at odd angles in the newly green spring grass. Those stones still standing had vague indentations where someone had once engraved names and dates of birth and death. But the engravings were nearly gone and by now unreadable, worn away by wind and rain and time. I found that oddly comforting and peaceful. Individual names are lost, but the forces of nature move on, grinding away the good and the bad and bringing forth new seasons.

This version of immortality is what I can imagine, and it's enough.

Acknowledgments

A good editor makes an author sound more like who she is, only crisper and more on point. I've worked with two nationally known editors over the years. The first was Marie Cantlon, who spent much of her career with Beacon Press in Boston. Marie was the first to tell me that I'm a fine writer, and to encourage me to write more physical detail about my characters. Although my interests tend to the psychological and spiritual, Marie reminded me that people are not just talking heads. The late Liz Maguire, publisher of Basic Books, acquired my first book, How Much is Enough?, in 2001. If Basic Books liked the project but didn't trust the capacity of the author, they'd assign you a writer. Echoing Marie, Liz told me my writing talent was trustworthy.

I decided to self-publish Good Daughter, Good Mother, because commercializing a memoir is hard if you're not famous, and because I have much less of a national platform in retirement than I did when How Much is Enough? launched. By sheer happenstance and good fortune, I found a young independent editor, Breka Blakeslee, an MFA graduate of the University of Washington. I'd hired Breka to help me with a revamp of my blog site, Pam Klainer's Day, and almost as an afterthought asked her to read an early draft of the memoir. Her comments were so good, so creative and helpful in shaping the text, that I hired her formally

to be the book's editor. Editing is really hard and gracefully accepting editorial feedback even harder. Breka is an amazing talent, right up there with Marie and Liz in skill if not in years. Breka also knows a great deal about production details, and has a network of contacts in the industry. Through her, I found Travis A. Sharp, a graphic artist who designed the cover. A young man's willingness to engage with an older woman's book caught my attention, and Travis delivered in excellent fashion.

Breka's fine editorial hand is on every page of this book.

Jenn Tai of Jennifer Tai Photo Artistry in Seattle created the author photo. I don't normally take a great picture, but Jenn took a great picture.

I asked several people to be early readers and to make a comment that might encourage others to buy the book and read. Laura Winters and Lynne McEniry write, teach writing, and were dear friends of the late Sister Alice. I trust their comments every bit as much as I would hers. Bev Flynn had an Irish Catholic mother, and Bev has been a mothering presence to generations of budding young adolescent students. Maria DiTullio is a daughter, a mother, a scholar and therapist, and an emerging writer. Monica McGoldrick came upon some of my early, unpublished work through a mutual friend, and found it helpful in her therapy work with multicultural families. Katie Capitulo is the daughter of a family with Scottish heritage, and the mother of a broadly multicultural family. Amy Klainer Moss is my sister-in-law, and we share a love of many of the same books. I trusted her to read with an appropriately critical literary eye and a generous heart. Ginny Daly and I cut our creative writing teeth in college under the demanding eye of Sister Mary Catherine O'Connor; Ginny founded her own communications firm and writes and edits professionally. Sharon Napier is an entrepreneur, a mother, a daughter, and a friend. She lives in the world of advertising, and understands the power of words.

Finally, I always count on the support of daughter Sara and son Matt, and they always come through. And I remember Jerry's quiet smile and unstinting encouragement for any project I wanted to attempt, and I count on that too.